HERITAGE
PHOTOGRAPHS
FALL 2015 | LIVE & ONLINE

D1536634

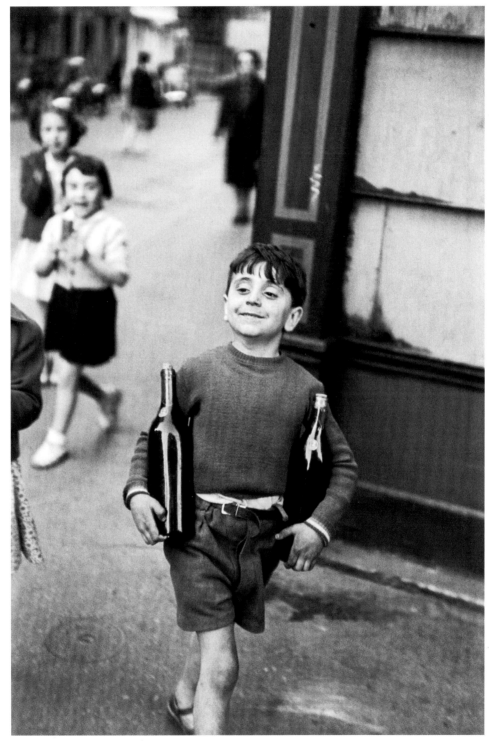

HENRI CARTIER-BRESSON | *Rue Mouffetard*, 1954 | Gelatin silver | 14 x 9-3/8 inches | Sold for $25,000 May 2015
Inquiries: 877-HERITAGE (437-4824) | **Ed Jaster** | Ext. 1288 | EdJ@HA.com

View Our Fall Auction at HA.com/Photographs

Always Accepting Quality Consignments in 40 Categories.

Annual Sales Exceed $900 Million | 900,000+ Online Bidder-Members
3500 Maple Ave. | Dallas, TX 75219 | 877-HERITAGE (437-4824) | HA.com

HERITAGE HA.com
AUCTIONS

DALLAS | NEW YORK | BEVERLY HILLS | SAN FRANCISCO | CHICAGO | HOUSTON | PARIS | GENEVA

Paul R. Minshull #16591. BP 12-25%; see HA.com. 37586

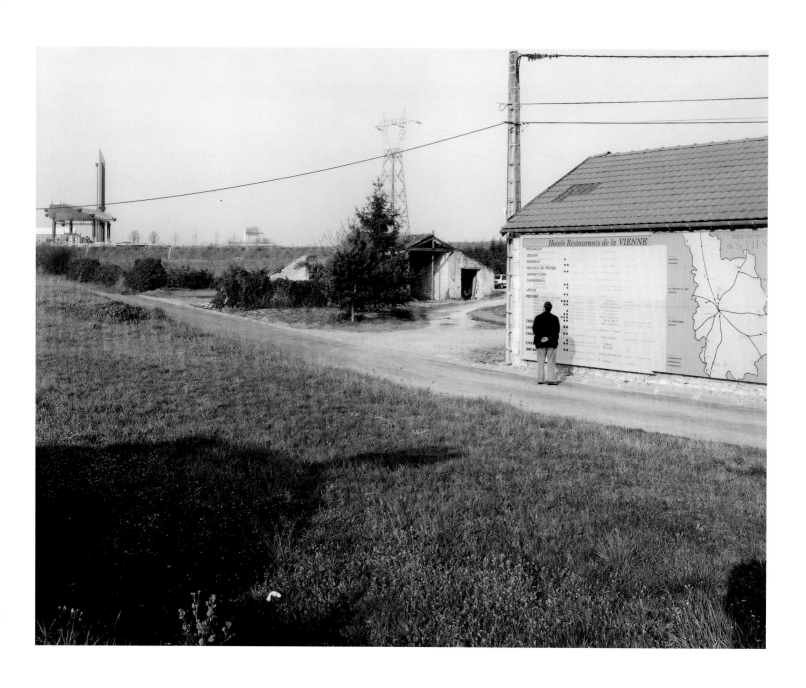

Guido Guidi, *Poitiers,*
France, **1996, from the**
series *In Between Cities*
(see page 50)
© and courtesy Guido Guidi

Editor
Michael Famighetti

Managing Editor
Paula Kupfer

Text Editor
Claire Barliant

Production Manager
Matthew Harvey

Production Assistant
Bryan Krueger

Work Scholars
Taia Kwinter, Lauren Zallo

Art Direction, Design & Typefaces
A2/SW/HK, London

Editor-at-Large
Melissa Harris

Publisher
Dana Triwush
magazine@aperture.org

Partnerships and Advertising
Elizabeth Morina
917-691-2608
emorina@aperture.org

Executive Director,
Aperture Foundation
Chris Boot

Minor White, Editor (1952–1974)

Michael E. Hoffman, Publisher and Executive Director
(1964–2001)

Aperture, a not-for-profit foundation, connects the photo community and its
audiences with the most inspiring work, the sharpest ideas, and with each other—
in print, in person, and online.

Aperture (ISSN 0003-6420) is published quarterly, in spring, summer, fall, and winter,
at 547 West 27th Street, 4th Floor, New York, N.Y. 10001. In the United States,
a one-year subscription (four issues) is $75; a two-year subscription (eight issues)
is $124. In Canada, a one-year subscription is $95. All other international subscriptions
are $105 per year. Visit aperture.org to subscribe. Single copies may be purchased
at $24.95 for most issues. Periodicals postage paid at New York and additional offices.
Postmaster: Send address changes to *Aperture*, P.O. Box 3000, Denville, N.J. 07834.
Address queries regarding subscriptions, renewals, or gifts to: *Aperture* Subscription
Service, 866-457-4603 (U.S. and Canada), or email custsvc_aperture@fulcoinc.com.

Newsstand distribution in the U.S. is handled by Curtis Circulation Company,
201-634-7400. For international distribution, contact Central Books, centralbooks.com.

Help maintain Aperture's publishing, education, and community activities by joining our
general member program. Membership starts at $75 annually and includes invitations to
special events, exclusive discounts on Aperture publications, and opportunities to meet
artists and engage with leaders in the photography community. Aperture Foundation
welcomes support at all levels of giving, and all gifts are tax-deductible to the fullest extent
of the law. For more information about supporting Aperture, please visit aperture.org/join
or contact the Development Department at membership@aperture.org.

Library of Congress Catalog Card No: 58-30845.

ISBN 978-1-59711-323-6

Printed in Turkey by Ofset Yapimevi

Aperture magazine is supported in part by an award from the National Endowment for
the Arts and with public funds from the New York City Department of Cultural Affairs
in partnership with the City Council.

aperture.org

NEW SETTINGS 2015

performing /
/ visual arts

NEW YORK
FRENCH INSTITUTE ALLIANCE FRANÇAISE /
CROSSING THE LINE FESTIVAL
- JORIS LACOSTE
SEPTEMBER 10 & 11
- ALI MOINI & GEORGE APOSTOLATOS
SEPTEMBER 29 & 30
WWW.FIAF.ORG/CROSSINGTHELINE

PARIS
THÉÂTRE DE LA CITÉ INTERNATIONALE
NOVEMBER 6 - 27
- ALESSANDRO SCIARRONI & COSIMO TERLIZZI
- ARTHUR H & LÉONORE MERCIER
- GIUSEPPE CHICO,
BARBARA MATIJEVIC & IVAN MARUSIC KLIF
- KELLY COPPER & PAVOL LISKA
- MICHEL FRANÇOIS & LÉONE FRANÇOIS
WWW.THEATREDELACITE.COM

A program by www.fondationdentreprisehermes.org

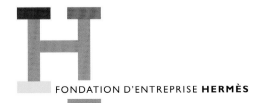

FONDATION D'ENTREPRISE HERMÈS

Opposite, clockwise
from top left:
William Klein, 1978;
Boris Mikhailov, 2014;
Rosalind Fox Solomon,
2002; *Ishiuchi Miyako*,
2012; *Guido Guidi*, 1997;
David Goldblatt, 2009;
*Bertien van Manen
[Eikenhorst]*, 1973;
Bruce Davidson, 2015;
center: *Paolo Gasparini*,
1978

The Interview Issue

What compels someone to become a photographer? And what drives someone to continue to be one, for as many as seven decades? How does a veteran photographer describe years of questioning politics, personal experience, social unrest, landscape, and history through the camera?

For this issue we have broken with our usual "Words" and "Pictures" format to offer nine in-depth interviews, firsthand accounts that underscore the generosity and intelligence of their speakers. Born between 1928 and 1947, the nine photographers here—Bruce Davidson, Paolo Gasparini, David Goldblatt, Guido Guidi, Ishiuchi Miyako, William Klein, Bertien van Manen, Boris Mikhailov, and Rosalind Fox Solomon—are still active today, adding to their already unparalleled bodies of work. In these pages, the medium is considered from various points of view, offering a range of philosophies, values, and perspectives, yet for all the differences within this group, they share a fundamental curiosity about the human experience.

The interviews took place around the globe, and five of the nine were conducted in languages other than English, in the photographers' native tongues: Japanese, Russian, Italian, Spanish, and Dutch. No matter the language, an underlying passion and drive come through in the force of each speaker's words. William Klein, for example, now eighty-seven, is sharp-witted and voluble; his anecdotes project ecstatically. No surprise, then, that we learn through the course of his conversation with writer Aaron Schuman that Klein had been out until very late the previous evening at filmmaker David Lynch's club in Paris.

That kind of restlessness characterizes each speaker. Solomon and van Manen are both peripatetic, having traveled throughout the world to focus on questions of community, ritual, place, and gender identity. Guidi, known for his understated images of European towns, meditates on how the mechanics of images, specifically perspective, allow for a description of the world—a world that is often politically fraught. Goldblatt has long used the camera to reflect the social realities of apartheid and postapartheid South Africa. For Gasparini, who has documented social conditions in his adopted city of Caracas, postrevolutionary fervor in Cuba, and experiments in architecture across Central and South America, photography cannot be split from ideology. Empathy for others has likewise motivated Bruce Davidson, who remarks that the joy of photographing, and returning to former subjects, sustains him. Ishiuchi was a reluctant photographer at first, but succumbed to the physical presence of pictures and their ability to trace history and time, from the personal (her relationship to her mother) to history on an incomprehensible scale (the bombing of Hiroshima).

These lifetimes of seeing through the lens might best be summed up by Boris Mikhailov, who made much of his work under oppressive Soviet rule. "When you're open to life, it responds to you," he remarks. "That is what an intuitive possibility of photography is—to crawl deeper into the depths of life." —The Editors

international limited-residency
MFA PHOTOGRAPHY
www.hartfordphotomfa.org

Photo © 2015 Aaron Hardin

Faculty and Lecturers Include:

Robert Lyons - Director
Michael Vahrenwald, Dr. Jörg Colberg, Alice Rose George,
Michael Schäfer, Mary Frey, Susan Lipper, Mark Steinmetz,
Ute Mahler, Doug Dubois, Gerry Johansson, Alec Soth,
Thomas Weski, Wiebke Loeper, Misha Kominek, Hiroh Kikai

We believe that the art world is situated within a global market and our program is uniquely designed to access and utilize this enriching perspective. Our program was created for the engaged professional investigating art, documentary practice, and the photo-based book.

Join us on Facebook:
Hartford Art School – MFA Photo

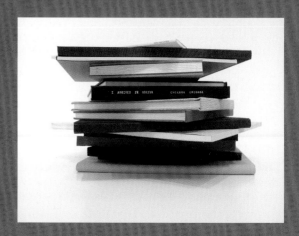

Alumni Include:

Bryan Schutmaat (USA), Adam J Long (USA), Dorothee Deiss
(Germany), Daniel Claus Reuter (Iceland), Geoffrey Ellis (USA),
Dagmar Kolatschny (Germany), Leo Goddard (UK), J Carrier
(USA), Tricia Hoffman (USA), Felipe Russo (Brazil),
Nicolas Silberfaden (Argentina), Morgan Ashcom (USA),
Chikara Umihara (Japan)

UNIVERSITY OF HARTFORD
HARTFORD ART SCHOOL
200 Bloomfield Avenue | West Hartford, Connecticut 06117 | USA

Collectors
The Biographers
On Recent Acquisitions

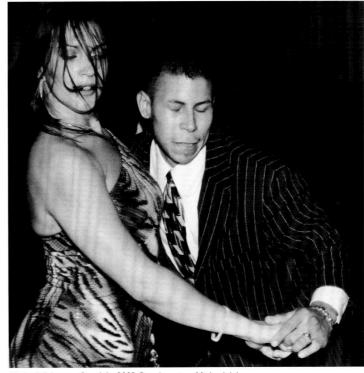

Michael Johnson, *Candela*, 2001 © and courtesy Michael Johnson

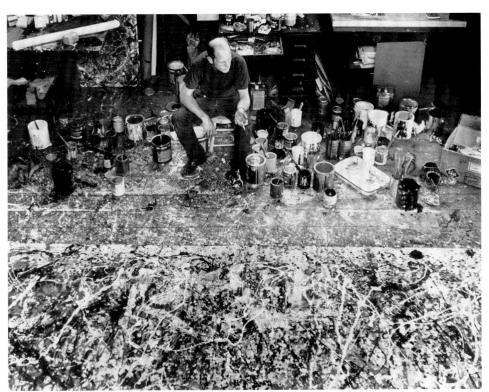

Hans Namuth, *Jackson Pollock in Spring*, 1950 Courtesy Deborah Solomon

Linda Gordon

I bought this photograph from the photographer Michael Johnson, who was selling his work on the street in San Francisco sometime in the early 2000s, a period when I was spending a lot of time in the Bay Area researching my book on Dorothea Lange. I'm also a former dancer—though not of this type of dance—and in that book I dwell on the difficulty of capturing movement on film. Lange could not easily do this, due both to her disability and to the slower film she used, but she did succeed in making many insightful images of bodily grace. This photograph does something else as well: it captures the intensity and pleasure of dancers lost in the rapture of music and movement. I only wish I could find Michael Johnson again and see his current work.

Linda Gordon is University Professor of the Humanities at New York University. Among her recent books are *Dorothea Lange: A Life Beyond Limits* (2009) and *Feminism Unfinished: A Short, Surprising History of American Women's Movements* (2014).

Deborah Solomon

My favorite photograph happens to be one that I own. Hans Namuth gave it to me as a wedding gift in 1989; it belongs to his well-known group of images documenting Jackson Pollock in his studio. In 1950, Pollock was living out on Long Island, and the Namuth photographs capture him in the midst of the white-hot process of creation— flinging liquid house paint through the air and onto his floor-bound canvas. In some of the pictures, the blur of an arm or a leg gives the impression that his movements are too fast to record, and that art itself is an unimpeded flow of inspired, impulsive gestures.

But the photograph I have is entirely different because it captures Pollock at rest. The mood is meditative. Shot from above, it shows the artist sitting on a low wooden stool, a cigarette in hand, thinking about matters we will never know. The photograph hangs outside my kitchen, and I see it every time I get up from my desk to fetch some coffee. It always seems to say to me: It's okay to take a break.

Deborah Solomon is the art critic of WNYC New York Public Radio, and the author of award-winning biographies of Jackson Pollock, Joseph Cornell, and Norman Rockwell. She promises to write a biography of a woman the next time around.

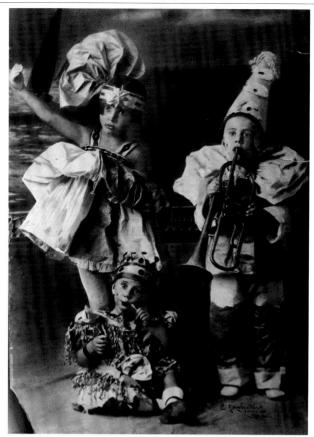

Myra ("Lally") and Misha Kamenetzki, ca. 1925 Courtesy Alexander Stille

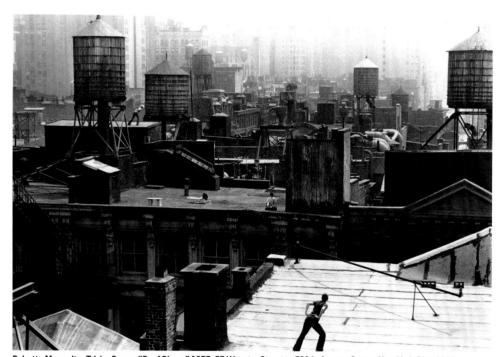

Babette Mangolte, *Trisha Brown "Roof Piece," 1973, 53 Wooster Street to 381 Lafayette Street, New York City*, 1973
© Babette Mangolte

Alexander Stille

I found this photograph blown up to almost poster size with a stiff cardboard backing buried underneath papers, books, and expired lottery tickets in the apartment of my elderly aunt Lally, who lived on the Upper West Side of Manhattan until her death a few years ago. The picture was taken in Naples (you can see the mark of a Naples studio photographer on the bottom right) circa 1925. It shows my father (the boy in the clown costume blowing a trumpet) and my aunt (the little girl seated on the floor with a perplexed expression), as well as a very pretty unknown Neapolitan girl. My father's family had moved to Naples only a couple of years earlier, having fled Russia after the revolution. My father was born in Moscow in 1919, and my aunt in Latvia in 1921, as my grandparents made their way from the newly formed Soviet Union to Germany and then to Italy.

There are many things I love about this picture: The fake seascape in the background evokes the lost world of studio photography, before cameras became widely accessible, in which it was a big deal for a family to go and have its picture taken. There is great poignancy for me to see these two refugee children—small and pale compared to their Neapolitan companion—working hard to assume an air of gaiety in their new world. They were illegal immigrants at this point, living in a condition of some precariousness. They threw themselves into their new Italian life—becoming Italian children and Italian citizens—only to have it taken from them about thirteen years later by Mussolini's racial laws of 1938. They lost their Italian citizenship and were forced to leave Italy, their paradise lost, for the United States. The picture must have meant a lot to the family, as it was one of a limited number of things they brought with them to the U.S.

Having lost everything twice, my aunt was incapable of throwing anything away, becoming a compulsive hoarder after her parents' deaths in the late 1960s. This photograph documents a moment during their brief but crucially important Italian idyll between one exile and another.

Alexander Stille's most recent book is *The Force of Things: A Marriage in War and Peace* (2013), which won the American Academy of Arts and Letters's Blake Dodd Prize for literary nonfiction. His biography of Silvio Berlusconi, *The Sack of Rome: Media + Money + Celebrity = Power = Silvio Berlusconi*, was published in 2006.

Cynthia Carr

For years I've had Babette Mangolte's 1973 photograph of Trisha Brown's *Roof Piece* pinned to my bulletin board. (I cut it out of a magazine.) Since I write about artists, I keep it near me as a reminder of the artistic impulse at its best. Brown positioned dancers on rooftops over several SoHo blocks. She was experimenting with this configuration. Would it make her any money? Would a critic rave? Would spectators even be able to see all the dancers? I don't think she cared.

There's such a purity to this gesture. I admit that I may be projecting; *Roof Piece* took place before I moved to New York. But to me, Mangolte's photograph—so beautifully composed—depicts a more innocent time in both the city and the art world. Despite the dense environment captured here, this is—in every way—a picture of spaciousness.

Cynthia Carr is the author, most recently, of *Fire in the Belly: The Life and Times of David Wojnarowicz* (2012).

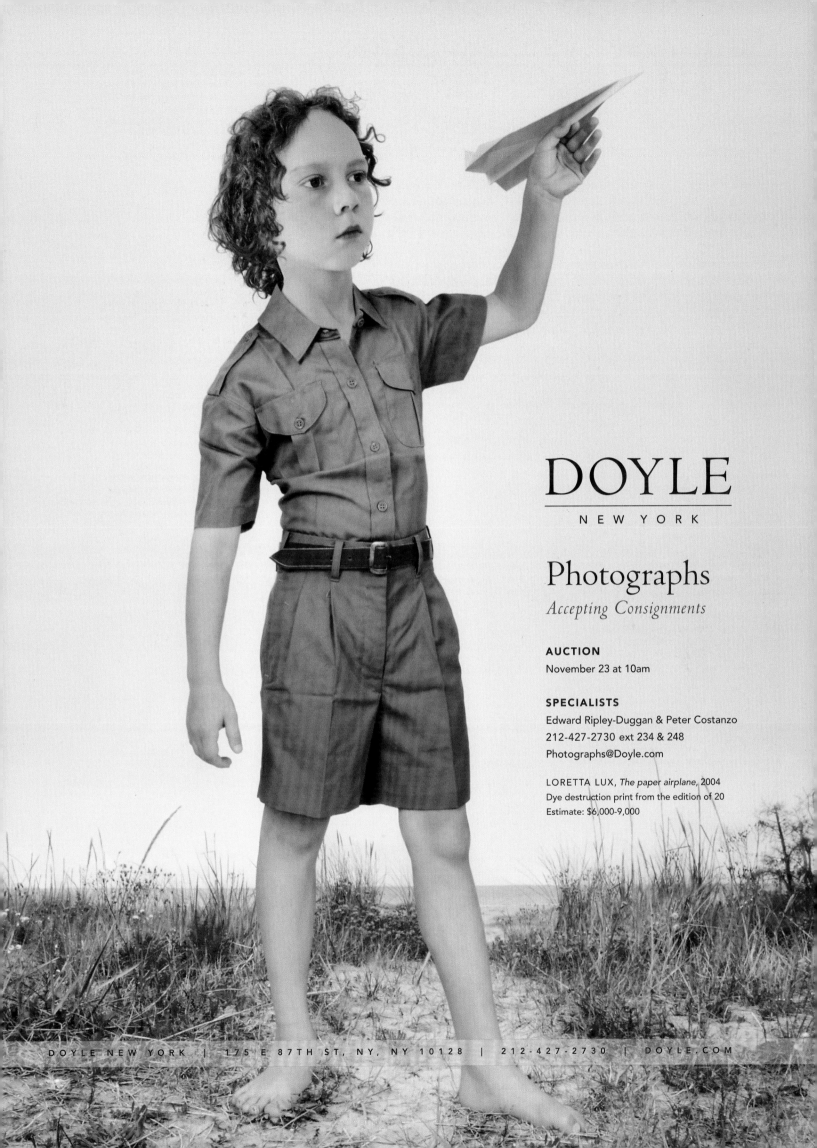

Curriculum
A List of Favorite Anythings
by Justine Kurland

Justine Kurland is a photographer of the road. Since the early 2000s, she has regularly crisscrossed the United States, frequently with her young son in tow, making pictures of traveling hippies, train hoppers, mothers and their children, car mechanics, and many others seeking their personal utopias. Her photographs combine romantic vision with a documentary sensibility, exposing both the charm and difficulties of an itinerant life. Kurland lives in New York City with her son, and teaches at Parsons, the New School; the International Center of Photography; and Pratt University. Her forthcoming monograph, *Highway Kind*, will be published by Aperture in 2016.

The works in this compendium follow one another as a stream of consciousness, with each successive selection invoked by the preceding one. My curriculum begins with love, moves to tears, uncovers desires, mediates consciousness, projects and interprets, and finally dissolves into blue. The connections are abstract and idiosyncratic, but they follow a path of associative logic.

Roland Barthes, *Camera Lucida*, 1980

I return to this book again and again the same way my son, when he was little, would insist I read *Goodnight Moon* every night before bedtime—suspended in the simple pleasure of familiarity. Or maybe it's related to my son in another way: the promise that at my death, he will return my love with interest paid. "You see," I tell my students, "Barthes 'engendered' his own mother." Regardless, what remains of value—what seems true to me—is Barthes's emphasis on the connection between love and photography: "I saw only the referent, the desired object, the beloved body." For Barthes, extreme love is what makes photography possible. Sometimes, in studying photography, it's easy to lose sight of that initial love.

Andrea Fraser, "Why Fred Sandback Makes Me Cry," from Dia Foundation's Artists on Artists Lecture Series, 2005

As a follow-up to Barthes's imperative that one must animate a work of art through emotion, Andrea Fraser's tears negotiate the impasse between art and the institutions that support it. I have seen teachers wrench tears from their students through the brute force of their authority—but that's not what Fraser is talking about here. She offers an alternative—the potential for art to open up a space for the viewer *within* the institution, to make enough room for us to have our own responses. She writes, "I don't believe art can exist outside the field of art, but I also don't believe that art can exist within the field of art. For me, art is an impossibility. And if art is impossible, then artists are impossible, and I myself am impossible. To the extent that I exist, I can only exist as a compromise, a travesty, a fiction, a fraud."

Moyra Davey, *The Problem of Reading*, 2003

Like Fraser, Moyra Davey addresses the conflicted and reciprocal relation an artist has with the canon. Davey's book asserts that the cyclical nature of making—reading to write and writing to read (with its fraught balance between duty and pleasure)—is a generative process. "The idea of a book choosing the reader has to do with a permission granted. A book gives permission when it uncovers a want or a need … a book can become a sort of uncanny mirror held up to the reader, one that concretizes a desire in the process of becoming."

Lisa Tan, *Waves*, 2014–15

The book that chose Lisa Tan is Virginia Woolf's novel *The Waves*. Woolf's experimental prose is both subject matter and guide for a film that contemplates its own condition. In several scenes, we are positioned in front of the artist's computer screen as she drafts a script, reads aloud, or navigates Google Cultural Institute maps while reflecting on technology and geography as a way to locate her own displaced consciousness. "With waves on my mind, I want to hold hands with what she says."

Allen Ginsberg, "Wichita Vortex Sutra," 1966

Tan's work draws attention to the ways in which perception is variously mediated. Similarly, Allen Ginsberg's poem distinguishes three separate iterations of the American landscape on a road trip through Kansas: the first is the roadside signage as seen outside the car windshield (found), the second is the broadcast voice from the car radio giving the news of the Vietnam War (programmed), and the last is Ginsberg's own mantra sung from inside the car (projected): "I lift my voice aloud, make mantra of American language now."

Albert Ayler, "Ghosts," 1964

Because the U.S. was founded upon a set of ideals, our identity as Americans is something invented rather than inherited. The New World was imagined as a kind of romantic dream of heaven on earth, with the potential for utopic innocence. Americans repeatedly declare the loss of our innocence, as though historical or contemporary atrocities (including those we commit) are merely the reverberations of original sin. To evoke heaven is also to conjure hell. The musician Marc Ribot first turned me on to Albert Ayler's recording "Ghosts," from the album *Love Cry*. He described it as follows: "Ayler stays on the melody, unpacking it, wrestling with it, until finally it gives up its ghost. And you hear the country melody as it should be played: twisted by the horror of our actual history."

Michael Schmidt, *U-ni-ty*, 1996

Schmidt's book slowly parses Germany's painful twentieth-century history, starting with the Nazi regime and continuing through reunification. The photographs are printed in heavy gelatinous grays, like the tar buildup inside a smoker's lungs. Schmidt's subject matter (concrete buildings, tape that once held up a sign, a kitchen table) is juxtaposed with appropriated images (a politician, a still from *Triumph of the Will*, a blueprint of a gas chamber). The final sequence in the book shows casual portraits of people we don't know: citizenry scarred by Germany's past. Schmidt writes, "I need my images as confirmation of that which I have experienced, and, to be sure, in a different form from that in which I experienced it."

Derek Jarman, *Blue*, 1993

Blue chronicles Jarman's last days, the loss of his vision and other AIDS-related complications. A voice narrates over a solid blue screen, vacillating between angry despair in the face of death and a hallucinatory reflection rejoicing in the color blue: "In the pandemonium of image I present you with the universal blue. Blue, an open door to soul, an infinite possibility becoming tangible."

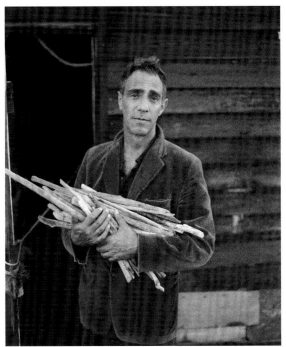

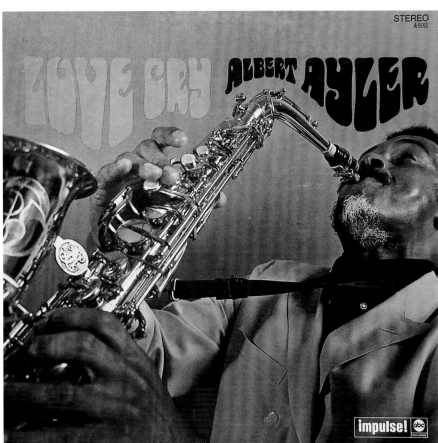

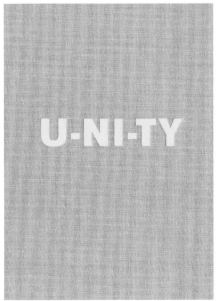

On Portraits
Geoff Dyer

In this regular column, Dyer considers how a range of figures have been photographed. Here, he reflects on images of Susan Sontag and the Russian poet Joseph Brodsky to ask: What, if anything, do author photos reveal about their subjects?

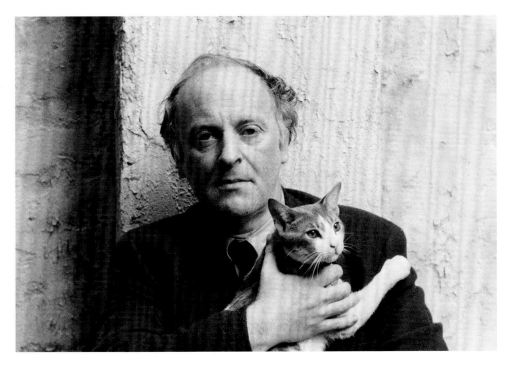

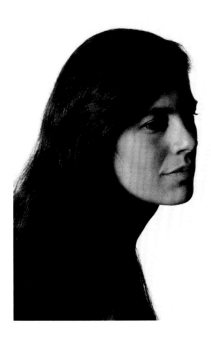

Author photos are one of the few areas of portraiture where your appearance doesn't matter. Your looks might make you easier to promote. You might attract more coverage, might receive more invitations to appear on TV, and the sum total of this varied media interest might lead to increased opportunities to hustle your wares, but the quality of these wares has nothing to do with how you look. This is not the case if you are a model (obviously!), an actor, dancer, or musician. The fact that your appearance is irrelevant is especially good news for women, who have historically been judged on how they look. When I see an author photo of a gorgeous woman I might think, Wow, she's gorgeous, but I don't think, She must be a gorgeous writer, I'll buy her book. The opposite is

also true. Writing, as Jean-Paul Sartre and George Eliot demonstrated in their very different ways, is the ideal occupation for the less than attractive. With his Parisian command of dialectics, Sartre turned this to advantage, explaining to Simone de Beauvoir (in her intensely moving and loving memoir, *Adieux* [1984]) that he had to date beautiful women in order to balance out his own extreme ugliness.

I should have made clear at the outset that author photos are not the same as photographs of authors. By "author photo," I mean one specifically sanctioned by an author for use on his or her books. An author photo is a *publicity* photograph in which the author presents him- or herself in the best possible light. Not that an author photo always starts out as an author photo. It can happen that writers are photographed for some kind of profile or news story and then become sufficiently enamored of the results to adopt this image—which was not taken in order to flatter—to embody their brand. Understandably, Diane Arbus did not generate much of a revenue stream in this way, though she did take remarkable pictures of Borges and of the young Susan Sontag with her son, David Rieff.

Memoirs of Sontag—a minigenre in the decade since her death—often mention how beautiful she was when young. Obviously she was clever, too, and she understood how to imbue cleverness with beauty—and vice versa. Specifically, she made being clever look glamorous. In a famous portrait by Peter Hujar even Sontag's clothes look brainy. Sontag worshipped the glamour of the intellect, which she then came to embody. (It is rare for anyone with talent and ambition to worship something without harboring a desire to become that which is worshipped. This was a vital component of Nietzsche's project of deicide. There can't be a god, he reasoned; if there were, then how could I bear not to be one?) In later life, Sontag's faith in her own sophistication and refinement hardened into impregnability. I love the way that someone who had written so brilliantly on the ethical imperatives of photography ended up in a long-term relationship with Annie Leibovitz. Did evenings at their apartment sometimes include an exchange like the following?

SS: You know, Annie, some of your portraits really suck.

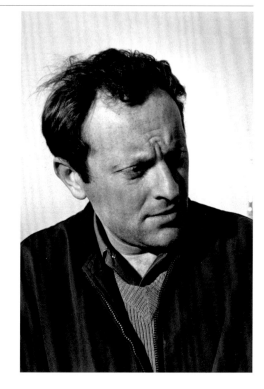

AL: **Well, if we're going to talk about sucking, Susan, let's leave a little room for *In America*.**

SS: **Oh, okay, which episode of *Friends* are we going to rewatch tonight?**

I said at the beginning that author photos do not tell us anything about the quality of the author's work. But as Sontag's friend Joseph Brodsky, the Russian poet, observed, at a certain point in our reading we always become curious about what a writer looks like. Thinking specifically of Auden (of all people, of all *faces*!), Brodsky began to wonder "whether the visual could apprehend the semantic." For years I was absolutely besotted by Brodsky (born on May 24, 1940, seventy-five years ago to the day that I am writing this). My love of his writing was accompanied by a deepening fascination with photographs of the man. These photographs made clear that the core of Brodsky's genius and his unshakable faith in the redemptive power of poetry were underwritten by the street cunning of the hustler. Or even that genius and faith are a hustle in the same way that—as Nietzsche understood—religions are hustles. Any émigré from the Soviet Union

who ended up in the U.S. realized this, and the luckiest of them—like Eduard Limonov—got lessons from *nachal'nik* (the boss). "America's a jungle, you know," Brodsky tells Limonov. "To survive here you need the skin of an elephant." Naturally he wasn't photographed riding an elephant like Christy Turlington, who had the skin of a supermodel. He was photographed holding a cat, or a cigarette. Sometimes he was photographed wearing spectacles, those external props of the scholar, which so emphatically undercut any suggestion of the hustler. And yet, paradoxically, pictures of Brodsky in glasses seem, more than any others, to suggest that he had internalized Paul Newman's eponymous role. I mention all this precisely because, when all is said and done, how Brodsky looked counts for nothing.

FUJIFILM **X-T1**

Photo © 2015 Jack Graham | FUJIFILM X-T1 Camera and XF18-55mm Lens, at 1/3000 seconds at F4.5, ISO 2000.

Do things with
Passion...
or not at all.

Using the FUJFIILM X-T1 camera has reinvigorated me. Its simplicity and ability to deliver professional quality images lets me worry about photography, not dials and menus! I feel comfortable shooting at high ISO's knowing any digital noise is going to be minimal. I have total confidence that the XT-1 and great FUJINON glass will deliver the images I expect in the toughest conditions.

-Jack Graham

**ENGINEERED
TO INSPIRE®**

www.FujifilmExpertXT1JGraham.com
facebook.com/fujifilmcameras
FujifilmUS

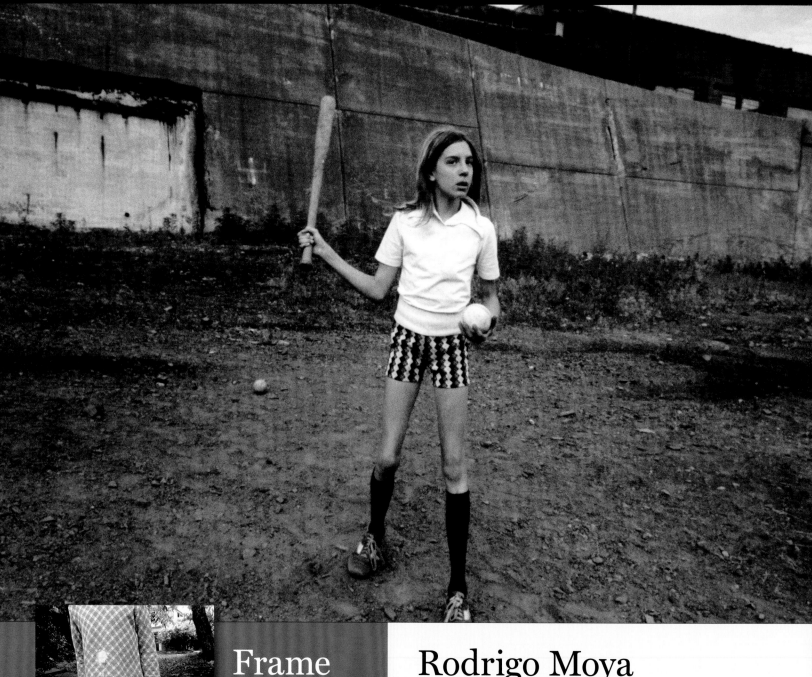

Redux
Rediscovered Books and Writings

A look at the catalog that accompanied a onetime photography-only biennial

Venice '79
Lyle Rexer

In 1979, Venice discovered photography—then turned its back on the medium. In a possible attempt to expand the Venice Biennale brand, the municipality, assisted financially by UNESCO and programmatically by the International Center of Photography, installed one of the largest photography exhibitions ever mounted in Europe. The catalog, *Photography: Venice '79*, expressed the tentative hope that this might be "the model for future such festivals." Instead it was a one-off that, in retrospect, provides a revealing glimpse of where photography stood globally and the contradictions that would henceforth make any exhibition employing the generic term *photography* highly problematic.

Like its off-year scheduling between two art biennials, photography's position at the time might be described as "between"—between art and technology, between expression and documentation, between politics and personal vision. These familiar dichotomies in photographic discourse (the jacket copy called them a "quarrel") played out in twenty-five separate exhibitions that made up *Venice '79*. Looking over the table of contents, a contemporary reader recognizes the presentation not as a survey of photography in general but rather an argument for expressive art photography. In the words of Carlo Bertelli, one of the organizers, it was "an effective view of a continuity which has to be taken into account." But what continuity? Exhibitions devoted to Alfred Stieglitz, Henri Cartier-Bresson, Robert Frank, and Diane Arbus emphasized their "mastery" and "consummate artistry," but so did exhibitions devoted to work by Weegee, Lewis Hine, and Eugène Atget, none of whom thought of himself as an artist working in any sort of formal tradition or continuum.

As critics of the time were beginning to point out, such an approach to the history of photography was selectively enfranchising to a high degree. The issue was not (and is not) that some photographers are chosen and some are banished from a pantheon, but that even in a sprawling exhibition like *Venice '79*, the complex, polyglot character and usages of photography are sacrificed to ideas about what constitutes photographic art. After all, arty gestures and decisions are common in every area of photography, from fashion photography to snapshots. A more illuminating overview might have shown how photographers of many different kinds communicate with their audiences through choices that enable them to negotiate meaning. But such an approach would have opened the gates to a tide of pictures from vernacular and commercial sources.

Likewise, by 1979 there were many artists and photographers adopting critical and interrogative approaches to photography. Few of them were included in *Venice '79*. Lucas Samaras, Ugo Mulas, Robert Heinecken, and Joan Fontcuberta were the most prominent conceptualists. Perusing the catalog, my favorite is Marialba Russo, a photographer previously unknown to me. Her sequence, in both black and white and color, shows a fake childbirth on a southern Italian street. The baby is

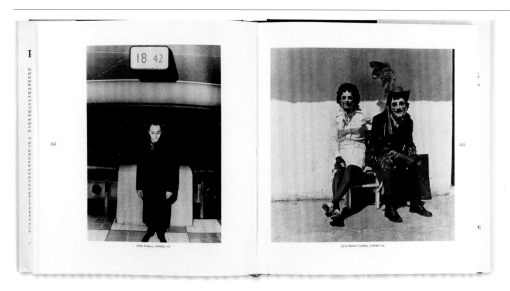

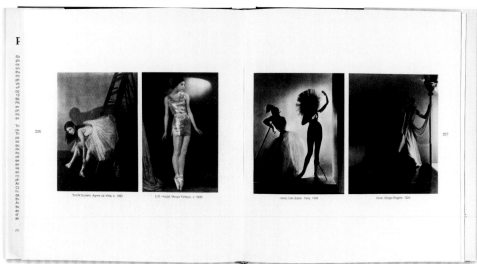

Pages from *Photography: Venice '79* (New York: Rizzoli, 1979), including photographs by Boris Kossoy and Carlo Bianco Fuentes (top), and Soichi Sunami, E.O. Hoppé, and Horst (bottom)

The increasing incorporation of photography into art biennials partly explains why there would be no *Venice '81.*

from Mexico, Fernell Franco and Carlos Caicedo from Colombia, and Geraldo de Barros from Brazil. On the other hand, the introduction by Raquel Tibol dismisses art photography in favor of documentary work—but then turns contemptuously on mere "mimetism." She demands that the work be anchored in social realities but also in the imagination. She extols mechanical modernity but decries technical perfection. Above all, she sets a wholly political agenda for photography, arguing that it should be aligned against imperialism and "oligarchic exploitation."

This edict sanctioned works displaying both kitsch symbolism and harrowing realism. It underscored dramatically that photography serves many ends, often at the same time, and thus can't be contained (or understood) by the boxes curators put it in. The increasing incorporation of photography into art biennials partly explains why there would be no *Venice '81.* (The Venetian organizers started an architecture biennial the next year, which has continued.) More important, however, the very amplitude of *Venice '79* showed the futility of trying to say something definitive about a medium that is as fluid and ubiquitous as the water surrounding Venice.

a doll and the mother a swarthy, bearded man in a dress. Shot in a frenzied style, it comments not only on the documentary mode (exemplified in Venice by exhibitions of work by W. Eugene Smith and Robert Capa) but also on the political issues of class and regional division.

Politics always complicates discussions of what is and is not art, especially in photography, where pictures are so often used for propaganda. One of the most important of *Venice '79*'s exhibitions, *Hecho en Latinoamérica* (Made in Latin America), demonstrated the force of photography as political witness but also the confusions of a theory and an exhibition that sought to define photography in expressive and formal terms. On the one hand, this collection of three hundred works by photographers from across the region, originally assembled for an exhibition by the Consejo Mexicano de Fotografía, constituted a bid for artistic recognition by marginalized countries. It was the largest selection of such photographs to appear in Europe, and it contained the work of many great artists, including Graciela Iturbide

Lyle Rexer is a photography critic, curator, and writer based in Brooklyn, New York. ⊶● He is the author of *The Edge of Vision: The Rise of Abstraction in Photography* (Aperture, 2010) and teaches at the School of Visual Arts in New York.

unseen photo fair
18–20 sept 2015
amsterdam
unseenamsterdam.com

William Klein

Interview by Aaron Schuman

When writer Aaron Schuman first arrived at William Klein's apartment, five stories above Paris's rue de Médicis, he was ushered into Klein's living room by his assistant. Klein, eighty-seven, had been up until four thirty in the morning the night before and was having a rest. After an hour or so of thumbing through this Aladdin's cave of trophies and treasures, Schuman heard Klein stirring in the rooms at the back of the apartment. "By the tone of his voice, I could tell that he had just woken up, and was reluctant to join me," Schuman said. "His assistant pleaded, 'But he's come all the way from England!'"

Finally, Klein entered the room, eyes wide and shining. This would be the first of two visits with Klein for this interview, which touches on the course of his remarkable career: his now-classic books on cities, including his hometown in *Life Is Good & Good for You in New York: Trance Witness Revels* (1956), *Rome* (1958–59), *Tokyo* (1964), *Moscow* (1964), and *Paris* (2003), all alive with Klein's signature kineticism; his 1960s fashion work for Alexander Liberman, the celebrated art director at *Vogue*. This was the era in which Klein turned to moving images, having just made his first film, *Broadway by Light*, in 1958: he would become known for his fashion-world satire *Who Are You, Polly Maggoo?* (1966), starring model Dorothy McGowan, and *Muhammad Ali: The Greatest* (1974), his cinema verité documentary on the fighter, among others. Recently, Klein has been revisiting some of his first experiments with still photography, abstractions from the early 1950s, some of which were exhibited at his London gallery last fall. In the conversation that ensues, he speaks about his remarkable career, now in its seventh decade, with the force and energy that define his photographs and films.

Aaron Schuman: **First, how old were you when you knew you wanted to be an artist?**

William Klein: I was pretty young—around ten or eleven. I guess I always had this fantasy that I could be an artist. But it was a long time ago; I forget. Do you see the cat? [*Points to solar-powered toy cat by the window wagging its tail like a metronome.*] You see what it's doing?

AS: **It's wagging its tail.**

WK: Why? Because there's light. There's a little solar panel in it. A Japanese editor brought it for me. Every time he comes, he brings another cat. I asked him, "How come you bring all these cats?" and he said, "We *love* cats." I said, "Everybody loves cats, but they don't always bring me cats."

AS: **When's the last time you were in Japan?**

WK: I haven't been there for twenty-five years. You know my book on Tokyo?

AS: **Yes.**

WK: Well, there was a group of dancers that became butoh [the dance theater group], and they wanted me to photograph them in the studio, but I said, "No, let's go out in the street." So we went out in Ginza, down little streets and everything. There's one picture I took of this crazy painter—the boxing painter, [Ushio] Shinohara. He lives in Brooklyn now; they did a film on him, *Cutie and the Boxer* (2013). It was up for an Oscar. Anyway, his wife did most of the talking, and I said,

"How come you speak such good English, and he can barely say hello?" And she said, "Well, you know—artists are stupid. And he's stupid" [*laughs*]. But he's a great artist.

AS: **Do you think artists are stupid?**

WK: No, I don't think so. It depends which one [*laughs*]. Ha, look at the cat. It's going crazy.

AS: **What first brought you to Paris?**

WK: The United States Army brought me to Paris. I came to Europe via boat, on the *Queen* something or other, and was sent to Germany during the occupation. Then I was discharged in Paris. I had gotten into the army at the end of the war, and since I had no knowledge of horses or radio transmissions, I was designated as a radio operator on horseback in Fort Riley, Kansas. After the war, the Americans thought they would be fighting the Japanese in Burma, and so I was trained to be a radio operator on horseback. I got out of college at eighteen and thought that I would have a cushy job in an office, but instead I was doing twenty-five-mile hikes.

AS: **And why did you stay in Paris?**

WK: I met a French girl and we got married. I thought it was better to live in Paris than in New York. Look at that nice cat I got from the Japanese. I see that fucking cat wagging its tail like a maniac. I asked the Japanese editor, "How long will it continue to wag its tail?" and he said, "Always." I said, "Perpetual motion doesn't exist!" My wife became a painter in the last five years before she

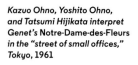

Kazuo Ohno, Yoshito Ohno, and Tatsumi Hijikata interpret Genet's Notre-Dame-des-Fleurs in the "street of small offices," Tokyo, 1961

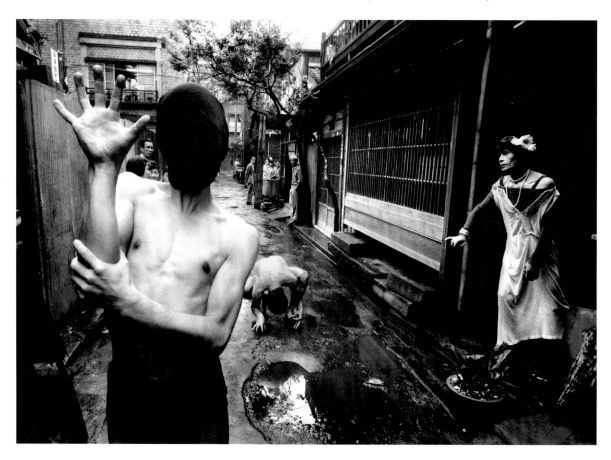

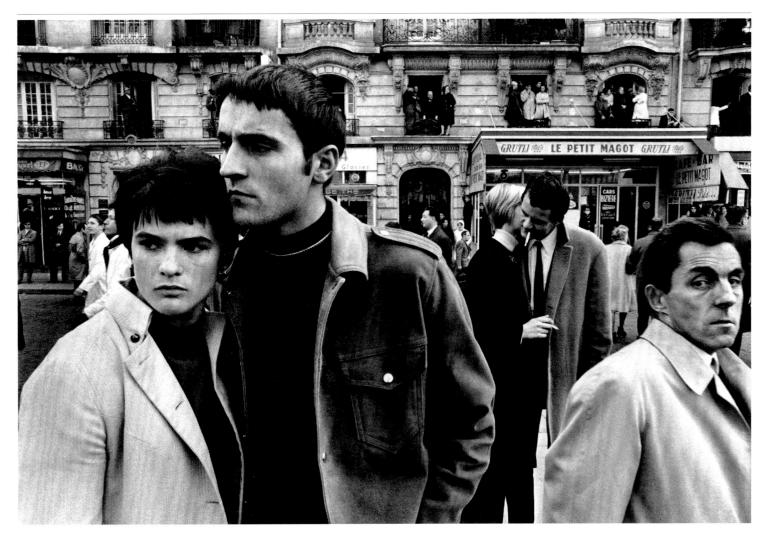

Le Petit Magot, Armistice Day, Paris, 1968

died, and I really like what went on in her head. She would be painting by the window, and I'd leave in the morning, and in the evening I would come back and there would be a painting [*laughs*]. But she never went to exhibitions or was worried about exhibiting her work. She was a real primitive.

AS: **You yourself started out as a painter.**

WK: Yeah, as a kid I took courses in high school—Art 201 or whatever—and in college also. When I first came to Paris, I worked in the studio of Fernand Léger. He kept saying to us, "Fuck the galleries. Fuck the collectors. This is not your problem. Your problem is to be part of the city." At that time, the walls of Paris were covered with these big paintings that the hacks working for the movie industry would paint—scenes from the films. You'd see these big paintings of a scene in a movie, and Léger would say, "These guys are more interesting than the stuff you see in galleries, that you want to imitate and develop in order to seduce collectors. All that's bullshit. Do what the painters did in the Quattrocento—work with murals and architects."

Then, in 1952, I had a show in Milan in which I exhibited abstract mural paintings, and an avant-garde architect saw the show. He had developed a space divider in a big apartment in Milan, and he said, "I have these panels that turn and can be moved on rails to cover a wall or divide a space." He asked me if I would be interested in painting

these panels on both sides, so I did. Then I began to photograph them, and since they were on rails, they could turn and move.

While I was photographing the paintings, I had somebody turn them. I was using long exposures because there was little light, and these geometric abstract forms that I had painted began to blur. I thought these hard-edged geometrical forms that I was using became different and more interesting with blur, which was a photographic plus and got me interested in photography. I saw that this was a way in which photography could direct a change in the use of geometrical abstract forms. Then I realized that I didn't need panels with abstract forms painted on them—I could do it in a darkroom, and so that's what I did. At that time, I felt that photography was leading the way. By varying the use of graphic forms, and using relatively long exposures to give variation to the forms I photographed, blur became part of my arsenal of graphic techniques.

AS: **You recently published a new book—which was released in conjunction with a show you had at HackelBury Fine Art in London a few months ago—titled *William Klein: Black and Light* (2015). It's based on a maquette for a book that you made of this work in 1952, yes?**

WK: Yeah, it was the first book I ever did—the maquette is over there somewhere. You know Kate Stevens [director of HackelBury Fine Art]? I call

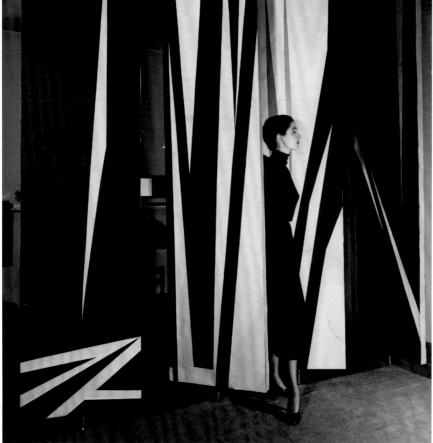

her Krazy Kate, like Krazy Kat. Have you seen the old *Krazy Kat*s?

AS: **Yeah, the comic strip.**

WK: Yeah, the comic strip. But in the old days it was in black and white, and really profound. The cat's main object in life was to throw a brick at the cop's head. Anyway, Krazy Kate is what I call her. She's very determined. Somebody said to me, "Listen, whatever Kate asks you to do, say yes; otherwise she'll drive you crazy." So she came to my studio several times, looked in boxes of all sorts, and for some reason she thought that the *Black and Light* work wasn't well-known enough, so she decided to make a show out of it. I didn't really think that was such a good idea. I did these things in a certain manual way, and I have the impression that people with computers do something similar now and wouldn't be interested in stuff I did sixty years ago. So initially I was against the show, but I remembered that my friend told me to always say yes to Kate. And the show was great. I was kind of surprised by it, and the things that happened leading up to that work I have a kind of nostalgia for.

AS: **You seem to be nostalgic for things specifically from your early childhood as well— *Krazy Kat* and so on.**

WK: Well, there were good things in America— *Krazy Kat* was one of them. In London we had afternoon tea with Kate Stevens, and I told her to look up *Krazy Kat* on the Internet. She did, and on her iPhone we got a concert of Shirley Temple. [*Begins singing*] "On the good ship, Lollipop, it's a sweet trip to a candy shop, where bonbons play, on the road to Mandalay." I added that Kipling line at the end. My mother decided that my sister would be the new Shirley Temple. In my film *Who Are You, Polly Maggoo?* the prince fantasizes about Polly, and one of the apparitions is Shirley Temple. So we had to find someone to sing Shirley Temple. Michel Legrand and I did the music, and at the time he was doing a record with Liza Minnelli, so we asked her. But she didn't know Shirley Temple! She had a voice that could go with Shirley Temple, but she didn't know Shirley Temple. I thought it was amazing, because Shirley Temple was the biggest star— she did ten or eleven films that were blockbusters. Her films came out, and my mother—who wasn't a cinephile—would bring me and my sister to Radio City Music Hall to be inspired.

AS: **Were you inspired?**

WK: Inspired? No, I hated Shirley Temple. We had to move three times because my sister was tap-dancing so much that the downstairs neighbors complained. But it was a nostalgic place to live, and be surrounded by my sister tap-dancing and the neighbors complaining.

AS: **Many of the most famous photographs from your first published book—*Life Is Good & Good**

for You in New York: Trance Witness Revels—feature children: kids playing stickball, a boy sitting in front of a checkerboarded candy store, children blurred while mugging for the camera, a kid shoving a toy gun into the lens.

WK: One time, *Life* asked well-known photographers to find the people that they had photographed two generations earlier, and they asked me to find the boy with the gun. But actually, when I took that photograph I was just walking down the street, I saw some kids playing cops and robbers, and I asked three of them to look tough, so it was a setup. But the idea of finding them again was crazy. I didn't go along with it.

AS: Did those boys remind you of yourself as a kid?

WK: I would try to be tough, and also I played cops and robbers. I dream a lot. Last night I was dreaming about a place where we lived, near the river, on 93rd Street. I would play with my sister on the rocks near the water. That image has kept coming back recently.

AS: Do you dream in black and white or color?

WK: Black and white, of course.

AS: What else do you dream about?

WK: I dream about a million things. It's incredible. I had a dream recently, and I still don't know whether it was a dream or not. It was about New York. Jean-Luc Godard was there, it was a Saturday, and there was an art opening. The people there were very friendly, and Godard was so, so nice, and also friendly. He was exhibiting his paintings, and people were saying, "Oh Jean-Luc, you have to come to my studio—I have some nice paintings to show you." And he would say, "Of course!" which is so little like him. It was so precise, and everybody was the way that they should be. It was Godard being a nice New Yorker. He's a prick, actually; I know him pretty well.

AS: So how did you go from making abstract black-and-white images in the darkroom to taking photographs on the streets of New York?

WK: Well, once I had the possibility of enlarging in a darkroom, I realized that the other photographs I'd been taking at the time were not as bad as all that. I was a primitive, and the photographs I was taking for myself were at the level of zero in terms of the evolution of photography. But once I had the opportunity to take the negatives and print them my way, I realized that I could use what I had learned—about graphic art, painting, and charcoal drawings, and so on—in my printing. So when I went back to New York, I had an idea of doing a book. I was twenty-four or twenty-five, something like that, and when you're twenty-five you can do that sort of thing; if you decide to do it, you just do

it. So I turned the bathroom in the hotel I was living in into a darkroom, and had access to a darkroom in my apartment. I washed the prints in the bathtub, and now these prints are considered "vintage prints"—they're worth a lot of money.

AS: I was just looking through some of your old magazines, and saw that the first body of work you published in *Vogue* was selections from *Black and Light*.

Blur became part of my arsenal of graphic techniques.

WK: Yeah, I was participating in a show called *Salon des Réalités Nouvelles* in Paris (1953), and Alexander Liberman—who was the art director of *Vogue*, and then became the art director for all of Condé Nast—left me a note asking me to come and see him. So I did, and he said, "How would you like to work for *Vogue*?" And I said, "Doing what?" and he said, "Well, we'll see. You can be assistant art director or something." We ended up deciding that I would do photographs, but I had no idea what kind of photographs I could do for *Vogue*. I looked at the fashion magazines, and I was really convinced that I couldn't do anything like what the fashion photographers were doing; I mean, I thought their technique was beyond my reach. But when I looked more closely, I thought they weren't so hot as all that, and the only photographers that impressed me were [Irving] Penn and [Richard] Avedon. The rest were just part of a system, and the more I looked at their photographs, the more I felt that there weren't any really interesting ideas behind them.

AS: Before shooting any fashion photographs for the magazine, you also published a series called "Mondrian Real Life: Zeeland Farms" in *Vogue* in 1954.

Opposite, top:
Black Knives, 1952
Opposite, bottom:
Klein's wife Janine with painted turning panels, Milan, 1952
This page:
Black Barn + White Lines, Island of Walcheren, 1952

WK: Yes, my wife inherited a house on the Dutch and Belgian frontier. One day we took our car and drove to the nearby island of Walcheren, and I saw these barns. They reminded me a little bit of the Dutch houses in Pennsylvania, and I learned that Mondrian had lived there during World War I. I thought that there must be some relationship between what he saw there and what he was doing later, so I photographed them. Then, when I met with Liberman again, he asked to see some of the stuff that I was doing, and when he saw those photographs he decided to publish a little portfolio of them in *Vogue*, which was unusual because it was a fashion magazine. But you know, fashion magazines at that time were the monthly dose of culture that women would get—theater, painting, exhibitions of all kinds—so those photographs fit in with the philosophy of Liberman.

AS: Did you enjoy working for such magazines at that time, when they had an important cultural influence as well as being about fashion?

WK: Why not? It was a way of making a living. The only things that were salable or publishable at the time were fashion photographs.

AS: Was that a concern of yours?

WK: It wasn't a problem, just an observation I had to make. I thought that the other photographs that I was doing—the abstract photographs, the realistic photographs, the New York photographs, and so on—were more interesting. But nobody else was really interested in them.

When I would do a session of fashion photographs my wife would ask, "What was the fashion like?" and I would say, "I have no idea."

AS: Were you frustrated by the fact that people were more interested in your fashion photography than in your art or street photography?

WK: I thought it was kind of bullshit photographing a dress, because I couldn't care less. I was interested in photography and in photographic ideas. When I would do a session of fashion photographs my wife would ask, "What was the fashion like?" and I would say, "I have no idea." I really had no knowledge. It was my fault because there were things going on in fashion photography—people like Yousuf Karsh, Erwin Blumenfeld, and other interesting photographers with a lot of culture. But I had no idea of the progression of fashion in the twentieth century. I did a film later on—*Mode en France* (1984)—and learned that the progression of the way women dressed, and the attitude of the designers, was also a reflection of what role women played in society. At the beginning of the twentieth century, women were dressed in fortresses; they were not accessible, and the dresses and outfits were

Opposite:
Evelyn + Isabella + Nena + Mirrors, New York (Vogue), 1959

stiff and impossible to open up. Then, people like Paul Poiret and especially Coco Chanel liberated the way women put on clothes. Chanel had women wear sweaters, and Poiret took away the stiffness. But I knew nothing about that at the time and didn't put it into perspective; nobody around me was interested in that. When I took fashion photographs, it was around the time that Dior made his so-called revolution. But when I look back, I realize that it was bullshit, because the real inventors were people like Chanel, who let women wear men's jackets and sweaters and so on.

AS: You mentioned your 1984 film, *Mode en France*, but you started making films much earlier, in the 1950s—what initially inspired you to start making films?

WK: Well, you know, once I had done books and told stories with my photographs, movies were an obvious development. In *Life Is Good & Good for You in New York: Trance Witness Revels*, the layout and turning of the pages was, for me, a movie. Instead of stopping at the level of pseudo-movie, I thought, Why not do a real movie? So photography and variations of graphic work led me to movies as well.

AS: Like *Black and Light*, your first film—*Broadway by Light*—was quite an abstract, graphic film.

WK: Yes, the New York photographs were criticized initially because they presented a vision of New York and America that was very harsh, black and white, and grungy. So I thought the next step would be to do a movie; I could do the same thing, but with something as beautiful as Times Square and the incessant ballet of advertising. The first thing that people photograph or digest in New York is Broadway and Times Square—it's the most beautiful thing in New York, and in America. But what is it, what are people actually seeing? They are seeing the spectacle of advertising; it's buy this, buy that. It's beautiful, but it's made up of sales pitches, and people are fascinated and seduced by advertising. That was American art at the time. And *Broadway by Light* was a celebration of this whole process of selling—of taking people by the lapels of their suits and saying, "Buy this! Buy that!" and being immersed in the graphic world of advertising. The beginning of *Broadway by Light* is a big close-up of the bottle cap of the Pepsi-Cola sign, which is like the sun—it comes up, fills the screen, and then you go on to the other advertisements. That was the first film that I did, and people were struck by it.

When I was at Léger's studio, there were three young American painters working there—Ellsworth Kelly, Jack Youngerman, and me. Ellsworth was very struck by *Broadway by Light*, and he arranged to have screenings of the film in New York, so all of these people from the art world saw the film and realized that what they were seeing were transpositions of this hard sell, which was Times Square and Broadway. Also, in those days there

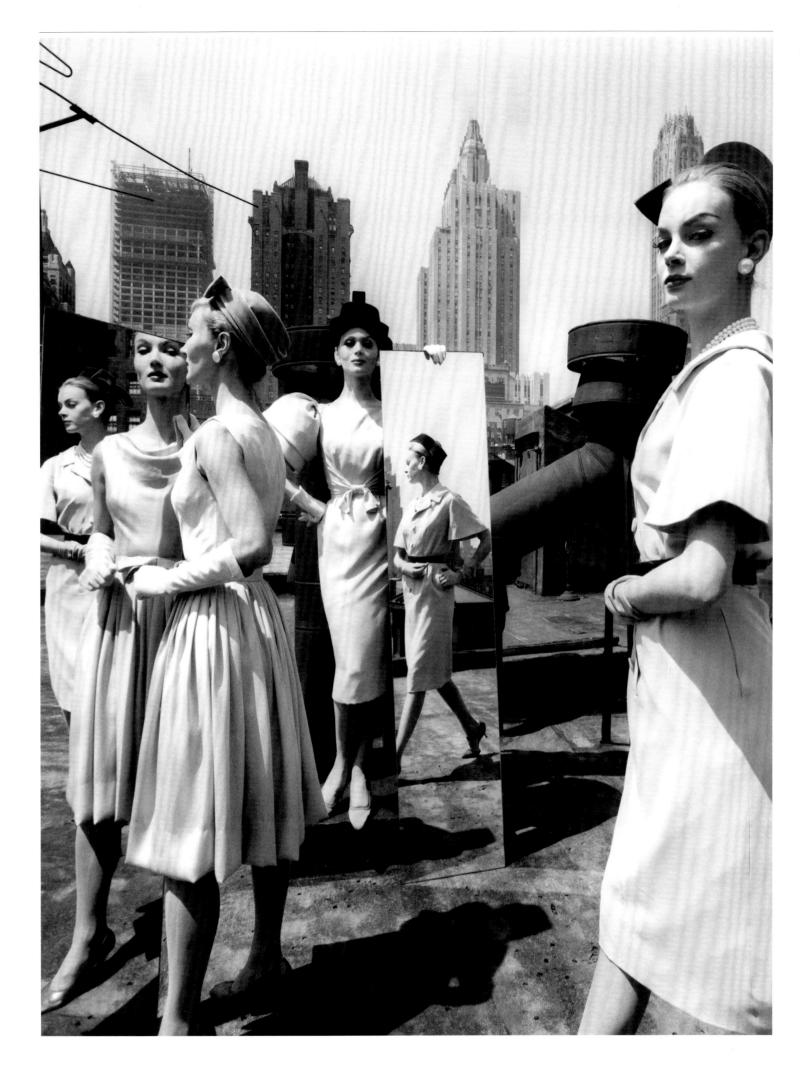

Top:
*Dance in Brooklyn,
New York,* 1954
Bottom:
*Big face in crowd,
St. Patrick's Day,
Fifth Avenue, New York,*
1955

was a culture of short films, many of which were produced by a guy called Anatole Dauman. He would have filmmakers like Chris Marker, François Reichenbach, and so on making short films, and there was a festival in the city of Tours—the International Festival of Short Films—where everybody would go and see them. *Broadway by Light* won first prize one year, and later on I also won first prize with *Cassius the Great*, which was about Cassius Clay preparing for the championship fight against Sonny Liston in 1964, and eventually became the feature film *Muhammad Ali: The Greatest.*

AS: **Were you a big fan of boxing?**

WK: Yeah, the sport I took at university was boxing, and then I boxed in the army. I was the middle-weight for my regiment, and we had competitions between regiments. If I boxed on a Friday night, I would have the weekend off, so instead of being AWOL, I would have a pass to spend two days going to the local cities and finding girls. But there were boxers in my regiment who had no idea about boxing as a science. They were farmers or

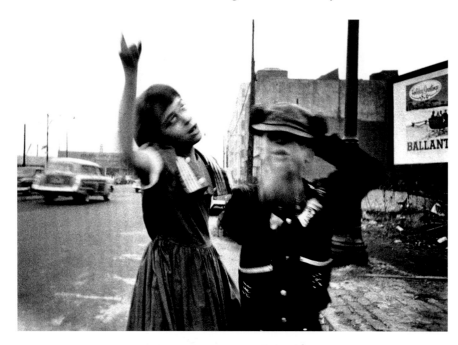

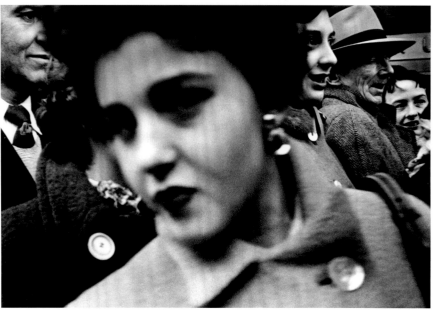

steelworkers, and all they knew was fighting in the streets. I remember that there was a boxer who wasn't very big, but he was powerful. He would go into the ring and just want to hit the other guy—and when he did, the fight was over.

AS: **What did you see in Cassius Clay that made you want to make a film about him?**

WK: I didn't understand anything about Cassius Clay when I started making the film. What I knew about Cassius was what I read in the white press. They all thought that he was a clown and that his fights were rigged. He was taken up by a bunch of sportsmen called the Louisville Syndicate. They bought the rights to Cassius Clay as they would a racehorse. They were from Louisville and always dreamt about winning the Kentucky Derby, so they saw a good investment in this young guy who had won the Olympic title. So they got the rights to him, paid for his training, and arranged his first fights. So most people thought that his fights were rigged, and that the career of Cassius Clay was completely manipulated. It was only much later that people realized how good he was, and what a rough fighter he really was, because he demonstrated that he could take a punch. He took too many punches, actually, and said, "I'm the greatest of all time!" before he could prove it. In Miami in 1964 he fought Sonny Liston, who everybody thought would wipe him out. But Sonny Liston had no idea how fast a fighter Ali was; he couldn't hit him, and after six or seven rounds Liston gave up.

AS: **Why did you decide to move from making short, abstract films to documentaries, and then to feature-length narrative films?**

WK: Well, most of the filmmakers that became the vanguard of French moviemaking, and eventually became icons, showed their short films at Tours and then went on to make feature films. The short films were all more or less abstract; they told a story, but the story was mostly about movies. So the festival was a place where film ideas were planted, which eventually became French as well as Polish, German, and Italian cinema. And how could you make a feature film without a story?

AS: **In 1969, you made a satirical superhero film called *Mister Freedom*, which, like *Broadway by Light*, was critical of American commercialism, but in a very different way.**

WK: Yes, superheroes are a common language of movies nowadays, but that didn't exist at that time. You would see all the superheroes in comic strips, but the thing the struck me was that you never knew who Superman, or the Hulk, or Spider-Man was working for. I mean, they were out for the destruction of evil and the promotion of good, but who was financing these guys—who was behind them, and who were they working for? So I had the idea to do a film about a superhero called Mister Freedom,

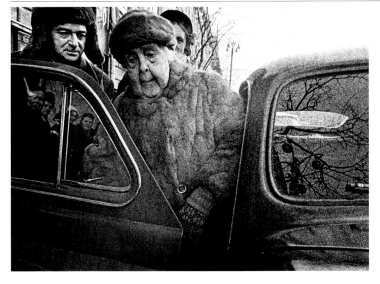

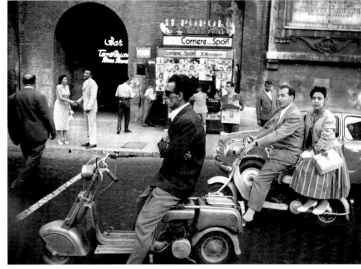

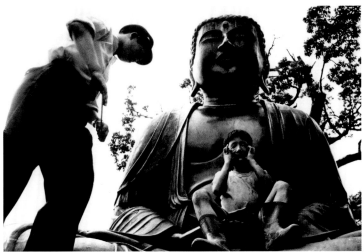

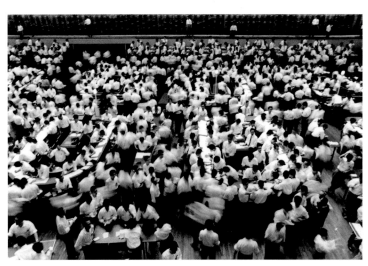

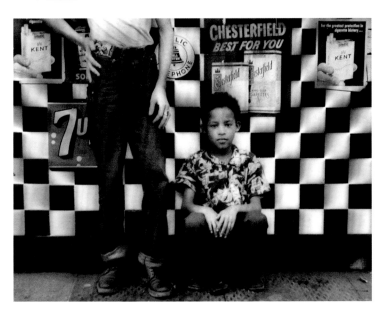

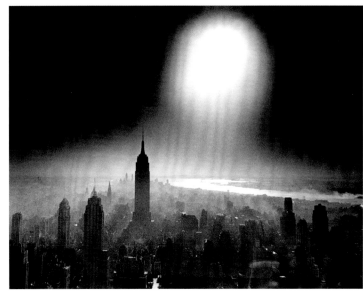

This page, clockwise
from top left:
*Alexandra Yablotchkina,
Russian Sarah Bernhardt,
Moscow, 1959; Red light,
Piazzale Flaminio, Rome,
1956; Tokyo Stock Market,
1961; Atom Bomb Sky,
New York, 1955; Candy
store, Amsterdam Avenue,
New York, 1954; Gokokuji
Temple, Boys Make Like
Japanese, Tokyo, 1961*

who was pushing American freedom, but treated France like a third-world country. Mister Freedom was like Captain America, but the hero of God knows what—he was selling the American dream, but the American dream in the hands of Mister Freedom was actually a nightmare. At one point in *Mister Freedom* you see the elevator of the Freedom Building, and each floor is a supernational company—steel, or oil, or Unilever, and so on— and it's clear that Mister Freedom is working for all the supercompanies of domination and oppression.

AS: **You also made a sports documentary in 1981 about the French Open:** *The French*.

WK: Yes, I used to play a lot of tennis—every day in the summertime, and two times a week all year around. I love to play; I love to hit the ball; I love the idea of geometry, and placement, and everything else that makes tennis great. Also, I was a groupie of heroes like Björn Borg, John McEnroe, and so on, so when I was asked to do a film on Roland Garros I thought that it would be a good

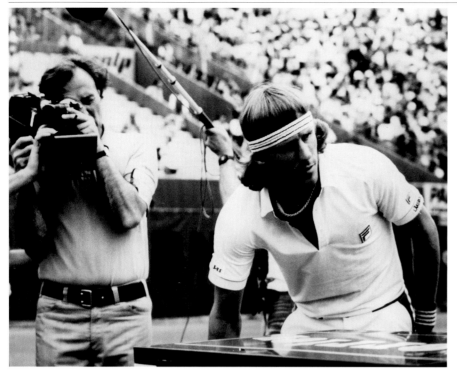
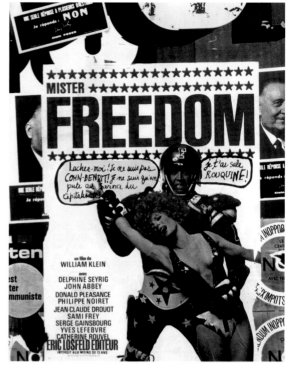
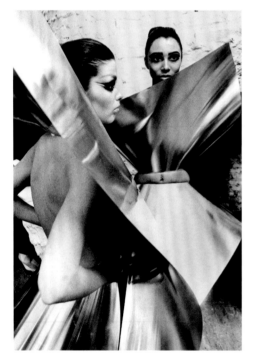

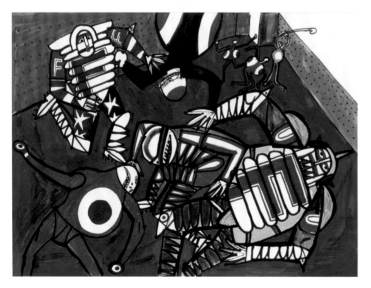

opportunity to get to know my tennis heroes, and eventually become friends with some of the people I admired. But it didn't really work out that way. I never got to be buddies with Borg or McEnroe, and a lot of these players were pretty stupid—Jimmy Connors's idea of participating in the movie was to drop his pants and simulate jerking off. There were only two or three guys who I got on with, people like Yannick Noah and a few others, who understood that I was trying to tell the story of what was going on in the world of tennis. But everybody in a tournament is out to make his mark, accumulate points, and progress, so they had no time for philosophizing about tennis and the role that they were playing. But I had fun.

AS: **Do you see any parallels between great sportsmen and great artists?**

WK: They are superheroes. Borg at one point was unbeatable. I remember there was an advertising poster for JVC with Borg jumping up and hitting a backhand; he was so perfect and beautiful. So these guys—Borg, Muhammad Ali—they knocked me out, and I learned a lot from them.

AS: **What are you working on now?**

WK: I wrote a film scenario about a year ago that I'm trying to get produced, and I just published a photography book, *Brooklyn + Klein* (2015). For me, having grown up in Manhattan, Brooklyn was always the pits; nobody used to care about Brooklyn. The only thing I remember is that when I was growing up, every time I met a girl at a dance in college or wherever, she would live in Brooklyn and we would have to take the subway for an hour. But Brooklyn was really a distant suburb. Nowadays, it's very chic, and everybody wants to live in Brooklyn—even Hillary Clinton has her office in Brooklyn.

I had gotten into the army at the end of the war, and since I had no knowledge of horses or radio transmissions, I was designated as a radio operator on horseback.

AS: **Why did you choose to make a book about Brooklyn today?**

WK: I had a contact at Sony—who is now making digital still cameras—and they wanted to commission a project. I was trying to think of a subject that wouldn't be at the end of the world, so I hit upon Brooklyn. Also, I guess it has something to do with my obsession with New York. But I thought Brooklyn wasn't what it's cracked up to be. I still have that Manhattan point of view a little bit, and see it as a second-rate suburb.

AS: **Did you find it interesting to photograph nevertheless?**

WK: I find everything interesting to photograph. For me it was always Hicksville and still is—even if Hillary Clinton does have her office there—so I wasn't seduced by Brooklyn. But I loved going to Coney Island when I was a kid, and I still do. And there were things that happened in Brooklyn that I don't think could happen anywhere else. One night we were watching a [minor league] doubleheader: the Brooklyn Cyclones against the Staten Island Yankees. Staten Island, can you imagine? How can they be Yankees? Anyhow, we were watching the doubleheader and a guy came over. He recognized me and said, "I'm a Czech rabbi. I came over to Brooklyn in 1980, and I remember the 1985 playoffs like it was yesterday. Do you remember that?" And I said, "No, I don't" [*laughs*]. And here's this Czech rabbi reminiscing about the playoffs in 1985, and he said, "Do you want to see a Hasidic prayer session?" And I said, "Sure." And this was at, like, midnight. So we went there, and they all had fur hats on; this was in August. And they said, "Okay, you can take photographs, but no faces." Then after a while they relented and started coming over to me, saying, "Take a picture of that guy—he's got an incredible face!" That was the weirdest evening I've had in a long time.

AS: **What did you do last night?**

WK: David Lynch has a nightclub in Paris called Silencio, and he asks various people to show their work and talk about it. So they invited me to come, and I showed a couple of film excerpts: from *Messiah* (1999)—a film I made about Handel's oratorio—and from my film about another messiah called Muhammad Ali, and several other sequences, as well as a mixture of different experiments in photography. I was there until very late last night.

AS: **What's it like to be an artist now?**

WK: I think it's a good way of living and … [*pause*] I find it difficult to answer that question.

AS: **What inspires you now?**

WK: The things I've done in the past lead to new things … and here I am, a hundred and fifty years old.

AS: **How does it feel to be eighty-seven? When you look back on your life and reflect on your work, are you proud of what you've accomplished?**

WK: How does it feel to be eighty-seven? Not so good. But I'm satisfied with the different things I've done. And I want to continue as long as possible.

Aaron Schuman is a writer and photographer based in London.

Boris Mikhailov

Interview by Viktor Misiano

Prankster, performer, and self-taught photographer Boris Mikhailov might be said to embody the archetype of the holy fool—that idea originating in the Russian Orthodox Church and carrying into literature in which someone pretends to be mad in order to offer spiritual guidance. Since he began making photographs in 1965, Mikhailov has continually broken the rules, both formal and ideological, to convey larger truths. He was born in 1938 in Kharkov, Ukraine; years later, in a now-famous story, Mikhailov was fired from his job as an engineer when he was caught using the factory's darkroom to develop nude photographs of his wife. The body—whether his own or his subjects'—remains a constant presence in his work, including images from the 1970s and '80s that played with and subverted Soviet-era visual codes. This play was often sexualized, leading one observer to describe Mikhailov as a "surrealist eroticist."

Throughout his career, his irreverent work has flirted with both conceptual and documentary traditions, employing a range of photographic techniques. Much of this prolific and diverse output was not shown in public until the early 1990s, after the collapse of the Soviet Union. Shortly thereafter, in 1997, Mikhailov began his controversial series *Case History* (1997–98), which documented post-Soviet Kharkov's growing homeless population.

Mikhailov now makes his home in Berlin, where he lives with his wife, Vita, his longtime creative collaborator. Last May, in Venice, during the opening of the Venice Biennale, curator Viktor Misiano, an old acquaintance of Mikhailov's, met the photographer in an apartment near the Campo Santo Stefano. Vita Mikhailov was also present and joins in this conversation that touches on Mikhailov's work then and now, the Soviet dissident poet Eduard Limonov, and Ukraine's recent political upheaval.

Viktor Misiano: **The last time we saw one another was last year in Kharkov, at the Yermilov Centre for Contemporary Art at the opening of an exhibition in honor of your seventy-fifth birthday. I happened to be moderating a lengthy, heated panel discussion on your work. It was impossible to ignore how proud the city is of you, how much you mean to it. And for you Kharkov means so much! It's your city, after all. And so much of your artwork is tied to this place.**

Boris Mikhailov: At one point I spent a lot of time developing this theme and came to the conclusion that Kharkov and I are one and the same. Not only because I was born there, but mostly because, having lived there for many years—though I now live in Berlin—I've deeply felt all of its good and bad sides. Maybe I'm wrong—after all, I don't have a formal artistic education, I came to art from the outside, as an amateur—but it seems to me that there isn't a serious artistic tradition in this city. There's just a small museum and an arts institute that hasn't produced anybody of significance. In spite of all that, Kharkov is a city with lots of energy, a city with enormous factories and scientific centers (as a matter of fact, this was the first place in the USSR to split the atom). This is the first capital of Ukraine. In other words, this is a highly tense place with a disproportionately limited cultural tradition. As a result, there was nothing here to influence me. Living here, I found myself in a sort of zero state— a state of total openness. If there was anything of importance here for me it was the local literature and song. This is where the singer [Klavdiya] Shulzhenko was from; she was an idol for the entire country. Though we have to admit she was rather vulgar, very much so in fact. Just like the poet

[Eduard] Limonov—a bright writer, but even he is vulgar. So I think vulgarity is one of the particular characteristics of this place, since it doesn't have a cultural tradition, but it does have energy and ambition. In some sense this vulgarity can even be considered revolutionary.

VM: **It's good that you mention Limonov; I always thought you two had a lot in common. In fact, he has a story, "East Side, West Side," in which over the course of thirty pages he describes walking through New York's Harlem at night. Nothing of note happens—he just re-creates his visual impressions—but it's impossible to tear oneself away from these unbelievably vivid descriptions. The way he builds these descriptions is like a film reel, they develop before us like a literary photographic sequence.**

BM: As soon as I got to New York, in the late '80s, I went to Harlem. Everybody told me not to go, and if I went, not to take pictures. Of course I went, and I went with a camera. I photographed from the hip, without looking through the lens. That was a special camera, a Horizon—prolonged exposure, panoramic views. I was incredibly curious; I'd never seen anything like it.

Many years ago in Kharkov, I was at a party where there was a student from Africa. Then, at my job as a factory engineer, I was warned that if I was ever found in the company of foreigners again, I would be fired. Because of that, I was extremely interested to find myself surrounded by African Americans, to understand how they live—what's the atmosphere of this neighborhood? All of a sudden, as I was crossing the street, right in the middle of it, some tall person suddenly hit me

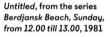

Untitled, from the series *Berdjansk Beach, Sunday, from 12.00 till 13.00*, 1981

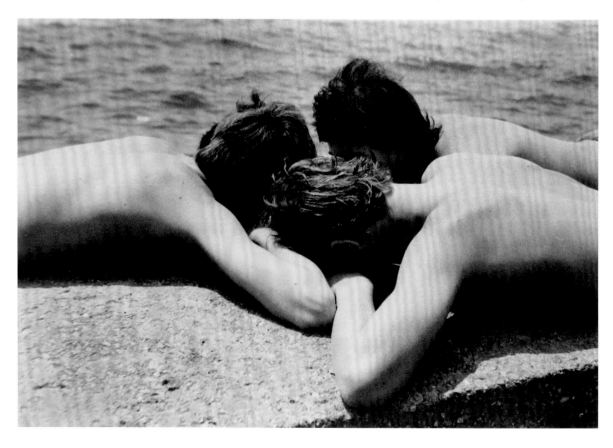

in the mouth unexpectedly with his huge fist. My ears were ringing. I was stunned and started yelling; he grumbled something at me and walked off. Then, I hadn't walked more than fifty meters before some other guy, squatting by a wall, shook his finger at me and also grumbled something. I had a feeling like he already knew what had just happened to me. So that punch in the face was what I remembered more than anything, for a long time, about my first trip to America. And the most amazing thing was that nothing even hurt from that punch. It was a kind of warning: "Careful, buddy, we have our own way of life here."

VM: **It's a very telling story. It seems that the life you were interested in exploring entered into dialogue with you, answered your call. I was also in Harlem during that same time, in the late '80s, but no one laid a finger on me. That's precisely what, in my understanding, you men of Kharkov—you and Limonov— have in common, this unbelievable ability to unmask the vital pulse hidden beneath reality's shell.**

BM: Worse—we bring real life upon ourselves! In one of his poems, Limonov has this line: "You smelled like Iranian piss." At the time, this frank and urinary image, completely unheard of then, won me over. Then, when I met the woman to whom these lines were dedicated, I tried to photograph her, but nothing turned out. Yes, there's definitely a connection between me and Limonov: We're both concerned with letting go of aesthetics and outward beauty. What's most important for us aren't outward appearances but the innermost depths of life and humanity.

VM: **There's also another thing you have in common. Limonov has a tendency to turn life into a performance, presenting himself as an artistic persona. You can't deny that elements of this are also very much part of your being. For both of you life is a performance, it's a stage on which to perform.**

BM: I can't say that the performative was initially embedded in my work. Early on in my career I made a few self-portraits, and in some of them I even depicted myself as historical or literary characters, but I stopped making that kind of work. But then came 1991—the time when the Soviet Union fell. That's when I made a series called *I am not I*, in which I once again began photographing myself. But why did I create that work? Probably because with the country changing, I felt it was necessary to uncover a new protagonist. But this was a protagonist who was sort of trying on the icons of the superheroes of Western mass culture— like Rambo, etc., and he was an antihero at the same time. It seemed important to me at that time to break out of the traditional role of the photographer who is removed from life, which he photographs as if from the outside. I wanted to raise the question: Why do you have the right

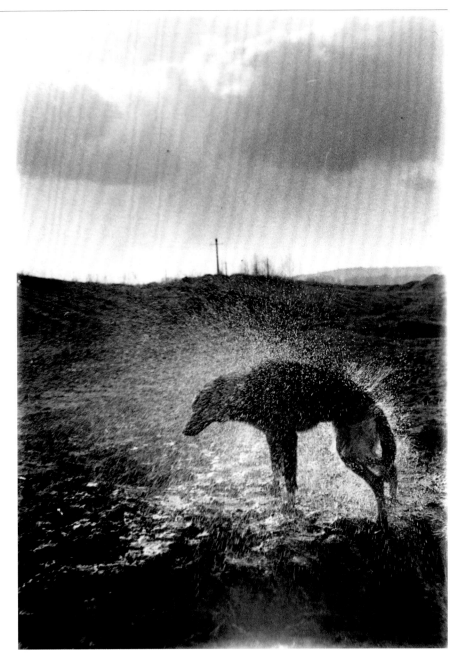

Untitled, from the series *City*, 1973

to photograph other people? And who are you? That's when I started featuring myself, suggesting in these images an answer to my own question: the part I play, that is who I really am.

VM: **Do you mean to say that the fall of the foundations of Soviet life also broke the foundations of photography, broke the traditional subject-object interrelation between the photograph and reality? Very interesting idea!**

With the country changing, I felt it was necessary to uncover a new protagonist.

BM: Yes, what was happening in the country at that time had a huge impact on me. It forced me to position myself differently in life and in photography.

VM: **And yet, when I was talking about the performative, I was referring not only to your appearing as a character in the photographs**

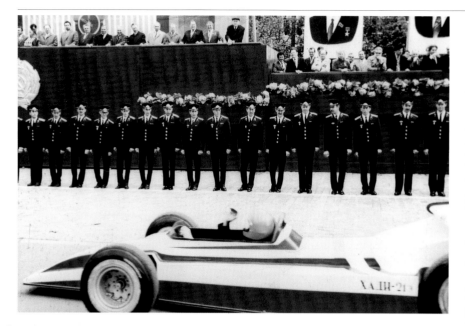

awkward coloration, brought the image closer to reality. It made it a bit vulgar or unrespectable (as a matter of fact, that same anniversary exhibition in Kharkov was called just that—*Unrespectable*). And that's how life really is—it's vulgar and unrespectable.

Vita Mikhailov [Boris's wife]: Viktor's question had a point that you overlooked. It's not just that you perform in your own photographs but that you look at life itself as a performance. For me, for example, a person on the street is just walking, but to you, he's performing.

VM: **That reminds me of a book by the anthropologist Alexei Yurchak, *Everything Was Forever, Until It Was No More* (2005). It describes how, in the later Soviet period, people who observed regime-imposed social rituals, such as May Day demonstrations or trade-union and party meetings, rather than interpreting them as roles to be performed, were actually changing the meaning of the social order. That's precisely why, though it seemed to everyone that the USSR would last forever, no one was surprised when it ended.**

BM: I'm not sure the word *performance* pertains to me. I'll put it differently. After the Khrushchev reforms of the late 1950s and early 1960s, it was clear to me that everything had to change. And though on the surface everything was becoming frozen, I was still constantly looking for signs of actual change. That's why all of life—built as it was on contrasting rituals and changes—seemed so unreal, at times almost carnival-like. Life was kind of struggling to break out of narrow forms that were being imposed on it externally. That's precisely what I was trying to show in my work.

but also to various forms of artistic intervention that you have employed in the developing process. For example, in *The Red Series* (1968–75), you began painting over photographs of Soviet demonstrations. Ilya Kabakov [the Soviet-born American Conceptual artist] was very enthusiastic about this series. It was, he said, as if the artist-protagonist is expressing himself through this method. That he, i.e., you, imagines himself as some superloyal Soviet citizen who not only docilely attends official parades, but also innocently colors the photographs of those parades to make them more joyful and festive.

Untitled, from The Red Series, 1968–75

VM: **That's probably why your Soviet-period work is free from the photojournalistic clichés that aimed to expose the repressiveness of the Soviet regime. For you that life is still vital, playful, and comical, at times even to the point of idiocy.**

BM: Still, life then was clouded by a sort of tension. After all, the beginning of my photographic career brought me face-to-face with the KGB. I wasn't jailed, but I was fired from my job and the visit by the KGB to check on me disturbed my inner peace. I felt their watchful gaze all the time. Especially when I traveled to Lithuania to attend photo-festivals.

BM: I actually adopted that technique because it harks back to an earlier epoch in the history of photography when it was still black and white and customary to color photographs in. I was doing that sort of work by commission and receiving lots of orders. Of course, when I started using this method on my own photographs, there arose this element of playful liberation of which you speak. But there's another important point here: Oddly enough, this doctoring of the photograph, this supposedly

Vita Mikhailov: Moreover, at that time not only the regime but all of society exercised control over what he photographed. If Borya would be photographing sunsets, there would have been no objection. But when he photographed something out of the ordinary, then anyone could come up to him and ask: What are you photographing here? That sort of random monitor-passerby was always looking over our shoulder.

BM: Every time I take a picture of unusual things—some kind of rusty pipe on the street—I feel a certain degree of tension, I feel a certain degree of fear. Society continues to control you—controlling behavior for which it can't find a reasonable explanation.

VM: **Society controls your gaze—where and how you should be looking.**

BM: It raises the constant question—to photograph or not to photograph? Will you dare or won't you? And we're not just talking about political or social conduct, we're talking about photographs, about conduct in photography. You know you can't photograph in a certain way, but you feel that the photograph is demanding that you do. You have to do it! To photograph precisely in this way!

All of life—built as it was on contrasting rituals and changes—seemed so unreal, at times almost carnival-like.

Vita Mikhailov: In the 1950s in Kharkov there was a sadly famous event. A group of young people dreamed of a different and freer life; they listened to Western music, engaged in creative projects, and so on. They were arrested and some of them were imprisoned. We later saw their case file, which contained a lot of photographs: these young folks had taken pictures of themselves on the beach in bathing suits. As a result, according to what was written in their official case file, they were charged with taking "Western poses," and were sent to prison on pornography charges. That was the atmosphere at the time when Borya took up photography.

VM: **And then there was your series *Suzi et cetera*, from the early 1980s, for which you could easily have been charged with making pornography. And your *Crimean Snobbism* series from 1982, in which you and your friends are depicted on a carefree vacation messing around and acting out the most idiotic mise-en-scènes; couldn't you say that in this series, you're taking on "Western poses"?**

BM: I would say these were exercises in liberation.

VM: **But the series was created during the Soviet period?!**

BM: Yes, it was even before perestroika. But I showed that people had already prepared themselves for another way of life; they had already begun living it.

VM: **Now, it seems, is the right time to talk about *Case History*. In these dramatic images, once again you challenged yourself to show the new post-Soviet life. I remember after you first exhibited this series that you were very concerned with how ethical it was to make this work and exhibit it. But I think that it makes no sense to come back to this topic at this point. What I would like to draw attention to, given this line of our conversation, is the fact that in *Case History*, you, in your constant quest to dive into life, reached, perhaps, the maximum depth. But again you not only show images of reality but also enter into a kind of relationship, implicating your protagonists—the homeless of Kharkov—in some sort of action.**

Untitled, from the series
Tea Coffee Cappuccino,
2000-2010

Untitled, from the series
Suzi et cetera, early '80s

BM: When Vita and I were shooting that series, it made me think of the American Depression, when the American government actively recruited photographers and commissioned them to photograph what was happening, to capture these experiences for history's sake. I was motivated by this precedent: I felt that it was important to photograph what was happening. And then yes, of course, in the new poverty, I saw a new protagonist. Of course there had been drunks on the street before, and homeless people, but they were less noticeable, there wasn't as large a concentration of them. Yet it was difficult to approach them because Society, with a capital *S*, tracked your every move, as we mentioned earlier. The reason I was engaging with them was because it wasn't possible to photograph them stealthily—that would have been impolite and unethical. Communication was necessary. There arose a need to overcome some inner resistance—if you can communicate with them, then it means you can cross some sort of boundary.

VM: Although your motivation was photography, you arrived at a particular code of ethics, a new way of living. You felt that the new protagonists required a new approach to the work, and this in turn assumed a new kind of human relations.

BM: Yes, that's true. Also, in those years, anybody could suddenly find themselves in such a situation. Vita and I were lucky, but it might have been otherwise. Hence the social barriers between us and them were very relative. For that reason photographing these people required a tremendous amount of empathy and respect on our part.

VM: You've spent many years living in Europe. Have you been able to feel life here as deeply and profoundly as you were able to in your home country? And are you able to interfere with life here, to play with it as much?

BM: There's no question here: the difficulty of photographing in the West is my lack of knowing the language.

Vita Mikhailov: It's not just a matter of language. It's a matter of context. Your place is there: you know it and understand it. Borya takes fantastic photographs of Berlin and it will probably become clear later on that no one else has captured such a Berlin.

BM: Yes, of course at home I have a better sense for the changing times, the rise of something new—and this has always been important to me. Although not too long ago, a year ago, it was easier for me to photograph in Berlin since I felt a glut of information back home. I wasn't feeling anything new. But when all of the political events began in Ukraine everything changed again. We'll travel back there soon and perhaps will encounter something new there.

Vita Mikhailov: As a matter of fact, after making *Case History*, between 2000 and 2010 we completed a very good series called *Tea Coffee Cappuccino*, which we then compiled into a book (2011). It reflected that new situation, which replaced the transitional 1990s.

VM: I remember that series: it showed the streets of Kharkov, its markets and flea markets. And while it was clear from the photographs that a prosperous life was still far away, they projected a tremendous amount of great positive energy. It was a bright contrast with *Case History*, and it definitely represented a new period of post-Soviet life. Although you did show what that epoch ended with in your 2013 series dedicated to the protesters in Maidan [Square, Kiev], which was exhibited at the Hermitage in St. Petersburg in 2014 as part of Manifesta 10. Once again, you showed these two themes that we've been discussing today:

an organic element of life that reveals itself from behind the shell of reality, and how that inner life takes on the veneer of a social performance. In this work, the Maidan protest movement appears in a sort of dark spectacle, almost gothic, controlled by irrational forces. These photographs show the fragility of the norms and conventions ruling the social order, how easily they give rise to something dark and frightening.

BM: Yes, I tried to accentuate all of this through the exhibition. But I have to say, the people at Maidan sensed all of this and worried about it. It was clear that they were preparing themselves for something; they remained in tense anticipation. And of course in large part this was the foreboding sense of war. People were very worried about it and I worried alongside them.

Vita Mikhailov: Don't forget, these photographs were taken in December, before the bloody culmination of events. [The protests eventually led to the Ukrainian revolution in February 2014.] Even then there was a fire burning in the square, and smoke was rising, but people were simply warming themselves around it. There were a lot of strange things there. That's where Borya photographed a person who ended up being one of the first victims. He was the first person to die at Maidan.

BM: And there were thousands of people there! Ultimately, the photographer needs to get lucky; what's important is the moment of photographic luck, though of course with reference to this situation it sounds somewhat sacrilegious. I'm not talking about mysticism, but some kind of inevitable event. When you're open to life, it responds to you. That is what an intuitive possibility of photography is—to crawl deeper into the depths of life than what you see on its surface. I can't say what this is and how it occurs, but that's how it is.

VM: **But isn't the camera always an extension of your gaze, which is diving deeply into life?**

BM: Yes, but it's important to keep in mind that without the camera this diving would be impossible.

VM: **On the other hand, you always trusted chance. Let's recall your series from the late '60s and early '70s, Yesterday's Sandwich—your early experimental series—to which, insofar as I understand, you've been returning conceptually of late. In those works you randomly placed one image onto another, not knowing in advance how it would turn out. And it ended up being extremely evocative.**

BM: I can't explain it in theoretical terms but this has always interested me. Photographic accident may be more interesting than a consciously

constructed collage. I was recently thinking about this. You photograph one subject, then another, you place them between one another and this unintentional connection turns into a story about life in its entirety. And this is all borne from chance, and this chance is photography.

Translated from the Russian by Elianna Kan.

Untitled, from the series *Look at me I look at water,* 1998–2000

Viktor Misiano lives between Moscow and Ceglie Messapica, Italy. Previously, he was a curator of contemporary art at the Pushkin National Museum of Fine Arts, Moscow, and director of the Center for Contemporary Art (CAC), Moscow. He is a founder and the editor-in-chief of *Moscow Art Magazine* and also an editor at *Manifesta Journal: Journal of Contemporary Curatorship.* His latest exhibition project is "Ornamentalism: Latvian Contemporary Art," Venice, Arsenale, Collateral Event of the 56th Venice Biennale, 2015.

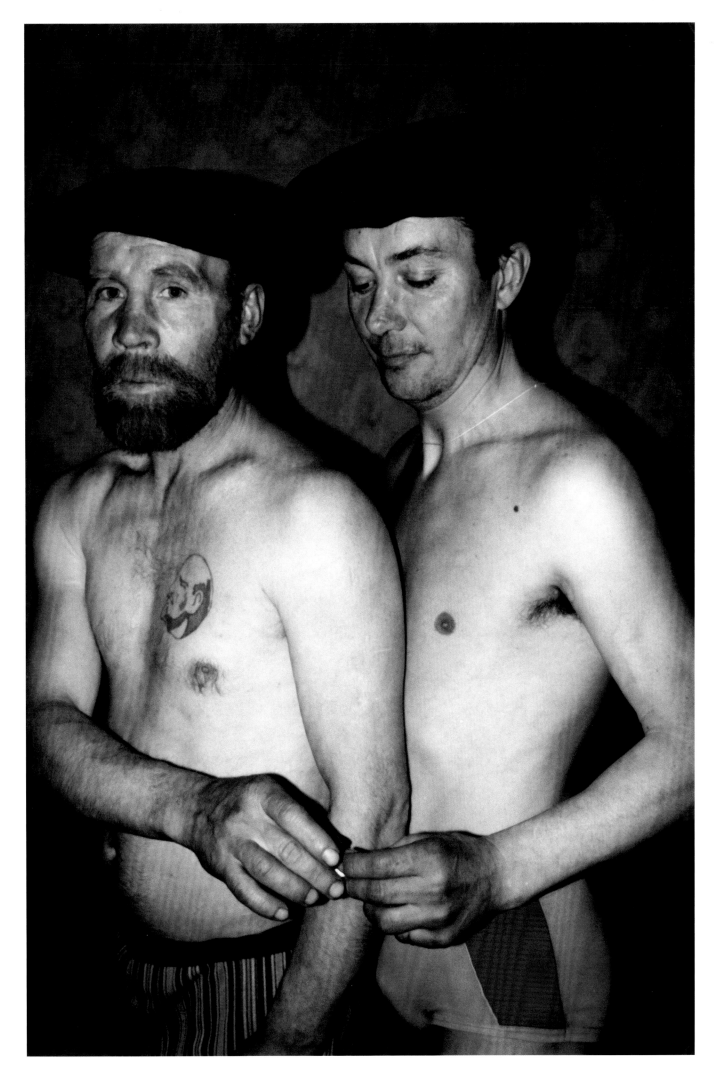

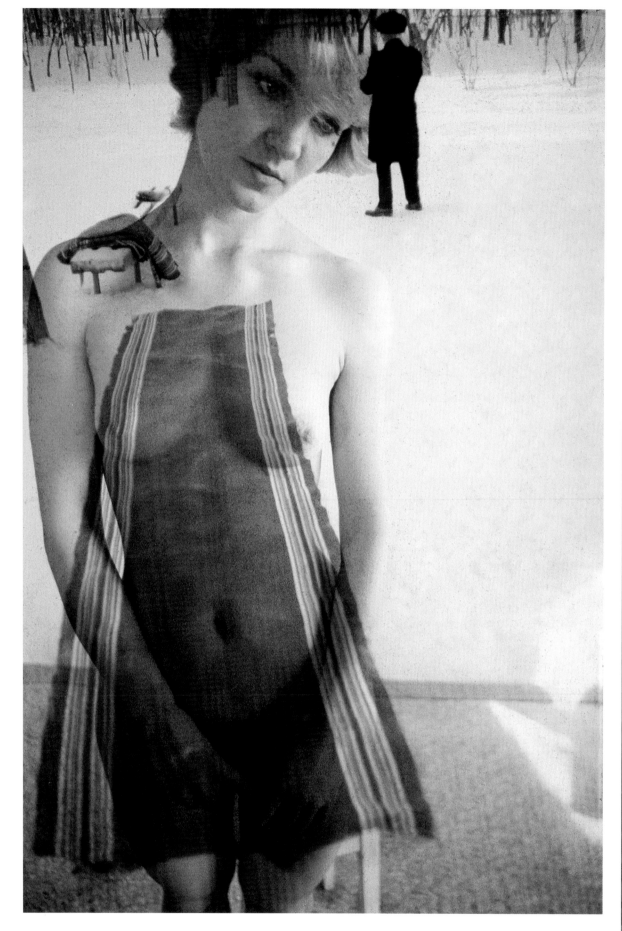

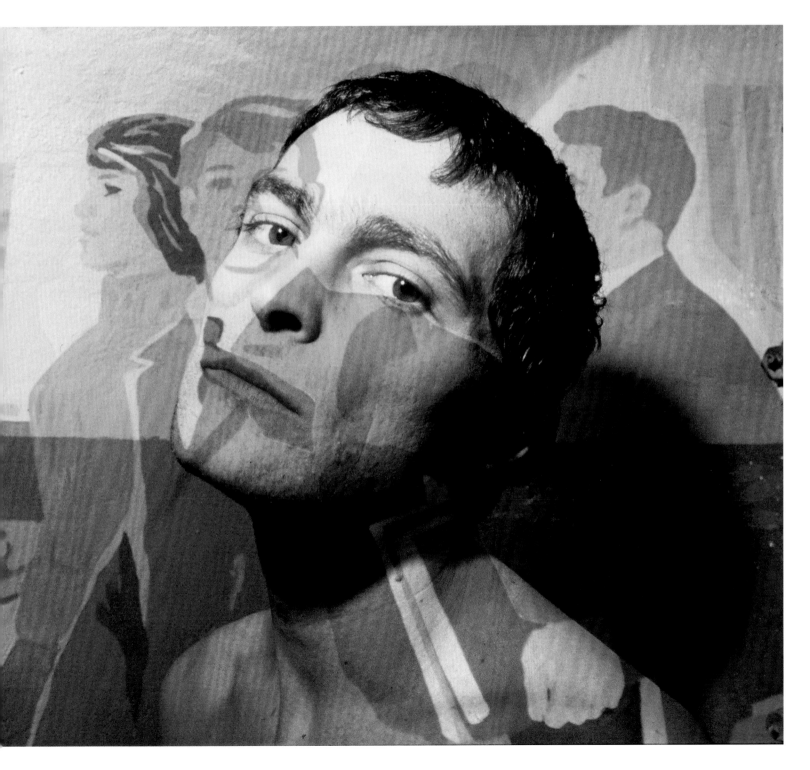

Guido Guidi

Interview by Antonello Frongia

"I was interested in everything: the portrait of a person, of a house, of a wall.... Nothing was unimportant; everything was worthy of attention," Guido Guidi says in these pages. Guidi was born in 1941, near Cesena, in Northern Italy, and since the 1960s has recorded quiet scenes in the Italian countryside and other parts of Europe, rendering rural towns, marginal landscapes, and lone figures in his signature soft palette. "All photographers love his work," Martin Parr says, "but it remains so under the radar and underrated, it hurts."

Guidi trained as an architect, painter, and draughtsman—and an abiding interest in perspective and modest architectural forms underpins his photographs. His influences range from Renaissance painting to the American photographers Walker Evans, Stephen Shore, and Robert Adams, whose work investigates place and vernacular architecture with cool detachment. Guidi, too, shares their interest in the "social landscape," and throughout the 1980s and '90s, he used a large-format camera to look at changes afoot in Italy as a result of industrialization or migration. In counterpoint to his photographs of the individual's relationship to the world are these larger explorations, including his photographs of Porto Marghera, the industrial area next to Venice; Gibellina, Sicily, hit by an earthquake in 1968; as well as urban peripheries.

Guidi still lives in Cesena, where he continues to photograph; he teaches at universities in Venice and Ravenna. His recent books include *A New Map of Italy* (2011) and *Veramente* (2014), which have helped bring his work to a larger audience. For this issue, Guidi spoke with Antonello Frongia, a historian of photography—in person in Rubiera, near Reggio Emilia, and also by phone—about his influences, his contemporaries (including Luigi Ghirri), and on how, in his view, "the spirit lies in simplicity, not in rhetoric."

Antonello Frongia: **When did you start taking photographs?**

Guido Guidi: I was sixteen, in my third year of high school. I was only familiar with my family's photo-album and my uncle's amateur photographs—he was the one who made the album. What I was looking at was vernacular, not refined photography. When I began taking photographs, I was using a 6-by-6-format camera, but I followed my uncle's example: I photographed my friends, although I was using a small tripod I had bought.

AF: **And so was it in Venice that you began to be seriously involved with photography?**

GG: In Venice I studied architecture, but it was a bit later, at the Corso Superiore di Disegno Industriale (an industrial design program) that I began to photograph with a certain awareness. I had been fascinated by perspective since the age of thirteen, when I enrolled in art school, so much so that during my first year I asked my older schoolmates to teach me the rudiments of perspective drawing. Modern painting completely abandoned perspective; as the art historian Daniel Arasse says, the white square on a white background destroyed perspective. Photography continues to be based on perspective, even if it may continually betray it.

AF: **What do you mean by "betray"?**

GG: In photography, as in Renaissance painting, perspectival deception is always part of the game. Perspective shows depth but also the negation of depth, namely the surface. Let's call it a perspectival game, when a photograph or a painting reveals the plot of its own structure, the means by which it is made. Perspective describes how the world is made. During the Renaissance, Alberti spoke simply of *commensuratio*, measuring things; perspective as symbolic form emerges later. Perspective was invented to measure the concrete world, the public square, the res publica. From a political standpoint, this new idea revolutionized the then-Gothic world. Cosimo de' Medici in Florence wanted to show that his policies were democratic, without deception, res publica. He wanted to show the things that took place in public squares, not in private rooms. Arasse says that after Palla Strozzi brought Gentile da Fabriano to Florence to paint a fairy-tale world suitable for a Gothic prince, Cosimo de' Medici called in Filippo Lippi, who, along with Masaccio, Donatello, and Brunelleschi, began a new visual discourse based on the measuring of the world, on perspective.

AF: **Which photographers did you know during your studies?**

GG: At the Corso Superiore di Disegno Industriale, Italo Zannier showed Henri Cartier-Bresson's *Images à la sauvette* (*The Decisive Moment*, 1952) and Paul Strand and Cesare Zavattini's *Un paese* (1955). All Italian photography in the vein of neorealism

was influenced by Strand, while more amateur photographers were looking at Cartier-Bresson. In 1967 I saw a Cartier-Bresson exhibition at the Musée des Arts Décoratifs in Paris, a large show with photographs of all sizes, some as large as bedsheets. The exhibition left me perplexed— the exotic places, the virtuosity—but I remember that I lingered over one of Indian women who were "raising up" the clouds [the photograph, *Srinagar, Kashmir* (1948) shows Muslim women praying at sunrise in the Himalayas]. When I began working seriously, I did some frontal portraits influenced by Strand. Actually, the first photographer I discovered on my own was Bill Brandt—the social Brandt, the one of the London catacomb metros, not the one who did nudes. But I was also interested in the aggressive photography of William Klein, with his harsh glance at people and the world, a very critical glance, very unflattering toward the subject. Many of my photographs from those years were polemical; they were about doing the opposite of the norm, like Klein and [Robert] Frank.

AF: **Is the sequence of photographs of the man reading a newspaper from this period?**

GG: It must have been around 1967 or 1968. I shot it in the waiting room of the station in Cesena, when I was traveling to Venice, where I was studying. I shot what was in front of me without aiming at the person, but to the side, so I wouldn't be noticed. Then I printed only the left part of the negative. I wanted to create a sequence; I wasn't interested in capturing a particular moment, even if the sequence is then made up of distinct moments. The photographs are presented in the order in which they were taken, as the camera recorded them.

So, we spoke before about perspective; for Brunelleschi, who also built mechanical clocks, measuring the world also meant measuring time. Perhaps unknowingly, I think through the sequence I rediscovered this idea of perspective as an articulation of time, the opposite of the "decisive moment." Maybe I was also influenced by the Conceptual art of this period, which I was following carefully.

AF: **What relationship did you have with the art world when you began? How did Conceptual art influence you?**

GG: These were years when Conceptual art was becoming established and clearly I kept up with what was happening, but I have never liked labels. For example, in my work it was considered Conceptual that I was writing beneath the photos, or showing two paired photos instead of only one. In fact I would do this in order to show the nature of process in my work. The root of these practices, which came to be called Conceptual, can be found in the Bauhaus: one of my teachers at the Corso Superiore di Disegno Industriale was Luigi Veronesi, who had brought a modernist, scientific attitude directly from the Bauhaus.

Cesena, 1967, from the series *La figura dell'Orante* (Orante figure)

idea of the haiku, for example. *Informel* is closer to photography than one thinks, precisely because of the rapid action. In both, there is the pleasure of the material, but there is also a refusal to take time to think about things. You do it and it catches you by surprise, because you don't know what you are doing until after it is done. For me, execution is important; if there is a reasoning process, it is amalgamated, mixed in with the material.

AF: **Were you interested in the "social landscape" around you at some point?**

GG: Really I was interested in everything: the portrait of a person, of a house, of a wall—it was all a pretext for experimenting. Nothing was unimportant; everything was worthy of attention. Certainly I was interested in the social landscape, in the 1960s and later. But the series of the man with the newspaper was also a sort of provocation; I anticipated some sort of reaction from him. I understood that photography, in addition to being a piece of paper, could be understood as a performance, a social action in space and in time that can provoke a reaction on the part of the subject.

AF: **Lee Friedlander's work has been important to you. Do you remember how you came to know his work?**

GG: I remember that I had seen Friedlander's name in Ugo Mulas's photobook *New York: The New Art Scene* (1967). And one of Mulas's *Verification* photographs, the one featuring the mirror, was dedicated to Friedlander. As soon as Friedlander's *Self Portrait* came out in 1970, I bought it, but it was only on the occasion of the lone photography biennial, *Venice '79* [see Rexer, page 19], that I was able to meet him. That was when I heard him talk about the vernacular. He said he wasn't interested in art photography, but in the vernacular photograph, in the snapshot. I could relate to this, of course, since I had grown up with the family photographs shot by my uncle, who had them printed at the photography store before gluing them into an album.

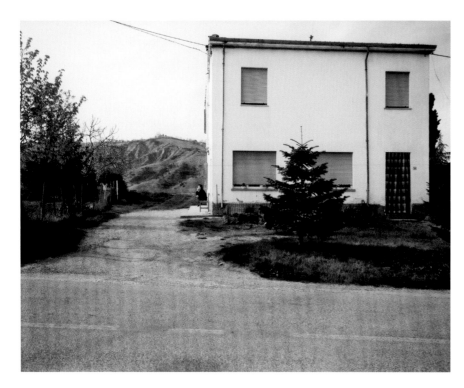

But I believe that all art has always been anachronistically Conceptual. And much neo-Conceptual work being done today bores me: it is sterile and academic. Conceptual art is often antithetical to looking, just as Duchamp was opposed to "retinal" art. But this phony distinction between the retina, which records, and the brain, which reasons, has been contradicted by neuroscience. Seeing pertains to the retina, and the retina pertains to the brain; it has the function of restoring already codified images to the brain; it already has the task of producing a thought.

AF: **Were you influenced by painting? You studied in an art school as a teenager.**

GG: *Art informel* taught me the notion of rapid execution. *Informel* painting is resolved in a moment. Jackson Pollock's gesture is also quick. It is a modality that goes back to East Asia, to the

AF: **Did you photograph people as emblems of society?**

GG: Even when I was just getting started, and I was photographing people, I was interested in men and women, period. Social types, such as those by August Sander, interested me less. There is a difference between the social landscape of Sander and that of American photographers like Lee Friedlander, but also Walker Evans and Paul Strand. In Evans's work, people usually have great dignity. In Strand's photographs, whether it's a farmer or a mayor, they are heroes. It is no accident that Strand loved Piero della Francesca; the figures in Piero's painting are regal. I have never photographed heroes; my focus was always on people,

not on types. I didn't want to make categories or taxonomies.

Even when I was making series, like the one on houses in the early 1970s, I didn't limit myself to photographing only that type of subject. Houses alternate with people, curbstones, trees. Once again, it seems to me that photographing only one type of subject requires a project done at your desk; I direct my gaze only toward those things I consider an emblem of something else. At a certain moment I felt pushed to leave my room, like in Wim Wenders's *The Wrong Move* (1975), when Wilhelm breaks the windowpane with the palm of his hand and leaves the house. I leave the house and what do I find? A house, an entrance door, a woman who passes by or who asks me something.

AF: **I recall that back in the 1980s you suggested reading Eugen Herrigel's *Zen in the Art of Archery* (1948).**

GG: I also had a little book on Zen and the camera [Robert Leverant, *Zen in the Art of Photography* (1969)]. But even earlier, there was Minor White, although I think I am more secular than White. Let's say that as a Mediterranean person I don't insist on the "spirit," or on the symbolism of clouds, as Stieglitz does, although I appreciate them a lot, as I also appreciate Strand's clouds, laden with rain and prehistory and also spirituality. However, all this is excessively rhetorical. I too am spiritual, but I wouldn't want to be rhetorical. The spirit lies in simplicity, not in rhetoric.

AF: **In the early 1970s you systematically photographed buildings, houses, small precarious constructions on the Romagna coast.**

GG: That series was another way to confront leaving the ghetto of the unique photograph, the photograph-painting. The title of that work was *Facciata* (Façade); I went back to the dictionary definition, which in Italian refers both to the front of a building and the "face" of a sheet of paper. The subject of the series, however, came from Walker Evans. Early on, in 1971, I had the catalog for the retrospective John Szarkowski curated at MoMA, which, for a long time, was my point of reference for understanding Evans's photography. I immediately liked his Victorian houses and above all those vernacular ones found in Alabama or in Ossining, New York.

AF: **Was there a moment when you devoted yourself to a more "classical" vision?**

GG: At some point I saw a sort of normalization of Klein's and Frank's rule-breaking attitudes, so my reaction was to go back to old work, to our great-grandfathers. My only radical passage was when I returned to old ways, using anachronistic tools like the 8-by-10-format camera. I was doing too many photographs; I was trigger-happy

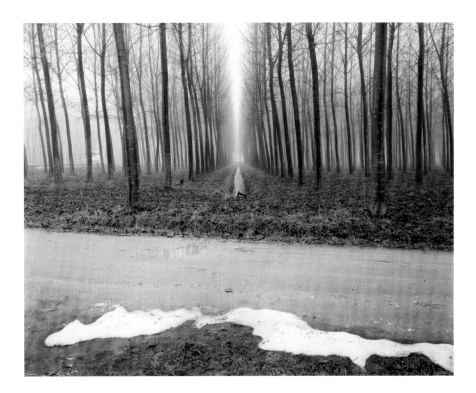

Romea, 1987, from the series Via Romea

and producing a lot of unsatisfactory negatives. The photographic grain always bothered me, and, in fact, my first camera, when I was sixteen, was already 2¼ by 2¼ inches, which was an anachronism for that time. Around 1976 I managed to get a 5-by-7 inch, and from then on I began working with a scarcity of means, in black and white, and a bit later in color as well, initially with

Let's say that as a Mediterranean person I don't insist on the "spirit," or on the symbolism of clouds.

low-quality lenses and with disappointing results. Studying the work of American photographers such as Stephen Shore, Joel Meyerowitz, and William Christenberry, I built myself an 8-by-10 out of plywood, although until 1985 I continued

to use insufficient lenses. It was clearly a return to Evans, to Weston, too, but above all to the old photographers from the nineteenth century, from Timothy O'Sullivan to Atget. Using a large-format camera was also a polemic with my friend Luigi Ghirri, who said, "What good is such sharp sight when we are in a dead end?"

AF: **What did Ghirri mean?**

GG: I believe that Luigi, citing Shakespeare, was thinking about the general situation; everything becomes topsy-turvy; life, time, everything goes to rack and ruin. It was like saying: "I was shipwrecked, and what good is it to collect stones or pay attention to blades of grass?" The psychologist Ruggero Pierantoni says that there are two ways of reacting when one is shipwrecked: there are those who start screaming in desperation, and those, instead, who gather up the remaining fragments of wood to build a raft. You need keen eyesight for looking carefully at all the details around. I think that Luigi recognized the shipwreck and that he took shelter in classical order, in a central view. But there was one thing we had in common: an interest in art, especially in old painting. I was more interested in the early Renaissance; Luigi, especially later, was interested in Bernardo Bellotto, in Caspar David Friedrich, in the eighteenth and nineteenth centuries.

AF: **In this view of a poplar grove on the Via Romea [previous page] you seem to respond to certain elements that characterize Ghirri's later work: perspective, the Italian countryside, the snow...**

GG: It is a photograph in the neoclassical tradition, with a central vanishing point at the back. Of the photographers of my generation, Luigi Ghirri was also very interested in perspective, and he was very precise about locating the vanishing point in a central position. It seems to me that for Ghirri this idea is connected to the desire to represent infinity, which is a romantic idea. My attempt, instead, has always been to escape from the idea of romantic infinity, to return to physical reality. In this photograph the vanishing point is central, but this barrier I put in the foreground is symptomatic: the earth and the snow are the archaic, primitive site, the place of childhood, of the defenseless eye, nonliterary.

The further away one moves from the center, the less power one senses. I seemed to have more freedom working at the margins.

AF: **Your discourse on perspective as a description of the res publica might seem to lead to the Italian piazza, but unlike photographers of your generation such as Ghirri, Mimmo Jodice, and Olivo Barbieri, you spent little time in historical cities, paying more attention instead to uncertain places with little structure. Why?**

GG: Because I am interested in interstices. The res publica is also and above all outside the center. In medieval tradition, as Pierantoni points out, the Madonna is positioned at the center of the

painting, Saint Joseph stands next to her, further to the side are minor saints, and even further away are the little angels who fly about. The further away one moves from the center, the less power one senses. I seemed to have more freedom working at the margins, like the little angels. The very fact of working with photography, instead of with the "fine arts," has given me the possibility of working in a free zone, with less embarrassment and more confidence, in an area where the academy and the art system have less power.

AF: **In Italy, your attention to the marginal has often been commented on as a denunciation of disorder, of the destruction of the landscape. Do you share this interpretation?**

GG: I have never felt I was so denunciatory. Certainly at the beginning, around 1968, nothing was going well. My friends were all protesters and I, too, participated in this social rage. But in my work there is not so much denunciation as a growing awareness, an attempt to touch things, to relate to the world, to understand it even in moments of destruction, of downfall. There is a phrase by the Baroque writer Giambattista Marino that I once heard quoted on the radio. About to die, Marino realized that the yellow rose that, his entire life, he had sought to describe in his writings was none other than the yellow rose at the foot of his bed. And so everything I have sought to do has been to make photographs of that thing there, not only an idea about how to represent that thing. Or as Evans said, photography is a medium; it shouldn't speak only about itself, but about the world.

AF: **You have spoken about sequence, about series. What role do books play in the definition of your work?**

GG: The book is the most rational part of work, the construction you do later, advisedly. With a photograph, instead, I sometimes don't know why I do it; I do it and that's it. Ideally the book should precisely respect the photographic sequence as it was shot. In prints and in books, unlike what Evans did and what I myself did at first, I never cut parts of the negative. I like for photographs to be seen as I have shot them, out of a sort of ontological respect for the camera, which entails a slight sin of hubris: not correcting signifies thinking one never makes mistakes. The importance of the sequence of the shots was confirmed to me in an encounter in Venice with photographer and curator Nathan Lyons in 1979. He suggested having an empty shot between one sequence and the next, in order to record on the contact print the interruptions between one period of work and another. In a certain sense this is the position of the psychoanalyst who analyzes the dreams one has, night after night, comparing the different dream-frames: Why, after photographing that chipped wall, did you photograph that pile of gravel, or that sky? And it is a method that is a bit

Surrealist, perhaps. But in the book the sequence is about communication; I want what I show to be intelligible not only to me, but also to others. Usually the problem is finding a visual connection between different moments. To achieve this result, I try to make sequences, not series, avoiding the creation of a rift between photographs, and working in a way so the subsequent photograph has a dialectic with the previous one. There must be a dialogue, but this dialogue is not literary. It is visual, between façades, between faces, between faces that look at themselves in the mirror, or look askance.

Translated from the Italian by Marguerite Shore.

Montebelluna, Treviso, 1985,
from the series *Cinque paesaggi*
(Five landscapes)

Antonello Frongia teaches history of photography at the Department of Art History and Archaeology, Università Roma Tre. He organized Guido Guidi's book and exhibition *Cinque paesaggi, 1983–1993* (2013, with Laura Moro) and edited the Italian edition of Lewis Baltz's *Texts* (2014).

*Presina di piazzola sul
Brenta, Padova*, 1984, from
the series *Cinque paesaggi*
(Five landscapes)

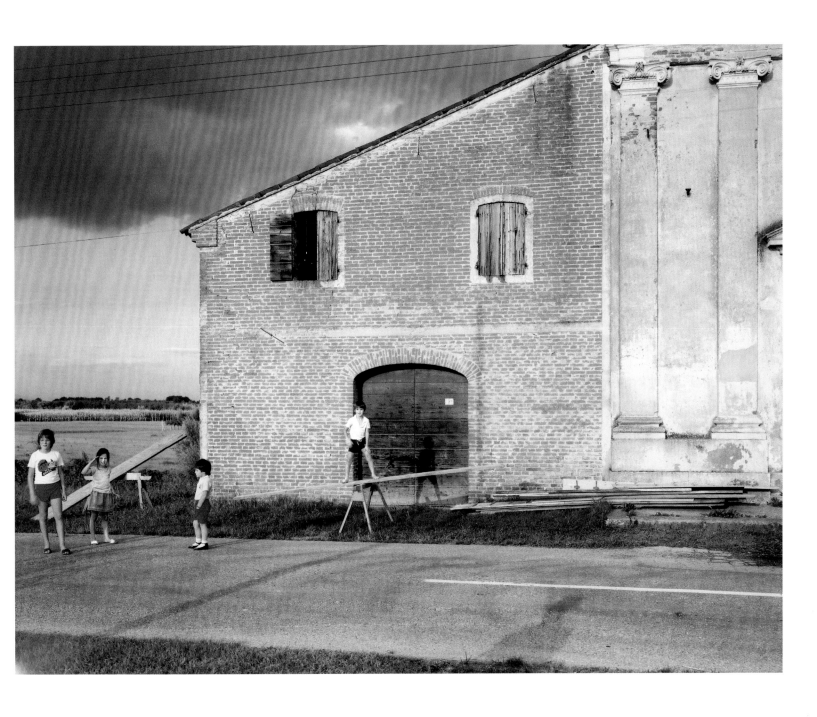

63

64

Rosalind Fox Solomon

Interview by Francine Prose

Solomon's photographic career has been defined by an itch for travel and a desire to use the camera as a means of self-discovery, or, as she puts it, as a way of "talking to myself." A student of photographer Lisette Model, who was known for her confrontational images of New York City's street life, Solomon, over many decades, has photographed extensively in South and Central America, India, and Poland—as well as in places closer to home, like New York and the American South. Her work, however, is often metaphorical, transcending mere descriptions of place. Since 2010, she's been working in Israel and the West Bank as a contributor to a project called *This Place*, along with eleven other acclaimed photographers, among them Josef Koudelka, Jeff Wall, Stephen Shore, Thomas Struth, and Wendy Ewald. A new book, provisionally titled *Noodles and Navels*, which looks at Solomon's childhood, parents, marriage, and liberation, is due out from MACK early next year.

When we asked Solomon with whom she might be interested in speaking for the issue, she replied, "a woman who writes for the *New York Review of Books*." Novelist Francine Prose—a regular contributor to the *NYRB*—agreed to conduct the interview, meeting with Solomon last April at her home in downtown Manhattan, where the two spoke about the trajectory of Solomon's career and her leitmotifs of ritual, religion, gender, and travel. As we moved into the final edits of this interview, Solomon, now eighty-five, was preparing for a trip to Israel, where *This Place* was opening at the Tel Aviv Museum of Art.

Francine Prose: **Can you remember the first picture you took that made you think, Oh, this is really something I want to do, this is going to be my life?**

Rosalind Fox Solomon: I didn't think, This is going to be my life, but I took a picture in Zagreb years ago and called it *Caged Woman*. It was a woman in a window, with some birds on the outside, and a birdcage on the inside. And it had a lot of meaning for me. I needed space to stretch and grow.

FP: **When was this?**

RFS: I took that picture in 1971 in Zagreb, Yugoslavia. In 1968, in Japan, I first started taking pictures. I was there on behalf of the Experiment in International Living, an international exchange organization based in Vermont. Earlier I had traveled to Belgium and France with the Experiment, when I graduated from Goucher College in 1951. At that time it was an international exchange program that sent Americans in groups of ten to European communities. The Experiment's motto was "We learn to live together by living together." In Japan, my hosts were a Japanese mother and son. I slept on a futon and shared meals with them, but our communication was limited because I didn't know Japanese. I started taking pictures as a way of talking to myself. I got the sensation of what it was to get something out through a camera that might represent what I was seeing and feeling.

FP: **Do you remember those early pictures of Japan?**

Engaged, near Jenin, 2011, from the series *THEM*

RFS: They weren't anything, really. I was awestruck by the differences between Japanese culture and our culture. Those first pictures that I took in 1968 were color, but I started taking black-and-white pictures soon after a friend of mine, who was a photographer at the *Chattanooga Times*, told me that black and white was more expressive than color. He helped me set up my darkroom. The thing that had a lot of personal resonance for me, and that I became very obsessive about, was photographing broken dolls. And that happened in the early '70s when I went to a market an hour or so from Chattanooga. There were tables of dolls, they'd just thrown these dolls on the table. There's a very famous photographer—

FP: **Hans Bellmer.**

RFS: I didn't know anything about Bellmer.

FP: **Good [*laughs*].**

RFS: He had a different attitude, of course. So, anyway, I did a huge series on the dolls in the early '70s.

FP: **What was it about the dolls?**

RFS: I was really living an exterior life. My husband was a shopping center developer. He wanted and expected me to entertain the real estate guys to help entice them to take leases in his shopping centers. That meant I spent tedious evenings with couples whose main interests were cooking and golf. My interests were different. I was involved with community affairs: the League of Women Voters and an adult education group. I began reading *The Feminine Mystique* [Betty Friedan, 1963]. The book made me more discontent. Photography seemed a worthwhile pursuit. I could have control over my work. Maybe the dolls expressed my feeling of just being a little broken. I did a huge series on them—and then I started doing portraits. I started photographing dolls close up and I learned how to take pictures of people that way.

FP: **The dolls didn't move, they didn't talk back. You didn't have to ask them anything.**

RFS: So I just kept photographing, and I learned how to work in the darkroom, and I would stay in the darkroom until two or three in the morning. I got deeply involved with what I was doing. I had a few artist friends who encouraged me. In the early '70s, I had a show of photographs that I had taken in Scottsboro, Alabama. The pictures were mounted at an artist cooperative in Chattanooga, Tennessee, where I lived at that time. I showed photographs of the dolls and also pictures of people. People came to the opening. They drank the wine and they ate the cheese, but nobody said a word about the pictures. I was crushed because nobody responded. I became withdrawn and quiet. I felt like I had lost my voice. After Jimmy Carter's election in

1976, my husband was asked to take a subcabinet position in the Carter government, as administrator of the General Services Administration. My husband had been active in local politics, was a commissioner on the Chattanooga Housing Authority, and worked on the Carter campaign. I was beginning a new project photographing and interviewing Tennessee doll collectors. At first I was distressed about moving, then I realized that life in a new environment was an opportunity for change. In D.C. we were invited to parties galore. There were place cards and I found myself seated between strangers. I was no longer mute.

FP: **You were taking pictures of Jimmy and Rosalynn Carter, right?**

RFS: I photographed Jimmy and Rosalynn during the election campaign, but in Washington, I got limited access. I rented a small space and set up a small darkroom. There was a closet where I rolled film and a bathroom where I developed it. I photographed outside the White House repeatedly, senators, congressmen, and artists— William Christenberry, Gene Davis, Sam Gilliam.

I visited and photographed William Eggleston in Memphis and drove around Mississippi photographing many of his relatives.

FP: **How did you start working with Lisette Model?**

Lisette was a strong influence. She was my mother in art.

RFS: Modernage lab led me to Lisette Model. Though I worked in the darkroom, I didn't know what I was doing. So when I got to New York, I took my film to the Modernage photo-lab and had prints made. I went to their Christmas party in 1971 or '72, and I met a photography agent, Henrietta Brackman. She made an appointment with me, saying, "Bring everything you've ever done." I said, "I can't. There's too much." She said, "You have to bring everything you've ever done." I brought two huge suitcases full of things, and after she looked at my pictures, she said, "You have talent but you need help. You should study with Lisette Model. She was Diane Arbus's teacher." Diane Arbus and Ansel Adams were the only photographers I had heard of at that time.

her work out had become more difficult. She talked about the work of other photographers—the ones she considered authentic and the ones whose work she did not like because it was commercial or derivative. I got impatient as I listened to her, but eventually, I realized that all of what she said was instructive. Finally, she would look at what I had done and critique the prints. Then she looked at my contact sheets to see what I had not chosen. She said to always go for the extreme. By this I think she meant, Be true to yourself as an artist. Don't censor yourself. Don't do your work to please others. She advised, Always make one picture you can give to a subject; otherwise be free in what you do. One of the most important things I learned from her was to take risks.

FP: **Did things change radically when you started working with her?**

RFS: I was in my early forties when I met her. Lisette was a strong influence. She was my mother in art. My birth mother was overly concerned about convention and propriety. Lisette was the opposite. She convinced me that the most important thing in my life was my work. She would say, "You need a close-up lens." And I'd say, "But that costs so much money." She'd say, "Can't you afford it, dahling?" She always pushed me to upgrade my darkroom, to get any kind of camera equipment that I needed, to keep moving ahead. And since my husband always felt it was important for me to buy modish clothes—he really cared about that— I knew that I could certainly afford to buy some camera equipment. I still remember a camera shop salesman who tried to convince me that I did not need to upgrade to a more professional enlarger. Lisette encouraged me to be oblivious to what people thought about me or my work.

FP: **You start off taking pictures of dolls. They don't talk. But when you begin to take pictures of the living, especially during festivals and rituals, what do you say to your subjects?**

RFS: I don't say very much.

FP: **You just started shooting?**

RFS: In the spring of 1978, I planned a week's trip to Guatemala with my husband. It was a vacation for him, and an opportunity for me to speak Spanish and take pictures in an environment far removed from life in Washington. After the initial trip, I went back a number of times. I traveled alone with a driver guide. This enabled me to get deeper into my work.

Even though I speak Spanish, I didn't say very much. I soon learned that if you engage very much, you lose a certain tension in the picture. Rather than make people feel at ease, I find that some tension between me and the person I am photographing yields something more complex. I always traveled with a local driver who spoke to people on my behalf as I began shooting. I carried

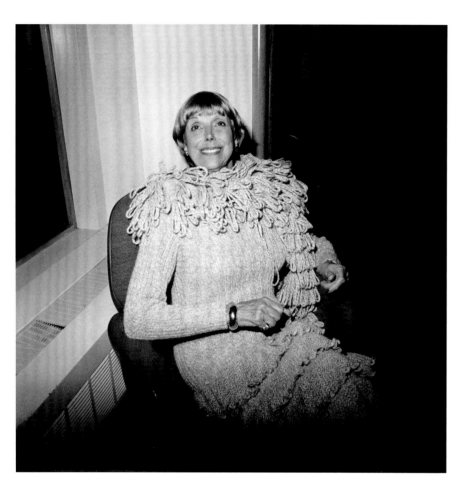

Joel Fanny Wellman, New York, 1977, from the series Women

I got in touch with Lisette and she said, "The next time you come, meet me and bring everything you've ever done."

FP: **You already had it packed in the suitcases.**

RFS: The next time I got to New York, I brought everything I'd ever done. Lisette came to my hotel room, and she looked at my pictures from six o'clock until midnight. Finally, she was too tired to go on, but she told me that I could study with her. Whenever my husband came to New York on business, I came with him and brought my pictures to show to Lisette.

FP: **And what did "studying" mean?**

RFS: Before we began, Lisette spent a half hour talking about herself and her career. She was blunt and though she had much success early on, getting

a Polaroid always and took pictures to give to people after I finished making my pictures. I also brought back proof prints on subsequent trips and gave them to people I had photographed.

I photographed shamans in Guatemala. There was a personal connection. My husband had a progressive congenital disease. Knowing that his mother, aunts, and an uncle had died of the disease, from the time that he found out during the first year of our marriage, I thought about this. I was interested in how other people dealt with sadness. In Guatemala, they coped with the help of shamans, ritual, religion. I encountered people who were in much more difficult circumstances than I could ever imagine. Once I was in a séance in Peru with two shamans, a man and a woman who were reputedly lovers. We were sitting around a little fire in a little hut for a coca séance. They incanted and sang, "Smoke your cigarette and cha-cha your coca." I told them that my husband was sick. I mean, I didn't really believe in this. I didn't believe in it but I just—

FP: **Everybody sort of believes in it.**

RFS: I thought maybe it would be helpful. So I told them about my husband and they took it very, very seriously. They told me that I had to get a guinea pig and rub the guinea pig on the body part that was injured or sick, and presumably the illness would pass into the guinea pig. So they told me to get a guinea pig and rub it over his body.

FP: **How did that play out when you got home?**

RFS: Well—

FP: **So when you found these drivers, you would say, "Do you know any shamans?"**

RFS: Yes. I photographed a lot of shamans in Guatemala. I also photographed landscapes, farmers, and Easter processions. In Peru, my driver was a twenty-two-year-old Chilean named Pablo. His parents had been supporters of Allende and they had gone to live in Germany after Allende was assassinated. Pablo went to Peru and married a Peruvian. Our first trip was idyllic. I had a lot of fun with him. The road up into the Andes was beautiful and untouched. We encountered women carrying spindles and weavers on the side of the road. In reality, people were living hard lives in a subsistence economy, but what was going on then was from another time. On my next trip with Pablo, I planned to photograph carnival celebrations. He sang revolutionary songs and stopped to use binoculars to look up into caves in the mountains. I began to think that he must be involved with the Shining Path [a Maoist guerrilla group]. We got rooms for the night in a pension in a small village. I got up in the middle of the night and went out into the van. I was scared.

At dawn, I went out in the street and talked to a woman, saying, "I'm with a driver and I don't have confidence in him." I was afraid to say anything more. She said, "Go to see the bishop." I told the

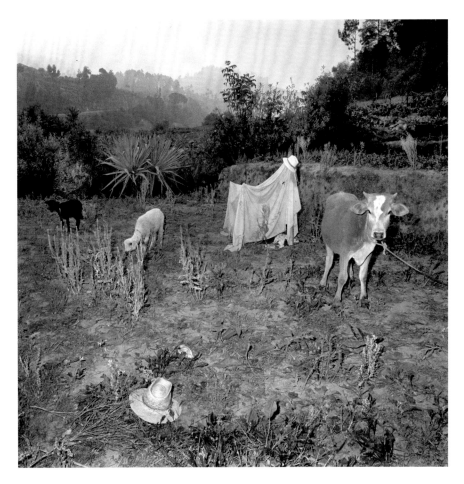

bishop that I had come to photograph carnival, but I had to leave my guide. He said, "Stay and take your pictures. We will help you." He introduced me to Madre Rosa Cedro. For a few weeks, I lived in a house belonging to the church that was near the convent and had meals with the nuns.

FP: **Is there a photo of her? Standing by a horse?**

RFS: Yes, I went with her on an overnight horseback trip to a remote area. I went back a number of times to that village.

FP: **Did your interest in illness and healing affect your work with people with AIDS?**

RFS: In 1988 in New York, I spent a year photographing people with AIDS that resulted in a show at the Grey Art Gallery. My interest in making portraits of people with AIDS was connected to the fact that

when my son was in his twenties, I got the heart-breaking news that he had inherited polycystic kidneys. (He had a kidney transplant six years ago and is now well.)

FP: **Most of your work has been documenting other cultures. When did you go to India?**

RFS: The first time was in the early '70s, with my husband. I was working with a 35mm camera. In 1981, I went on my own with a fellowship from the American Institute of Indian Studies. I went three years in a row to photograph in Calcutta, from '81 to '83.

FP: **Did you time your visits to coincide with festivals?**

RFS: Yes, I was there during the fall goddess festivals. But I also photographed the filmmaker Satyajit Ray, and other artists and poets. My guide's father had willed the family home to the goddess Kali. His brother left his wife and family and established an ashram in the family house where his followers came to worship. He became a guru. When the guru died, I was told that instead of cremating

him, they put him into a cage and dropped him into the Ganges, and they brought him up every year during the time of the Kali festival.

FP: **No!**

RFS: Honestly. I went back there.

FP: **What about *This Place*, the project in Israel and the West Bank that you began in 2010? What did you do there?**

RFS: The photographer Frédéric Brenner invited me to participate as one of twelve international photographers in a project, originally with the working title of *Israel: A Portrait in Progress*; the idea was to get twelve outside takes on this land with a long and layered history. We were all told to do our own work. I proposed photographing Israelis, Palestinians, and pilgrims. I centered some of my work around religious events and I made portraits of people wherever and whenever I could. I was interested in the unexpected. I had never photographed in a Muslim culture, and because I was painfully conscious of the fraught political situation in the country I wanted to know and

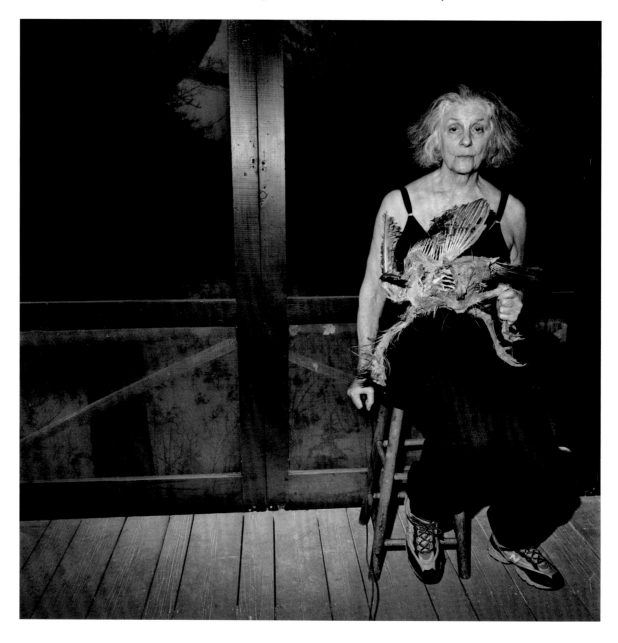

After 9/11, MacDowell Colony, New Hampshire, 2002, from the series Self-portraits

understand more. I spent several weeks in Jenin, on the West Bank.

FP: **I love those photographs of the two guys with the tattoos. There's a guy who has what seems to be a word or phrase in Arabic on his heart, and then there's a guy with a Jewish star on his arm.**

RFS: The man with the tattoo on his heart told me that his appearance was such that he could be taken for either Jewish or Muslim. On a bus, after a bombing in Gaza some years ago, he heard horrible things that affected him so much that he went through a long period of depression. My book *THEM*, published by MACK Books in 2014, includes some of what I heard as I worked on my project.

FP: **Did you go to Israel more than once?**

RFS: I made four trips to Israel during 2010 and 2011. I spent five months photographing for the project. Once I stayed for two months, which is a very long time to stay. It's hard to stay there for more than a few weeks.

FP: **Why?**

RFS: Because of the stress and the tension. You can't get away from it, and it's very heavy.

FP: **Did you know what you were looking for before you went?**

RFS: Not really. I had to write a proposal to say what I was going to do. I was interested in photographing people among groups not usually on the radar. Christians as well as Israelis and Palestinians feel a stake in Israel. I photographed some Christian rites, including pilgrims at the Field of Shepherds in Bethlehem and an Armenian Easter ritual at the Church of the Holy Sepulchre in Jerusalem. I also photographed Filipino caretakers of seniors, undocumented Africans, Africans who came from Sierra Leone twenty years ago as construction workers and whose children's first language is Hebrew. It was essential for me to spend time with Palestinians and to understand their lives. This was made possible by Marcus Vetter, a German filmmaker who rebuilt the Cinema Jenin and made films in the town, bringing Palestinian actors and technicians into the process. In Jerusalem and Tel Aviv, I photographed many Israelis. Some of them I met on the street or on the beach. They were strangers who agreed to be photographed. I met others through friends. I never knew how it would all come out. In the end, I chose the best photographs. Among them were some unpeopled images that helped with context.

FP: **There's a very beautiful picture of a mother and daughter. Is that right?**

Transformation, Bahia, Brazil, 1980, from the series Ritual

RFS: Yes, the close-up. That's Yaffa. She raised five children alone when her husband left to become "a religious." She acts in and directs a theater group made up of Israelis, Palestinians, and Africans.

FP: **What's it like, going through your archive? Looking back.**

Rather than make people feel at ease, I find that some tension between me and the person I am photographing yields something more complex.

RFS: I found frames on contact sheets that I had completely overlooked. I found proof prints that I didn't particularly value years ago. One is a picture of my mother wearing a dress with cascades of big loops around her neck, which reminds me of her critical eye, how she used to dis anyone who did not meet her standards. She'd say, "You can always tell a woman's age by looking at her neck." The photograph [see page 68] illustrates my mother's concern about her own neck. It also portrays her as an example of a woman who could say, "Women's lib will ruin everything." Before I regarded this as a picture of my mother; now I see it as an image of a woman of a certain era who happens to have been my mother.

FP: **Do you think that there are things you can do now that you couldn't do when you were younger?**

A Heart Tattoo, Tel Aviv, 2011,
from the series *THEM*

RFS: That's interesting. I was aware of it the whole time.

FP: Is there anything else you'd like the readers of *Aperture* to know?

RFS: Would it be strange to talk about my prints?

FP: No, not at all.

RFS: I just want to say that my printing has been very important to me over the years. That taking the pictures is just one part of the process, and producing the pictures involves a great deal. Interpretive printing is really important.

FP: Here's an impossible question. How do you know when you get it right with a print? When you get what you're looking for?

RFS: It just—I feel it. Even now I supervise somebody who works for me with digital printing. I don't do it hands-on, but I sit there, and I know that the picture has to be a tiny bit lighter, or needs more contrast. And when it's right, I just feel that it's right. It's an intuitive feeling. It might not be right for somebody else, but it's expressing what I want to express. It has always been an important part of my work as a photographer.

I've been talking about printing, but there's something else. When I photograph an individual, I want to connect with her or his interior. I'm not looking for the outer coating. I want a few moments when we stare into one another, exchanging our histories and feelings in a glance. Something in the way that a person looks at me is part of it, and I capture that. I want intensity. What I can project of myself—and what bounces back from the person I am facing—makes the picture. Sometimes it's just a moment, a moment of connection.

RFS: Probably. I do think there's some advantage in being older. For one thing, I think I can be more open. I mean, I was always honest with myself and in my work, but I have nothing to hide at this point in my life. Also at this stage I have some other interests that I want to pursue.

FP: Such as?

RFS: I am taking voice lessons. And I am taking dance workshops in Canada. I think about writing and telling my stories and I am working on a multimedia installation.

FP: Can you talk about your book of photos of Poland [*Polish Shadow*, 2006]?

RFS: I went to Poland in 1988 and photographed symbolic landscapes and signs. I photographed cemeteries, an apple orchard after Chernobyl, a little girls' dance class, and I made portraits. In general, the printing was dark. I felt darkness there in 1988. I photographed outside Majdanek camp and I visited Treblinka. When I went back to Poland in 2003, I returned to a different Poland, a Poland that had become part of the Western world. I visited Auschwitz, photographed in a mental hospital, made portraits of mothers and sons. I am Jewish, and though I had photographed in Catholic and Buddhist cultures, I had never addressed the Holocaust. I first went to Poland as a response to the acceleration of ethnic violence throughout the world.

FP: The Holocaust so permeates that book, but the book never says anything about it really.

Francine Prose is a Distinguished Visiting Writer at Bard College. Her latest novel, *Lovers at the Chameleon Club, Paris 1932* (2014), has recently appeared in paperback.

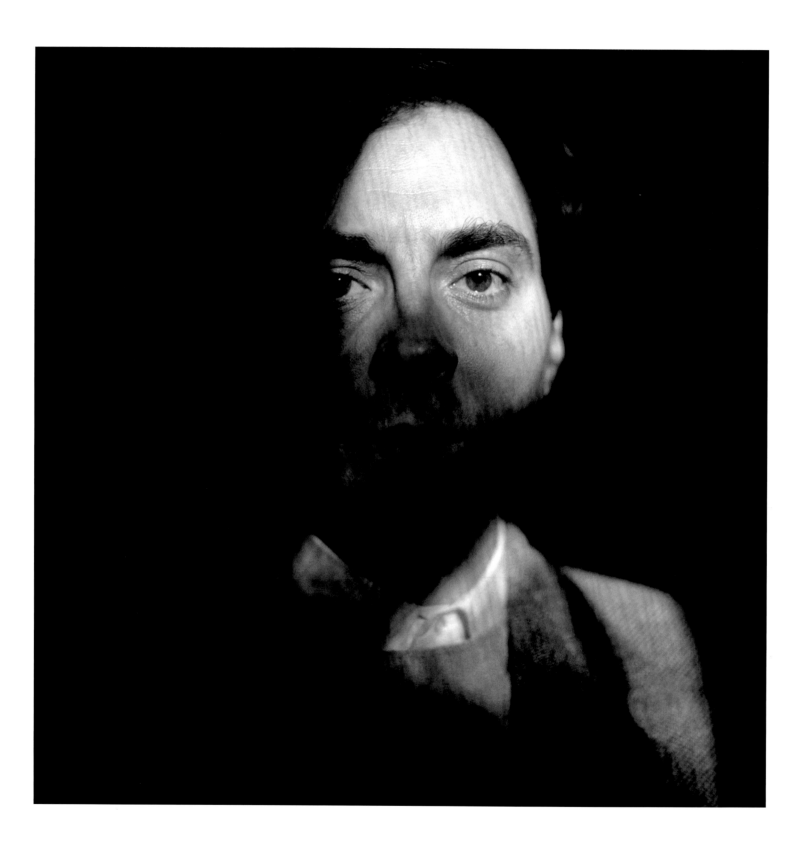

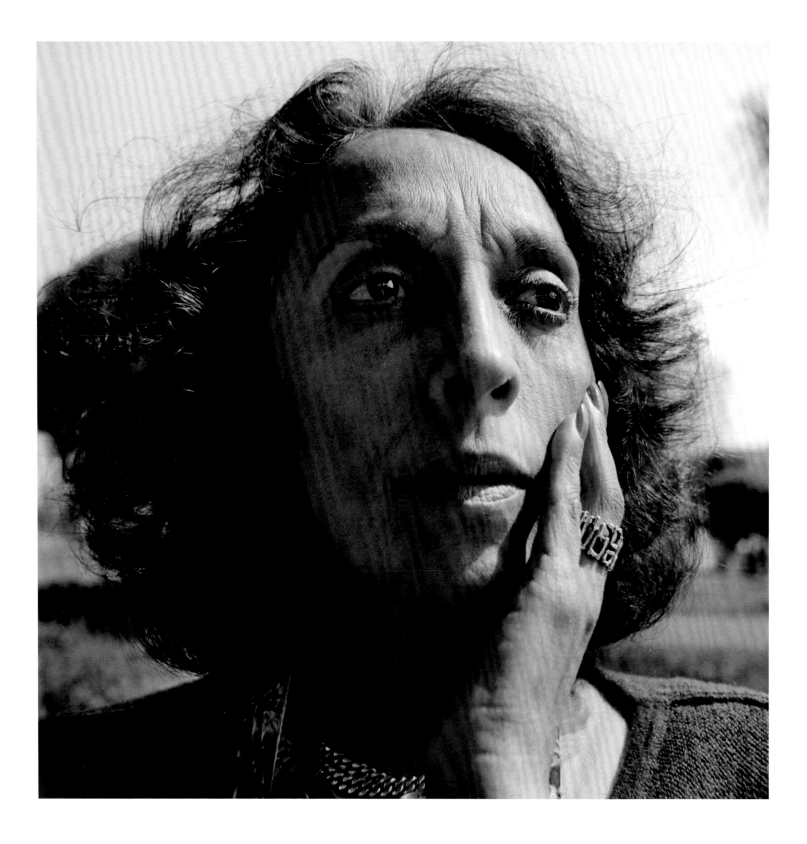

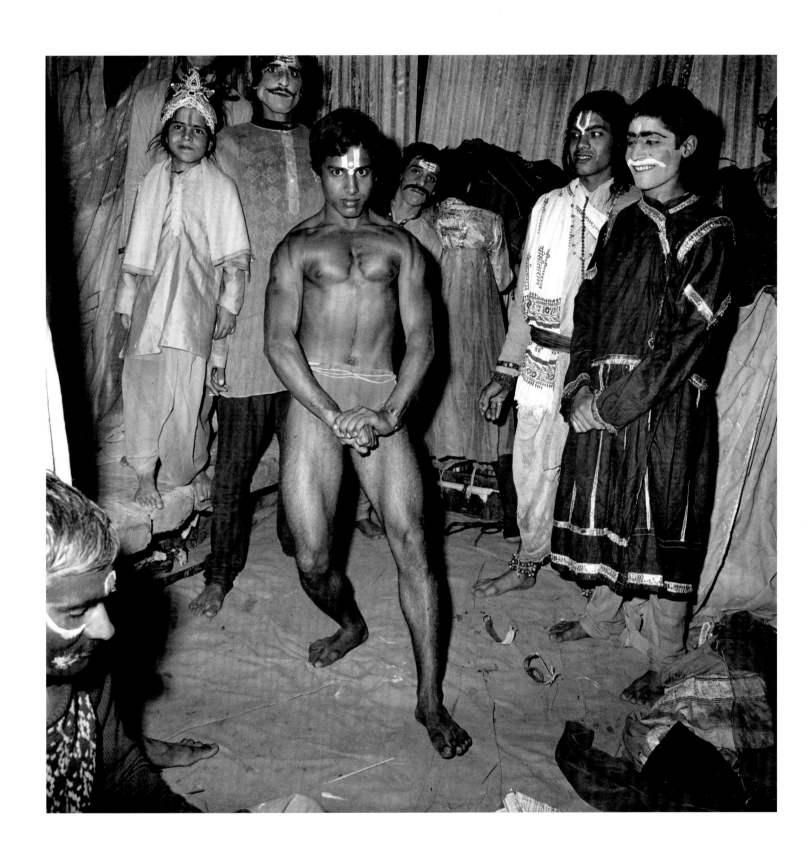

Backstage, India, 1981,
from the series *Ritual*
All photographs courtesy
Bruce Silverstein Gallery,
New York

Bertien van Manen

Interview by Kim Knoppers

Born in 1942, Bertien van Manen began her career in the 1970s as a fashion photographer. Commercial photography, however, soon left her wanting and unfulfilled; like many photographers of her generation, inspired by Robert Frank's *The Americans* (1958), she subsequently shifted toward an expressive and intimate documentary approach. Some of her earliest work addressed the lives of immigrant women in her home country, the Netherlands, and the curiosity that motivated that work prompted her to explore communities all over the world, from bootleggers in Appalachia to villagers in the former Soviet Union, for books including *A hundred summers, a hundred winters* (1994); *East Wind West Wind* (2001); *Let's sit down before we go* (2011); *Easter and Oak Trees* (2013); and *Moonshine* (2014). Her photographs, made on trips throughout Eastern Europe, Russia, Asia, the United States, and, most recently, Ireland, often focus on the human experience of undertaking a journey.

Although van Manen's work has been exhibited in many of the world's leading museums and is held in major collections, she remains something of a photographer's photographer. Of her unique snapshot sensibility, the Swedish photographer JH Engström notes: "If I'm distracted by all the photography out in the world, Bertien's work reminds me that photography is all about the heart."

For this issue, Kim Knoppers, curator at Foam, Amsterdam, visited van Manen at her home studio, located on the third floor of a classic canal house on Amsterdam's Keizersgracht, for a conversation about the path of her well-traveled career and what it means for her to revisit older bodies of work, including her mid-1970s Budapest photographs, which will form her next book project.

Kim Knoppers: You began making photographs in 1973, after you graduated from university, when you had a family with two small children. Why did you feel the urge to change tack?

Bertien van Manen: I'd done a lot of translation work and taught French, but I was continually at home. I wanted to get outside. While studying French at the University of Leiden, I worked as a model for a while. I lost interest in that and thought, I'll turn things around—I'm going to get behind the camera instead of being in front of it. That's when I started photographing my children.

We had a party at our house, and the fashion and advertising photographer Theo Noort was one of the guests. He saw my photographs and asked me to be his assistant. Later, I worked at an advertising studio in Amsterdam. I knew nothing about photography or how to develop film. I learned all that from Noort and the studio.

KK: **How did you end up as an independent fashion photographer?**

BVM: I first earned money as a photographer for the Dutch women's magazine *Viva*. There, I photographed Sylvia Kristel [the stylish star of the 1974 soft-core porn film *Emmanuelle*, one of the first erotic films to be released worldwide by a big Hollywood studio]. The story making the rounds in the Amsterdam bars was that at the age of sixteen Kristel had announced, "You wait and see: I'm going to be famous." She did a great deal to make that come true [*laughs*]. Kristel appeared in the first soft-core porn film and was naked all the time. I was one of few female photographers in fashion in Amsterdam. The models appreciated working with a woman instead of all those guys. They felt freer

and less like objects of desire. So I had an astonishing amount of work.

KK: **Why did you leave fashion again, this time as a photographer?**

BVM: In 1975, the photographer Kenneth Hope showed me *The Americans* by Robert Frank, and everything changed. How can you capture in words what he does? He wasn't at all in the business of making beautiful photographs, yet that's what they are. The coincidental, the inadvertent—I thought his photographs were magnificent. The roughness of his work and the absence of the spectacular appealed to me enormously. I immediately wanted to travel. The children were slightly older and I had the romantic idea to go to Budapest in the mid-'70s. It was such an old, baroque city that was then behind the Iron Curtain. I have showed the pictures I made there only twice: at the former Institut Néerlandais, in Paris, and in the magazine *Street Life*, the British equivalent of *Rolling Stone*. At the moment, I am revisiting this work.

Around this time, I burned my bridges at *Viva* because I was fed up with fashion—it was hollow—and went to work for *Avenue*, *Nieuwe Revu*, and *Panorama*. [*Avenue* was a Dutch fashion magazine inspired by *Vogue*, moving between popular and elite culture. Renowned writers and photographers were associated with it, such as W.F. Hermans, Cees Nooteboom, and Ed van der Elsken. In the 1970s *Nieuwe Revu* steered a left-wing, rebellious course perhaps best encapsulated as "socialism, sex, and sensation." Both *Nieuwe Revu* and *Panorama* are part of a strong Dutch tradition of social reportage.] But I was not very connected to the editors of these magazines. I took my photographs and delivered them. I felt more attached to the

Budapest Metro, 1976, from the series Budapest

scene around the leftist publication *De Groene Amsterdammer*. Photography in this magazine was actually marginal, but the editor in chief was impressed by my Budapest work and from that moment I worked regularly for him. This was toward the end of the '70s and the early '80s. Photography became more important for *De Groene Amsterdammer*, and Dutch photographers like Hans Aarsman, Taco Anema, and Han Singels were involved. Everyone who was left-oriented started at *De Groene Amsterdammer*. We had a good time at the office. Once I was asked to take a photograph of the editorial team behind their desks without clothes. I traveled with the Dutch writer Geert Mak to the United States to portray leftist Americans. We had to find them with a lantern [a Dutch expression].

KK: **What led you to embark on your first long-term, self-initiated project, *Vrouwen te Gast* (Women who are guests), in 1979?**

BVM: I had had enough of the hectic life of working for magazines. I wanted to have more time to make less superficial photographs. I saw the 1975 book *A Seventh Man: Migrant Workers in Europe* by John Berger, which portrays the lives of guest workers. There are photographs in it by Swiss photographer Jean Mohr, Berger's frequent collaborator. It remains relevant because the tension and effects of migrant labor are still major issues in Europe today. The introduction stated that unfortunately they hadn't gotten around to documenting the women. No wonder, since it was made by two men! They hadn't even made it through the door with the Muslim women.

That's my subject, I thought, and in 1979 I started working on *Vrouwen te Gast*. I didn't just photograph women who'd joined their husbands but also single women who'd come to the Netherlands to work. Suddenly those rural women were shut up alone in a tiny backroom apartment, unable to speak the language, and they sat there languishing behind closed curtains. I decided to group the women according to their countries of origin: Turkey, Italy, Spain, Morocco, Yugoslavia, Tunisia, Portugal, and Greece.

KK: **How did you manage to get into those women's homes?**

BVM: There were plenty of community centers for male immigrant guest workers. One center organized sewing lessons for their women. They helped me. The Muslim men wouldn't let their wives be photographed casually in the house; for them an "official portrait" was enough. In the end the combination of posed and more spontaneous photographs worked well.

The book was published by the feminist publishing house Sara in Amsterdam. I had to spend a full day there defending the order of my edit in front of a collective of eight women. Ultimately I persuaded them that my edit was best. In the last paragraph of my text for the book, I noted that the Dutch women's movement had

Turkish girls, Amsterdam, 1979, from the series *Vrouwen te Gast* (Women who are guests)

done nothing for immigrant women. The book was a success because it got all sorts of things started for these women who were invisible and to whom no one had ever paid any attention before. It really had an impact. Dutch language courses for women were organized. Neighbors went to visit the women in their homes. The immigrant women came out of isolation.

Those women were shut up alone, unable to speak the language.

KK: **Did you consider expanding the project to other countries?**

BVM: Along with photographer Catrien Ariëns, I was commissioned by the Rijksmuseum in Amsterdam to photograph the women's movement in the Netherlands. Eva Besnyö [Dutch-Hungarian photographer, 1910–2003] rang me. They'd asked her first but she was unavailable. I felt honored and

Budapest, 1976, from the series Budapest

whereas there they were still making dyes from plants and flowers. The decision to photograph in color was extremely important.

KK: How was it that you ended up in Russia?

BVM: I'd wanted to go to Russia for a very long time. My grandfather lived in a big house on a country estate in North Brabant, and there his relations from Poland and Russia would visit him regularly. One of them I was told to call Uncle Eugène, but he was really a cousin. As a little girl I found Uncle Eugène unbelievably exciting. That must have had something to do with it, unconsciously. In 1982 I went to Poland to make an editorial for *Vrij Nederland* [a Dutch magazine] about women living behind the Iron Curtain. I went with a philosopher of Polish descent who wrote the article. It was exciting because we brought fifty IUDs from a friend of my husband's who was a gynecologist. Women used medieval methods for birth control, like foam tablets. I must have a photograph of the small factory where they made these foam tablets. We were caught at the border, but after giving the customs official one of the IUDs for his wife, he let us enter Poland. The Russian influence there was huge, of course. In 1987 I traveled to Russia for the first time with a communist journalist from the British paper the *Morning Star*. By then I'd taken a course in Russian and could speak the language a little. We went to Donetsk, in eastern Ukraine, where there's so much conflict now, a coal-mining region. I was keen to photograph the miners.

I didn't succeed in Donetsk. The union, which was heavily controlled by the communist government, arranged for a beautiful table with a white cloth and a buffet of Russian food at a woman's house, and behind it stood a lady in traditional costume. It was a tourist attraction. One evening I literally broke out—I escaped from the people who were looking after me, the guards. During this time, the union was strongly orthodox and people were not allowed to talk to foreigners. I went and stood on the street and stuck up my hand. A car stopped and I said to the man at the wheel, "I want to go to where the *shakhtery*, the mineworkers, live." He took me there. But they weren't allowed to talk to foreigners, unfortunately.

I returned to Russia in 1989, to Moscow, to polish my Russian. My teacher asked if I'd like to come and live with his family. They had a spare room and it was a way for them to earn a little extra money. So that's what I did. He lived there with his parents. I stayed in his house for several weeks. In total I went back fourteen times and traveled through Russia, Moldavia, Kazakhstan, Uzbekistan, Ukraine, Tatarstan, and Georgia. I always stayed in the houses of local people who became friends. I wanted to grasp the beauty and the mystery of daily life. "I haven't seen you for a hundred summers, a hundred winters"—that's what people in Russia say when they haven't seen each other for a long time. It became the title of my book.

let myself be persuaded. But I'm not particularly proud of the book that came out of it. The texts are unbearable. For example, one of them explains what kind of ailments you get during menopause. I found myself in yet another of those halls full of gray-haired women in dungarees. Absolutely not photogenic.

KK: Do you regard the early period of your work as a learning process in which you grew and reached full maturity with *A hundred summers, a hundred winters* [photographs taken between 1990 and 1994 in Russia]?

BVM: Yes, although there are also some really good photographs in *Vrouwen te Gast*. For *A hundred summers, a hundred winters* I started in black and white. But that didn't work. Cartier-Bresson, and I don't know how many others, had made nostalgic black-and-white photographs in Russia, but I found the colors there so extraordinary. The colors of our Western clothing were synthetic,

KK: **The people in your photographs seem to forget they're being photographed. No doubt that has to do with the amateur compact cameras you use.**

BVM: I started off working with Leicas and Nikons, but one day they were stolen from my house in Amsterdam. I took compact cameras but with good lenses with me because it was safer. They were just little toys, so they didn't get stolen. People felt less threatened by them, anyhow. You're with a guest who also takes photos, rather than with a photographer who's your guest. I could leave them lying on the table and I always had about three of them with me. Sometimes people would start using the little cameras themselves. I was staying with Irina, who has since then become a good friend, and her aunt, and there were two boys of about ten. I arrived home in Amsterdam and looked at the contacts and thought: Was I so very drunk? Did I really make photos like that? Then I realized that the boys had been photographing each other, with bare bottoms and in other funny poses. Even the photograph of the little boy on top of the wardrobe that ended up in *Let's sit down before we go* was made by them.

KK: **I find it extraordinary that you can get so close to people without making the observer of the book feel like a voyeur. Is that something you make a conscious effort to achieve or is it intuitive?**

BVM: I'm always terrified I'm bothering people, and that they won't like me.

KK: **That's difficult, considering the kind of photographs you make, but it's probably also your strength.**

BVM: Yes, but sometimes the things I haven't done keep me awake at night. I was brought up in a very Catholic environment, of course, and I'm totally fascinated by all those Russian Orthodox churches. One day I heard music coming out of a church in the countryside. I went in and saw the priest standing there. All the women were on their knees in a line in front of him. My god, I didn't dare photograph that. I'm fearful of everything that has to do with the church.

KK: **The Polish journalist Ryszard Kapuściński wrote the foreword to *A hundred summers, a hundred winters*. How did that come about?**

BVM: Joseph Brodsky [the Russian-American writer] was supposed to write the foreword. He visited me here in Amsterdam and it was great to see how enthusiastic he was, but he fell ill and died. Kapuściński had written a book called *The Emperor* (1978), which I found tremendous. Not a bad replacement, but it's still a shame.

KK: **You said that your fascination with Russia is very personal. After the publication of**

Willem van Manen,
Bertien Eikenhorst, 1973,
from the series *Easter and
Oak Trees*

A hundred summers, a hundred winters, **you went to China to work on your next big project,** *East Wind West Wind* **[photographs made between 1997 and 2000]. Was there a similar personal link with China?**

BVM: My attention was turned in that direction by Paul Wombell, who at the time was director of the Photographers' Gallery in London. He was in Amsterdam and he invited me to put together an exhibition at his gallery, but I was in a black hole. *A hundred summers, a hundred winters* had been so intense. He suggested I should go to China because the country was changing so much. I went there ten times before I finally knew what I was looking for. I traveled to both the major cities in the east and south, as well as rural villages in the west, wanting to depict the daily life of common Chinese people. I always came back with beautiful calendar pictures, but that wasn't what I was after. The tenth time I was with my friend Xiao Feng at his friend's home, an apartment on the twentieth

Pjotr and his family, Apanas, Siberia, 1993, from the series Let's sit down before we go

floor in the city of Chongqing. We'd been inside all day. In the late afternoon we went out. We got onto the street and the heat, the crowds, and all those voices came flying at me. There was a buzz all around me. Suddenly I knew that I wanted to capture that vibrant feeling. I immediately started photographing things that at first you may not realize can be truly magnificent. One photograph was taken in a small movie theater where movies were shown twenty-four hours a day. Young people escaped their domestic environments and the gaze of their parents by going there.

"I haven't seen you for a hundred summers, a hundred winters"—that's what people in Russia say when they haven't seen each other for a long time.

KK: **All your books, with the exception of *Easter and Oak Trees*, which features black-and-white photographs of your family taken between 1970 and 1980, are set in areas and communities that are fairly closed.**

BVM: In Siberia I walked through a village and people came out of their houses to greet me and invited me in for a cup of tea. In China, in a small town in the north, they announced through the town's loudspeakers that a foreigner was around. "There's a white woman who looks different. She's

a person too, just like us. Leave her in peace and don't touch her." My guide translated it for me. I thought that was fantastic.

KK: **For *Let's sit down before we go* [photographs taken in Russia between 1991 and 2009] you asked the photographer Stephen Gill to go through all the contact sheets from your Russia archive. Why did you desire to look back?**

BVM: I kept coming upon photographs and thinking, Why isn't this in the book? There turned out to be far more intriguing photos than I'd expected. Of course I couldn't be sure, because they're my own photographs. So I asked Stephen. The expression "Let's sit down before we go" comes from the Orthodox Church. People would kneel for a moment to pray before starting out on long journeys with horses and carts, because there were all kinds of dangers along the way, such as wolves and Siberian snow. It's still the custom, but now they do it quickly as a kind of ritual. [*Van Manen demonstrates, briefly sitting down and then getting up again.*] I thought it was a good title for a project in which I too sit down and go through my archive. A moment of reflection.

KK: **The photographs in *Let's sit down before we go* were made in the same period as *A hundred summers, a hundred winters*, but they're very different in style. Why is that?**

BVM: Stephen Gill and I paid attention to different things in the editing. Twenty years had passed since I took the photographs. A development had taken place in photography and in myself. This book is far freer than *A hundred summers, a hundred winters*. At that time certain things weren't "allowed." The Robert Frank method was far from accepted by everyone in those days. Nothing was supposed to be in the picture that didn't "belong" there. Everything had to be neatly within the frame. Overexposure was a mortal sin. But overexposure produces a strange and exciting effect. In *Let's sit down before we go* imperfections became a unifying theme.

KK: You always get very close to other people. And you've said that you sometimes have difficulty with that, with taking such intimate pictures. *Easter and Oak Trees* is based on family photographs from your archive. You reveal yourself and your family during intimate, private moments. What is the setting for *Easter and Oak Trees*?

BVM: At Easter I usually went with my family to my grandfather's large country estate in the province of North Brabant. We have a favorite Joe Cocker song in the family, on the record *Mad Dogs & Englishmen*. At one point Joe Cocker says, "This izzzz Easter." He can say that really beautifully. And the estate is full of oak trees.

KK: Have you asked your children, now adults, what they think of the book?

BVM: They think it's beautiful, but they have mixed feelings about some of the photographs.

KK: Do you often find that people who end up in your books are ultimately shocked by how they appear?

BVM: People look so differently at themselves than the way I look at them. That's why it's often difficult when you send them the photographs. I think they look great, but there's always something wrong with their figure or with their chin. Nowadays, of course, there are so many opportunities to photograph yourself. Everyone makes some kind of glamour photograph so that they're shown to the best possible advantage and can direct every aspect. Those are of course very different types of photographs than the ones I make.

KK: *Moonshine*, your most recent project with MACK, is about mineworkers' families that you visited between 1985 and 2013 in the Appalachian Mountains in Kentucky, Tennessee, and West Virginia. Before that, you tried to get in touch with mineworkers in Donetsk. Why are you so interested in mining communities?

BVM: I grew up in the mining region of Heerlen, in the south of the Netherlands. My father worked at the state mines and I attended a local Catholic school where I was surrounded by miners' daughters. I often visited their homes and I loved it there. At my friends' houses everything happened in a little room where the windows were steamed up from soup on the stove. The mothers fascinated me. I found it so cozy there. At our place it was all a bit colder. I felt far more at home with those mineworkers' families. Also, my very first photography project was on miners in a little mining village in West Yorkshire, UK, called New Sharlston.

KK: For the last year and a half you have been photographing in Ireland. Do you have the feeling that you've already found what you're looking for there?

BVM: Actually, I do, though I go back to perfect it and to have more material to choose from.

KK: That's relatively quick compared with your other projects. Why do you think that might be?

BVM: For my other projects I photographed people in their own environment. That was my great fascination. In Ireland I dispensed with the people and reflected more on the atmosphere and on the death of my husband Willem. He died seven years ago. I photograph the Irish west coast a great deal: It is the end of Europe, the end of the world. It's about endlessness, about ruin and death. It's poetic and mythical.

At the moment I'm reading everything I can get my hands on about Ireland. Much of the literature from Ireland is about families with lots of children, steamy relationships, Catholicism, a father who drinks and tyrannizes and lashes out. The mother is kind and cares for the children. There are of course beautiful lines about nature, by novelists like John McGahern, or about the sea, by John Banville. Or by poets like Michael Longley, with his poetic everyday directness, or Seamus Heaney, whose poems sometimes are mythical and go back to anonymous early Irish lyrics. But I also read a lot of French and German literature. There's now a little French bookshop two streets away from me and it's wonderful. I need literature when I'm traveling. Fyodor Dostoyevsky, Bulgakov, Gogol— all those magnificent Russian books. They've all become friends of mine.

Translated from the Dutch by Liz Waters.

Kim Knoppers is curator at Foam (Fotografiemuseum Amsterdam).

Opposite, top:
*Couple and painting,
Grooves Bar, Shanghai,* 1998,
from the series *East Wind
West Wind*

Opposite, bottom:
Weifang Travelling Yangsu,
1997, from the series *East Wind
West Wind*

This page:
Kendra, Kentucky, 2007,
from the series *Moonshine*

Tullan Beach, Donegal, **2014,**
from the series *Ireland*
All photographs courtesy Yancey
Richardson Gallery, New York

Bruce Davidson

Interview by Charlotte Cotton

"Too much in photography is shoot and leave," Bruce Davidson says in his conversation with curator Charlotte Cotton. Indeed, Davidson is often intent on looking back—not out of nostalgia for the past but rather to follow the course of his subjects' lives. This has been the case with those he photographed in a number of his first and most acclaimed series, including *Brooklyn Gang* (1959); his work documenting the civil rights movement, the 1965 Selma march and the March on Washington two years earlier; and his project *East 100th Street* (1966–68), on the lives of Harlem residents. Davidson began photographing as a teenager in Illinois, transforming a closet into a darkroom and apprenticing at a local camera shop. While stationed in the military in France in the 1950s, he met Henri Cartier-Bresson, who invited him to join the Magnum agency in 1958. Davidson modestly sums up what defines his ability to connect with his subjects: "It's about trying to be a human being," he says.

Now eighty-one, even as he describes ideas for his next photographs, Davidson has been looking back again, this time through his archive, revisiting older bodies of work. Steidl has released a number of new volumes, including *Los Angeles 1964* (2015), which may be a revelation for viewers who associate Davidson with New York City, a perennial subject of his. For this interview, Cotton visited Davidson at his home on Manhattan's Upper West Side last April. There the two spoke about his early infatuation with picture making, about walking the streets of Paris with Cartier-Bresson, and of the constant photographic challenge of getting past the obvious.

Charlotte Cotton: **I read recently that in the process of recalling a memory, we literally reposition that memory in a new place in our neural systems, among new experiences— a new context. I find it a really liberating thing to think about, that we are constantly renewing moments from our past. What do you think of that idea?**

Bruce Davidson: That means time hasn't affected the way I see, or what I see, or the joy in seeing. I live with a camera now in exactly the same way I did when I was sixteen. That hasn't left me—that memory, that boyhood with photography.

CC: **What were you like at sixteen?**

BD: Most young boys have a buddy. I had a camera. I was pretty much a loner, and I was doomed to failure because I wasn't interested in anything other than taking pictures and developing them in my darkroom.

CC: **When did this start for you?**

BD: When I was old enough to take the El train into Chicago to take pictures and come home before dark. My mother allowed me to do that.

Once she remarried, her husband was a lieutenant commander in the navy and he, like other lieutenant commanders, was given a Kodak camera, which was like a big Leica—it was a range-finder camera. It was quite something. Some of those pictures have survived. The joy of photographing sustains me.

CC: **Where would you go to photograph when you were a teenager?**

BD: I would go down to Maxwell Street, which was a flea market. Or Michigan Avenue, the Rookery Building lit up at night. There's a picture of a woman with a babushka in the flea market from 1950. That meant something to me. Maybe I saw a woman in my family wearing a babushka. But I knew that this person was an immigrant— not homeless, but almost homeless. When I was fifteen and my mother remarried, we moved into a fancy house across from a forest preserve and I would go into the forest to take pictures. I came upon a trailside museum and they had a baby owl sanctuary. And I took a close-up picture. When I was fifteen, I entered the Eastman Kodak high school snapshot contest with that picture, and won first prize in the animal division. Owls live a long time, so recently I called the museum and they said, "Well, if it was forty years ago, we'd say the owl is here, but it's been over sixty years since you took that photograph and we don't think that any of our owls are that old."

CC: **It sounds like your interest in photography and the change of circumstance for you and your mother coincided.**

BD: My mother remarried when I was about fifteen and I became interested in photography at ten. I received my first good camera for my bar mitzvah. This was during World War II. I knew it was going to be a good camera. I was so excited about it that I forgot the last four lines of my haftarah and made it up.

I actually started taking and developing photographs when I was ten years old. I was waiting to join a basketball game and a friend called Sammy Nichols said, "Do you want to see developing in my basement?" I said, "What's developing?" So I went into this Midwestern, dark, dank basement. There was a red light. He flashed a piece of paper and put it in a tray of what looked like water to me, and an image appeared. And that image coming out of nothing excited me to such an extent that I ran home and asked my mother if she would empty my grandmother's jelly closet— which was small, but big enough for me. And she did. So that was the beginning. I wrote "Bruce's Photo Shop" in black paint on the door.

CC: **How did you develop your skills as a photographer when you were young?**

BD: There was a camera store in town—Austin Camera. They took me on as a stock boy: I dusted the cameras, cleaned the toilets and the floors.

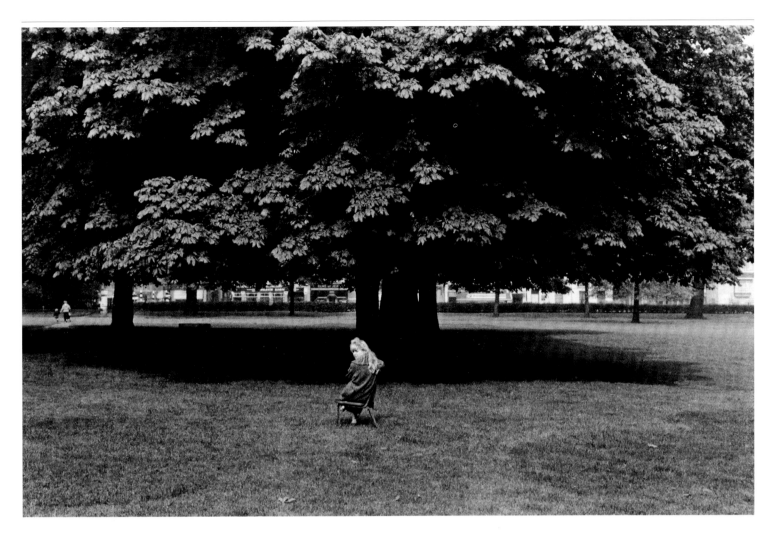

*Blonde girl sitting in the park,
London, 1960*

And an old country gentleman came in. His name was Al Cox and he had a studio in the town. He told me, "Anytime you want to come by, kid, I'm there." So I did. He was an incredible craftsman. First of all, he could make dye-transfer prints, so I was exposed to the process. He was a commercial photographer working for the newspaper and I'd go along with him. He would shoot with a Rolleiflex and a flash. Whenever my mother called to find me, I was always with Al Cox. When I was admitted to RIT [Rochester Institute of Technology], Al read somewhere that the first thing I would be doing was pinhole photography, so he made me a pinhole camera with interchangeable pinholes. So he sent me off to college. He could also build strobes and was a ham radio operator. He was a genius old guy—he was an old guy to me.

CC: **Tell me about the relationship you were forming with cameras and all the material stuff of photography, like chemicals. It's one thing—which I'm sure we will come back to— to think of photographic capture, of looking and learning about the world through photography. But it sounds like you were also learning through Al Cox about technology and materials of photography and about how to render something, not just capture it.**

BD: It meant a lot to me. I bought an old 35mm Contax camera when I was at RIT. Walking the streets at Rochester, I found the Lighthouse Mission. It was very atmospheric—a place where

these vagrant men would come to get a bologna sandwich and listen to the sermons. I was already exposed to the idea of not a picture but a series.

CC: **And that would have meant the picture magazines at that time, such as *Time*?**

BD: Well, yes. My hero was Gene Smith [W. Eugene Smith]. There were two young women in my class at RIT and one of them had a copy of Henri Cartier-Bresson's 1952 book *The Decisive Moment*, and she showed it to me. There was also an inspiring teacher, Ralph Hattersley. He showed us Smith, Cartier-Bresson, Irving Penn, and others. This really sent me in that direction—not imitating, but finding the way I wanted to photograph.

I go in and it's a blank canvas that I have to work with. I start without preconceiving.

CC: **What did you feel you were seeing in Cartier-Bresson's photographs? What resonated with you?**

BD: The way he saw life. Life was moving; the world was in flux.

CC: **So did this feel attainable to you—did figures like Smith and Cartier-Bresson seem close to you?**

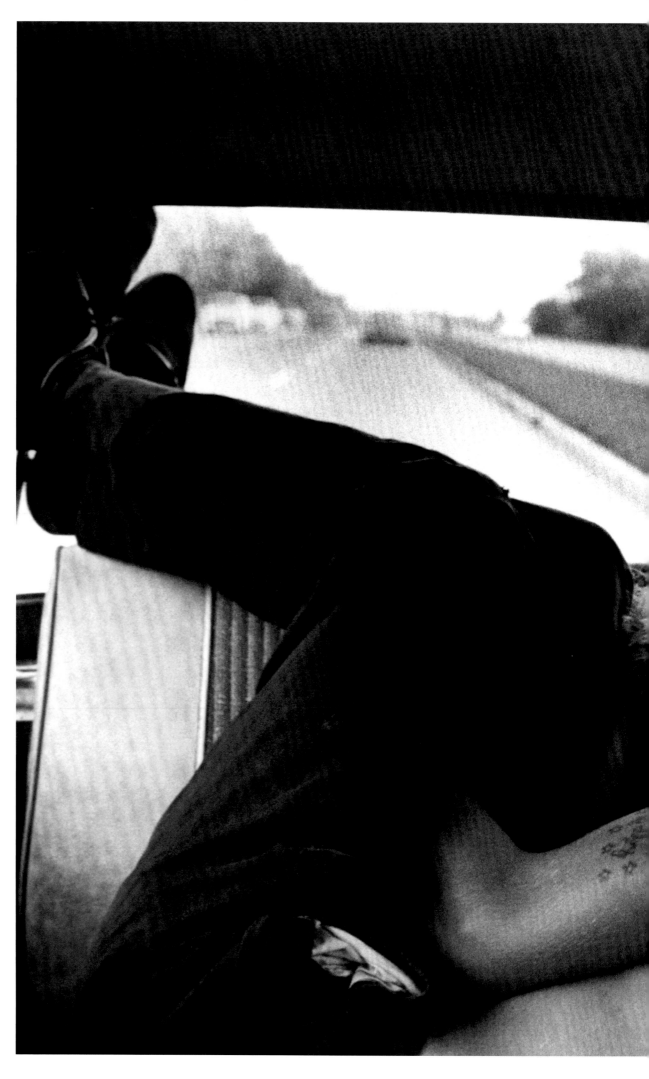

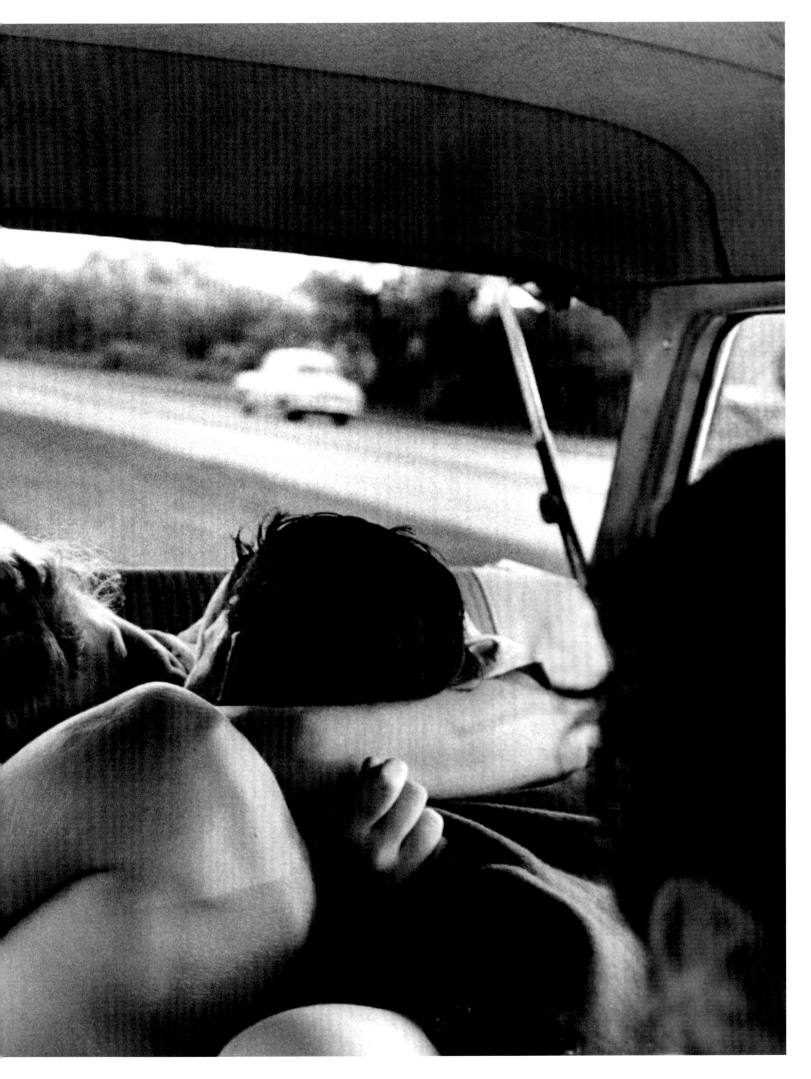

BD: Oh yes. There was a gallery in New York called the Witkin Gallery. And Gene Smith used to go there. I used to go up to the gallery and see him and I just couldn't say anything. He saw that I was doing good work but I couldn't touch him. Later I really got to know Cartier-Bresson. After college at RIT, I spent some time in the photography department at Yale—I was in the graphic designer Herbert Matter's class. I was drafted and sent to the Arizona desert, but before I went I photographed the Yale football team, not the game, but the tension and the mood among the players. I submitted the pictures to *Life* magazine. A year went by, and then they ran them. The captain in charge of the labs had been in the barbershop and had seen my pictures in *Life*. He burst into the darkroom and said, "Private, did you take these pictures?" I said, "Yes, sir, I did." And he said, "Take that mop away, you are photographing the general this afternoon." That was a *real* decisive moment. Somehow, I got really lucky and I was sent to the photo-labs for the Signal Corps in Paris. I was in the supreme headquarters in Paris and there were French soldiers in this international camp and I took up a friendship with a French soldier who was a painter. He took me home to his mother's house in Montmartre to have lunch. And that's when I saw the widow hobbling up the street. "This woman lives above us in a garret," he told me, "and she knew Toulouse-Lautrec and Gauguin." I had a motor scooter, so I would go up from the fort to Montmartre to photograph her. That's when I submitted my work to Cartier-Bresson at the Magnum Paris office. It took a couple of weeks before I got an appointment with him. He was very interested in the contact sheets and the rhythm implicit in shooting. Then I walked outside with him and it was like the street was made up of his pictures. All those moments were there if you could just take a chance.

CC: **From a young age you seem to have intuitively known how not to take the obvious shot.**

BD: I think I'm a less intellectual photographer. I go in and it's a blank canvas that I have to work with. I start without preconceiving—at least that is true of the work I have made that counts. I have to find my way into a subject—like the Brooklyn teenagers I photographed in 1959 (I published the work as *Brooklyn Gang* in 1998). It's a little different for me because I often come back to the scene of the crime. For instance, Emily [Haas Davidson, Davidson's wife] was interviewing Bobby Powers— the leader of the gang—for over ten years and got to know things that I didn't. I knew his life was depressed but I didn't know that they lived in alcoholic poverty, or that his mother had seven children. Emily dug all of this out in her research for *Bobby's Book* (2012); her full interviews and my pictures could make another book in their own right, with new information. It was a mood of isolation and the feeling of those kids—although they are now about seventy-five years old, those that are left. About four years ago I was looking at my contact sheets from Brooklyn and there was a picture of a woman smoking and crossing the street with the church in the background. I showed it to Bobby and he said, "That's my mom."

CC: **So you do go back.**

BD: Sometimes. It's a growing realization that maybe a photograph doesn't end there. In 1965 I photographed the Selma march. I was introduced to a woman named Annie Blackman, and took a picture of her holding her child. She had seven children or so, and Felicia was her youngest. In 2002 I went back on my own to Selma and found many of the people I had previously photographed.

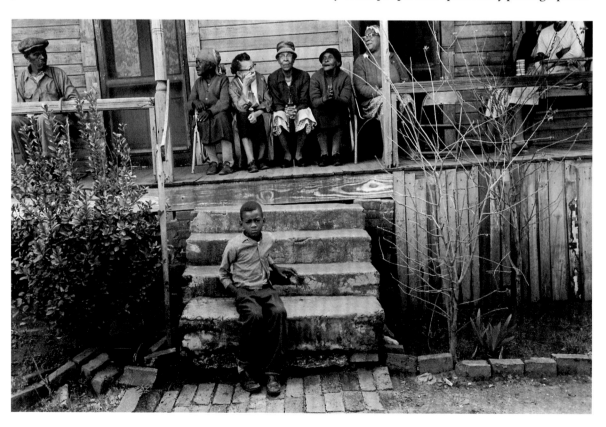

Selma, Alabama, 1965,
from the series *Time of Change*

I was most pleased to find Mrs. Blackman's children, many of whom were still living in the same area, and learn how their lives had changed for the better as a result of the civil rights movement. Felicia is now an insurance agent working with local farmers. So that would be one instance of returning to find out where someone ended up. There will be others; I just have to find them. I have a record of them all, and I met everybody. Too much in photography is shoot and leave.

CC: **Have you been following the conversation about what's been happening in Baltimore, Ferguson, New York—there's talk that we are entering a new chapter of the civil rights movement.**

BD: Oh, yeah. But we've heard this story before in Watts [the Watts riots, 1965]. This is about young people, young kids who have nothing in their life except a pent-up violence, because there's nothing there for them. Jobs, schooling, education, housing—it's not there for them. Once you crush the atoms, they're going to explode.

CC: **How does your approach to social engagement relate to caring about people you've photographed?**

BD: It's about trying to be a human being.

CC: **I suppose that's the permission the camera gives you—to really look at something, to get close to someone and have a connection.**

BD: It can be a good thing or a disaster. It's always a challenge to get beyond the obvious.

CC: **Like the Yale football pictures, you clearly knew what you _didn't_ want the pictures to be.**

BD: Well, I had an epiphany. It was my thesis work, and Herbert Matter allowed me to do that as my project. I remember I had an appointment to meet Coach [Jordan] Olivar and he said, "Son, you are much too small for Yale football." I said, "Well, sir, I really just want to photograph the tension that's implicit in that kind of combat." And I never saw the game, because my back was always to the field. I was much more interested in the guys on the bench, or during halftime and seeing all the bandaged players.

CC: **That's quite a willful way to take pictures— your criteria are definitely your own. Is that your personality?**

BD: I think that if you watch a seven-year-old playing—putting together their Lego or superhero toys—I'm not much different. I look at my grandson and think, That's exactly what I do— I try to put all the parts together. I have fun. It's just me and reality. Emily and I have been married forty-six years now; she has worked on a lot of projects. When we were first married, I was ending my project on East 100th Street.

James Duffy and Sons
Circus, Ireland, 1967,
from the series *Circus*

So I decided to take Emily to a circus in Ireland—Duffy's Circus—on our honeymoon. We're going to a place where it rains every day? With circus people? But it worked out well [*laughs*]. I wanted to take a picture by climbing up to the top of the tent to look down at the trapeze artist. And Emily was below holding a strobe light, but she had the strobe facing the wrong way. So I wrote on a little piece of paper, "Move light left," and I dropped it down and she thought it was something from heaven, that she must get it. She turned it over, looked up, and said, "Okay, okay." It reminded me of *La Strada* [film by Federico Fellini, 1954]; she was my Gelsomina.

CC: **You've given me a good sense of the beginnings of projects, as not being preconceived, and that you are really open to what is in front of you. I'd like to know more about completing projects. When and how do you know that they are finished?**

BD: When you can't do it anymore. You have to be careful not to do something that will stop it in the middle. Like any relationship, you can lose the passion that's provided you with the excitement to photograph. And there's the challenge of

continuing to find something when that excitement isn't there anymore. I don't have the time now to wait as much, so I have to give up. In gaining something you may lose something.

CC: **And I guess it is also a question of sustaining the motivation to work with a subject. I mean, when I come away from seeing you, I always feel that we talk about human beings, fairness, seeing things—a very personal version of the political. Some of your projects are outwardly political, and they clearly express a view about the world.**

I try to put all the parts together. I have fun. It's just me and reality.

BD: Everything is political. If you burp—it's political. The difference between myself and my daughter Anna is that she is a farmer, and she's married to a farmer, so farmers see her as a farmer, not a photographer. So they are very comfortable with her taking photographs. I didn't have to be black or Puerto Rican to take photographs on East 100th Street, I just had to stay there long enough for people to understand what I was about. And I still, to some extent, have a relationship with those people.

CC: **Are you expecting us to read that into your work—not, as you say, that you speak from**

the position of an activist exactly, but that you believe people should see and acknowledge what you are seeing?

BD: That's what my Los Angeles photographs of the foothills (2008–13) are all about. It's beautiful, set against the city grid. I was thinking today that it's not going to be my most known work, but you have to give me credit for going from the East to the West Coast. I enjoy nature, and getting out there. And even if these photographs don't end up hanging in museums, they are about me and about being really free. I stayed at an apartment hotel in Santa Monica. I bought a dark cloth and turned the closet into a darkroom.

CC: **You have a history of closet darkrooms!**

BD: It's an old 1940s hotel with a kidney-shaped swimming pool, and with huge closets. That became my darkroom for loading film. So my assistant would pick me up at 9 AM—

CC: **Well, I remember that you were often getting up to photograph much earlier than that—I was really struck by how hard you work. I was quite exhausted by your schedule from a distance!**

BD: It is hard. Because it's about light and finding a place to photograph with a few shots. At the end of the day, I'm exhausted; I get some food and go back, and I'm famished. I have to eat and then I fall asleep, then I get up at 2 AM, wash my hands,

Santa Monica Beach, Los Angeles, 2008, from the series *Nature of Los Angeles*

load the film into my camera ... so that cycle is really healthy for me [*laughs*]. I can't manufacture an idea. There has to be something—a tension. I'm thinking of photographing different parts of New York City, to find things. It will be in color—it has to be simple, and during the day, because we will be walking around. Like, on the corner here, there is an Egyptian father and two sons with a coffee van. They make the best coffee around. It's a dollar a shot—we get three dollars' worth every morning. I like to know where they came from; I like the way that they almost dance as they work. But I haven't taken the photographs. Yet.

CC: **Your *Los Angeles 1964* project is about to be released.**

BD: When *Esquire* asked me to go photograph LA [in 1964], I didn't know anything about LA. I get there, and you need a car, and it's smoky; your eyes tear, the pollution, and people are sort of catatonic, in a way. So I photographed that. I handed them in to *Esquire*, and they didn't know what they were about. It wasn't the LA they were looking for. So they returned all the pictures to me, and they sat in my drawers for years. They evolved, once we understood the hostility in that city at that time.

When I came back to LA, twenty or thirty years later, it was different. I saw it in terms of a landscape. Take the Hollywood sign, for example. Everyone looks at it and takes a picture of it. I managed to find someone who could place me behind it. So I was photographing what it sees, and what it sees is a scrub desert. I explored the hills in relationship to the highways—the highway grid. I began to see the grid in terms of the nature that surrounded it, and the beach, but the beach allowed parking on the dunes, on the sand. In LA the beach is a parking spot. Anyway, later I explored those things. The rich vegetation, the desert, the foothills, and the beauty of the palm trees. I thought the palm trees were a poem.

CC: **You're originally from the Midwest, but I think of you as a true New Yorker, and New York has been a perennial focus in your work, including Brooklyn gangs, and the subway, and Central Park. Could you comment a little bit, just in contrast to LA, for example, about New York as a subject?**

BD: I always start with a blank canvas. Every body of work comes out of a different state of mind, and I really have to be in a state of mind to be drawn into this black hole of reality.

CC: **How would you describe that state of mind?**

BD: You have to feel some pressure, something that you need to find, something that's calling you. In the subway, it was the movement and the color of movement. The subway became a studio for me. It was a place where I'd go every day just to discover whatever it is that I'm allowed to see.

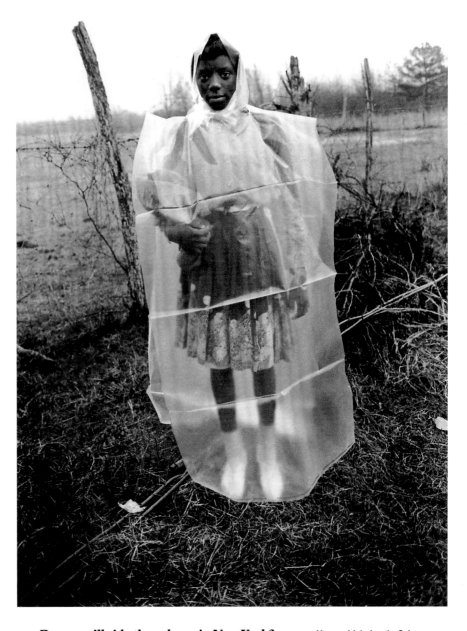

CC: **Do you still ride the subway in New York?**

BD: Oh, yeah. And I still get lost.

CC: **I'm also thinking about all of the disciplined work you have been doing over the past few years going through your archive, selecting and printing, and, of course, publishing with Steidl. What do you think you have learned in the process of looking at your archive?**

BD: There are surprises. Sometimes I come across a pile of pictures that I have overlooked. Now, we are discovering pictures of myself [*laughs*]. It's very before and after. But there are an awful lot of pictures to be made, and as long as I can physically do it, it's great. It was only when I turned eighty that I said, "My god, I have turned a corner in my life ... eighty is almost ninety. Maybe I should get a digital camera, and I'll just go places, and no one will see these pictures."

Young girl during the Selma march, Alabama, 1965, from the series Time of Change

Charlotte Cotton is a writer and curator based in New York. ● Her book *Photography Is Magic* will be published by Aperture in September.

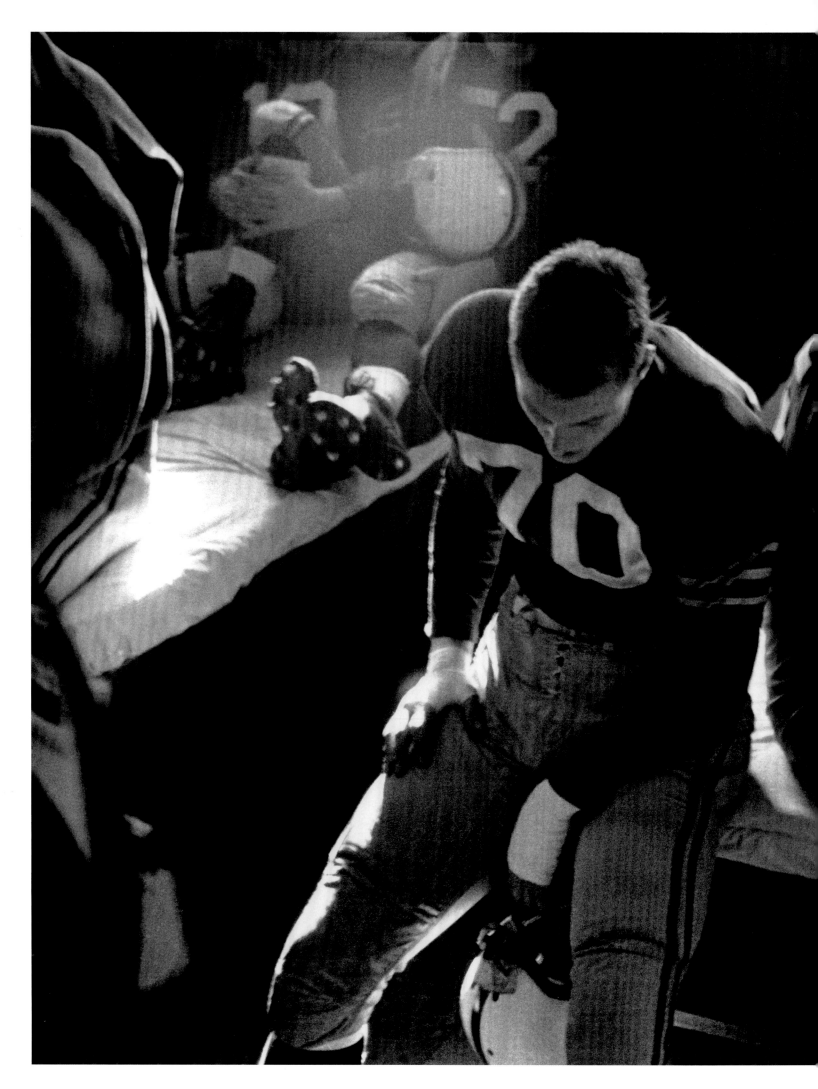

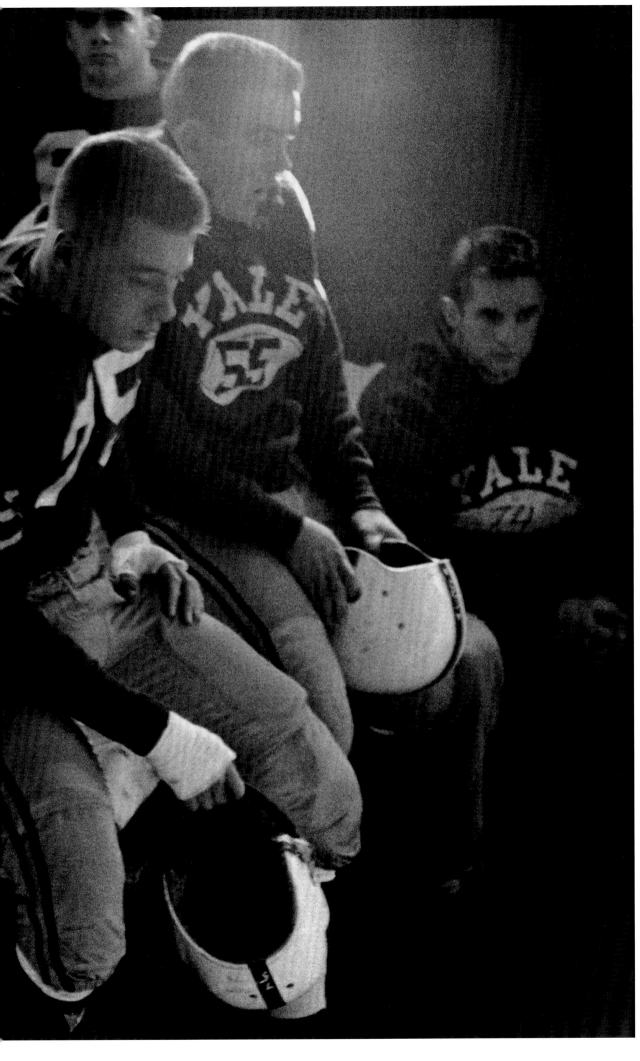

Yale football, New Haven,
Connecticut, 1954,
from the series *Yale Football*
All photographs © Bruce Davidson/
Magnum Photos

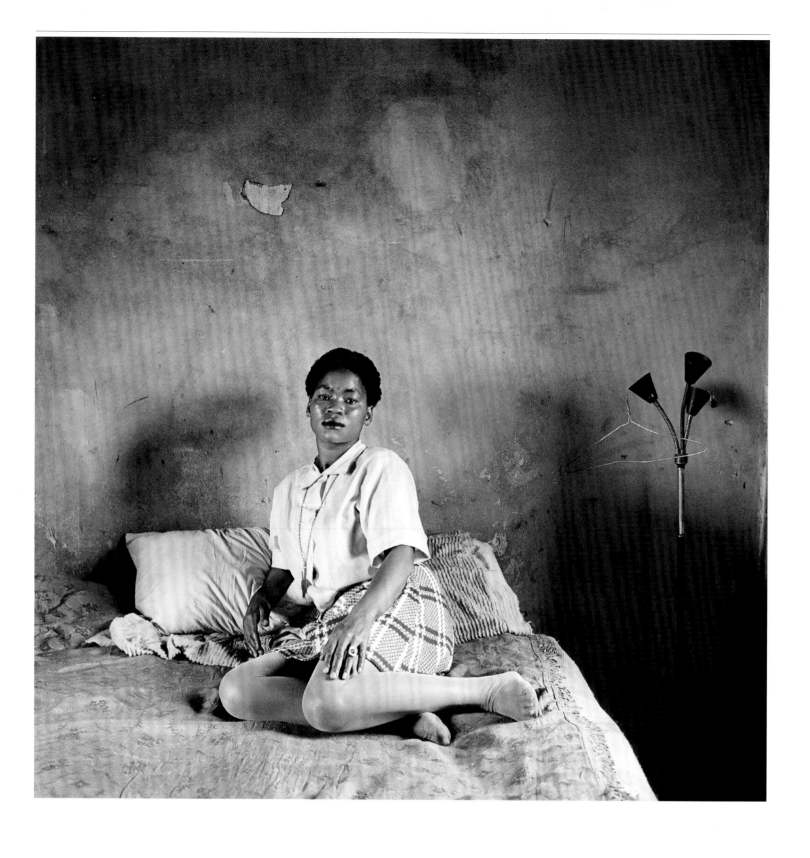

Mrs. Miriam Diale in her bedroom,
5357 Orlando East, Soweto,
October 1972, from the series
Soweto

David Goldblatt

Interview by Jonathan Cane

"Events in themselves are not so much interesting to me as the conditions that led to the events," David Goldblatt says to interviewer Jonathan Cane. While other photographers have focused on the turmoil of South Africa's colonial and apartheid years, Goldblatt, who is now eighty-four, tends to train his lens on quieter subjects emblematic of the prevailing social order. He will soon be republishing his series *In Boksburg* (1979–80), in which he looked at daily life in a white middle-class community in the years of apartheid. Among his many series are *Some Afrikaners Photographed* (1961–68); *On the Mines* (1973), documenting South Africa's mining industry; and *The Transported of KwaNdebele* (1989), addressing the plight of black workers forced to travel great distances for employment. More recently, for *Ex-Offenders* (2010–present), he photographs individuals on parole at the scene of their crimes.

 The conversation that follows took place last May at Goldblatt's home in an old Johannesburg suburb; like much of Goldblatt's work, it was framed by events in the news—the controversy over a statue of Cecil John Rhodes, the mining magnate and imperialist symbol, at the University of Cape Town, for instance. In protest of the university's faculty, overwhelmingly dominated by white men, an activist threw human feces on the Rhodes statue in March 2015; the statue was subsequently removed, and has since become a symbol for "decolonizing" the university. This concern with monuments has been central to Goldblatt's work for many years. Also happening around the time of Goldblatt and Cane's talks were xenophobic conflagrations across South Africa—deeply unsettling violence involving exiles and refugees from other African countries. The photojournalism documenting these recent conflicts throws into relief the incisive work Goldblatt made during the most violent times in South Africa, and which he continues to make still.

Jonathan Cane: **You've photographed many walls, fences, boundaries. I think of your 1986 photograph *Die Heldeakker, The Heroes' Acre: cemetery for White members of the security forces killed in "The Total Onslaught," Ventersdorp, Transvaal* [see page 112], or any of the precast fences in your iconic book *In Boksburg* (1982).**

David Goldblatt: They occur in my work because they are part of our life, absolutely. But I haven't particularly sought them out. I am very conscious when I drive around the country of the number of game fences we have, and what the effect of those are, and I have photographed those. A lot of farmers have switched to farming with game, because they save on labor and they are able then to fence off their land in such a way that they make it virtually impossible for people to walk over it, and to use their land as a means of getting from point A to point B, never mind doing anything else on the land. So there are these very high fences dotted around the country now, many of them electrified, and it's not clear to me whether the electrification is to keep the game from moving too close to the fence or to keep people out.

JC: **You live in a gated community, which is typical in South Africa. How do you feel about that?**

DG: I feel very negative about it. We have a boom at the only motorcar entrance in the suburb, and a guard there, and by municipal regulation he's not allowed to stop anybody, so it's meaningless, really.

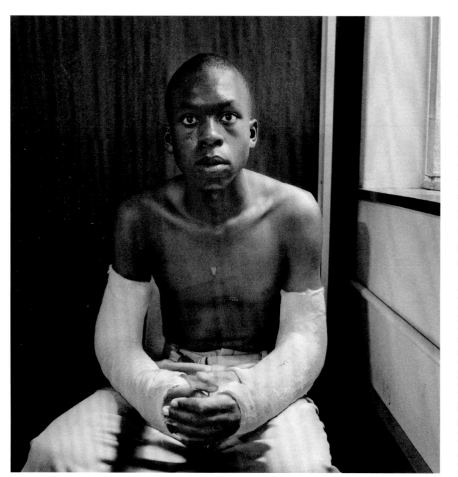

And he might question a person coming through, but he's not really supposed to. We have an electrified fence that we put up after my wife and I were held up inside our house by men with pistols. It protects us, but I don't kid myself. We're not in Fort Knox. It would be very easy to break in again. I just think that I'm not a very tempting take, you know.

JC: **The vibracrete fence of prefabricated, modular concrete slats and pillars, for me as a Joburger, is emblematic. My father always said we must turn the fence outward—have the good side out and the crappy one facing in. That was our civic duty to our neighbors.**

DG: I've never thought about that subtle variation on the use of the vibracrete fence. I think they are very significant as part of our makeup, really. It's a cheap way of fencing your property, and obviously very popular. If I had to refence our property, I might be tempted to use it, but I would most certainly reject it. And I have photographed some in the course of my work.

JC: **You're republishing *In Boksburg*. Why republish this book three decades later?**

DG: Well, there's a man in Germany by the name of Gerhard Steidl, who is probably the prince or the king of photographic books, who is totally obsessed by quality. And I am in the very fortunate position of having become a sort of favored photographer of Gerhard. He told me at lunch a few years ago, "I want twenty books from you in the next twenty years." So I've got an extensive program to fulfill [*laughs*]. Of course, it's not possible to do it; it would be quite impossible to do. But he more or less accepts whatever I suggest we publish.

JC: **You wrote in your original introduction to that book that in Boksburg you observed the "wholly uneventful flow of commonplace, orderly life." This included weddings, garden maintenance, and sports in a whites-only town. Observers have noted that you are interested in the commonplace rather than the dramatic, that your violence is the violence of a vibracrete fence rather than "necklacing" [the apartheid-era style of execution where aggressors forced gasoline-filled tires around their victims' torsos and then set them alight].**

DG: Yes. This is perfectly true. First of all, I am a physical coward. I shun violence. And I wouldn't know how to handle it if I was a photographer in a violent scene such as James Oatway photographed last week for the *Sunday Times* [of the so-called xenophobic violence]. I think he is very brave. But then I've long since realized—it took me a few years to realize—that events in themselves are not so interesting to me as the conditions that led to the events. These conditions are often quite commonplace, and yet full of what is imminent. Immanent and imminent.

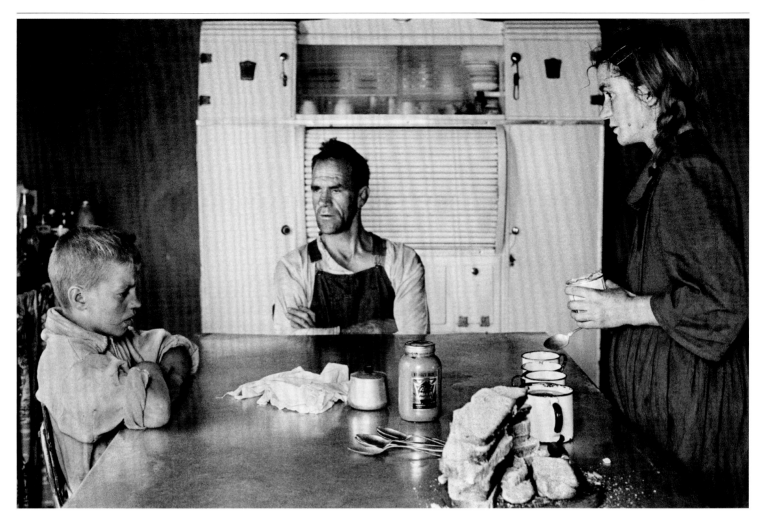

In Boksburg was partly about the banality of ordinary, law-abiding, and also, on the whole, moral people, who were knowingly living in a system that was quite immoral and, indeed, insane. We were all complicit in it. And that complicity is, I suppose, what In Boksburg is about.

JC: **Do you think by republishing it you're saying something about a kind of continued complicity?**

DG: I wouldn't. First of all, I claim nothing for my book.

JC: **That seems like a spurious claim to me.**

DG: No, I don't think it is. I would claim that the work is done with some insight, and that possibly these insights are relevant, and possibly these insights will percolate and, by osmosis, become part of the consciousness. But I've never, ever thought that what I do will actually directly influence someone to do or not to do something.

JC: **Is that why you've always claimed you're not an activist?**

DG: Because I am not an activist. An activist takes an active part in propagating their views. My colleagues in photography in the 1980s were activists, undeniably. They acknowledged it. They claimed that this was their role. And I respect them greatly for that.

A plot-holder, his wife and their eldest son at lunch, Wheatlands, Randfontein, September 1962, from the series Some Afrikaners Photographed

JC: **Some people disrespected you because they felt you weren't enough of an activist.**

DG: Yes. That's par for the course. I have to accept that. But I wasn't prepared to compromise what I regarded as my particular needs. For a time, I think some of the people who later became very good friends of mine, and who are still my best friends, were rather suspicious …

JC: **… because the world was burning, and you were taking photographs of people mowing their lawns. Did that seem to you at the time to be a very interesting, strange approach?**

I've never, ever thought that what I do will actually directly influence someone to do or not to do something.

DG: I thought it not only strange, but very uncomfortable. I mean, just now with Alexandra burning and Soweto burning, and parts of KwaZulu-Natal, I have felt what I often felt during those years, that what I was doing was probably irrelevant, but I had to accept that this was the way I am. I am not James Oatway or Paul Weinberg or John Liebenberg, who went right into the depths. I am what I am.

JC: **You talk to the people you photograph, in the sense that you don't sneak a photograph of them.**

DG: I don't sneak a photograph of them, but I often don't talk.

JC: But do you always ask permission?

DG: Oh, yes, invariably I ask. But in general, I try not to talk. The reason being that I want the subject to be very aware of the situation, and conscious that he or she is being looked at. I set up the camera, and then I don't look through the camera, because I want the subject and me to be in eyeball-to-eyeball contact. It's sometimes quite difficult, because you're dealing with a powerful person. You are really trying to assert your mastery of the situation.

Making a photograph is rather like writing a paragraph.

And you have to be in control of the situation. That's quite tricky. I want the subject to feel tension. I don't want the subject to feel particularly comfortable with me. I used to do a lot of portraiture of leading people: Mandela. [Joaquim] Chissano. [Robert] Mugabe. [Kenneth] Kaunda. And so on. Not [Samora] Machel. I never photographed Machel. I would insist—often at the cost of serious differences with security, police officers, and the like—on putting the subject into a straight-back chair, something like that, rather than an armchair, or what I call a *goma goma* chair, which you sink into.

We had an interview with Mandela just before he became president. It was in the house in Houghton where he was living then. Anyway, he'd been up since four o'clock in the morning doing exercises and whatever else he did. He came down at five for that appointment, and I had insisted—because the house was full of *goma goma* chairs—that I wanted the straight-back kitchen chair. The press officer, Carl Niehaus, who was later in disgrace [for his financial improprieties], said, "You can't put Mr. Mandela onto a kitchen chair." I said, "I insist." I said, "I've come to photograph Mr. Mandela, not the furniture: I want a kitchen chair, and I insist." Eventually, when he saw the photograph, he conceded that it was the right thing to do. You've got to take control of the situation. Otherwise, it's a runaway.

JC: Language is fundamental to what you do.

DG: Well, the kind of photography that I am interested in is much closer to writing than to painting. Because making a photograph is rather like writing a paragraph or a short piece, and putting together a whole string of photographs is like producing a piece of writing in many ways. There is the possibility of making coherent statements in an interesting, subtle, complex way.

JC: You are known for your long captions.

DG: I usually offer them in a form where they can be split. I learned from *Life*, *Look*, and *Picture Post*, which were expert at conveying information on three, four levels really. There were the photographs, which were the simple focus of what the magazines

Die Heldeakker, The Heroes' Acre: cemetery for White members of the security forces killed in "The Total Onslaught," Ventersdorp, Transvaal, November 1, 1986, from the series Structures

were doing, and then there were three layers of wordy information. There was the main caption, which was short, pithy, and gave you some basic text. There was a subsidiary caption, usually written in a lighter face or a smaller point size. Then there was a text. By means of these three layers of information, or verbal information, or written information, they conveyed a great deal in a really digestible way.

JC: **You have collaborated with some of the most respected South African writers: Nobel Prize-winner Nadine Gordimer wrote an essay for your first book,** *On the Mines* **(1973), and recently you published** *TJ & Double Negative* **with Ivan Vladislavić. Tell me about your relationship with Ivan.**

DG: I admire him greatly, first of all, his ability to write books. But perhaps more relevant and more important is his ability to seize upon often insignificant details of our life here that are key to an extrapolation of our life. So in one of his books, there's a man who is the proofreader for the Johannesburg telephone directory. I mean, you've got to have an extraordinary imagination to imagine that. In the book that came out of what we did together, he exhibits a similar kind of imagination. Part of the story involved [the collection of misaddressed] "dead" letters of a Portuguese man who used to be a doctor, and one of the highly qualified men in Mozambique, who comes here and can't get work but becomes a letter sorter.

Ivan has this ability to, I don't know, to somehow extrapolate our life in terms that are often amusing and yet tragic, and always, always relevant to our life.

JC: **Which writers do you still hope to work with?**

DG: I would say that there are two people with whom I would love to collaborate. Marlene van Niekerk [Afrikaans novelist, poet, and professor]. I can't imagine what we might collaborate on, but I'd dearly love to. And Njabulo S. Ndebele [author and former vice chancellor of the University of Cape Town].

Marlene and I have had a couple of public discussions. That was when I realized what a formidable person she is, and her grasp of things. She knew my work intimately, and she asked questions that penetrated right to the heart of things and yet without harassing me. Subsequent to that, I asked whether I could meet her. At that time, as an extension of what I had done in *Particulars* [made in 1975 and published as a series in 2003], I was attempting to do some nudes, and I had done one or two, and then formed the idea that I would like to do portraits of people in the nude. So we made a date to meet outside Cape Town for lunch, at which I told her my undisguised and unlimited admiration for her, and I said to her, "I would like to do a portrait of you in the nude."

Girl with purse, Joubert Park, Johannesburg, 1975, from the series Particulars

She laughed. She said, "Absolutely out of the question." She said, "First of all, I am in the academic world here and that just would be unacceptable, but secondly, I am a very shy person, and I just wouldn't do it."

JC: **Do you have an archive of projects that could not or should not be done?**

DG: Over the years, there have been things that I have wanted to do, but, for one reason or another, couldn't. Mainly these have been things that were just very difficult to do. For example, in the 1980s I wanted to photograph subjects who had been detained and tortured, and I photographed some of them in the course of providing visual evidence for a court case. A number of photographers did this. Lawyers would want pictures of people who'd been *shamboked* [whipped] in prison; they'd want pictures showing the wounds. I did a number of those. But I wanted more than that. I wanted to do portraits of people who had been tortured. I did one or two, and it was terribly difficult because people were afraid. There is one picture that has been published quite often of a young man with his arms in plaster [see page 110]. I did two photographs of him, one front and back, and I photographed one of his colleagues. But I gave it up. It was just too difficult to get people who were prepared to accede to this.

JC: **You mentioned that you are digging back into your archive. What does it feel like to look back—and to still have twenty books planned?**

For me there is no question that the land itself, that "land" as opposed to "the landscape," is something that I would like to explore.

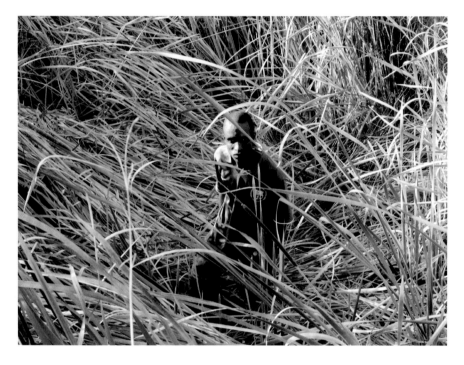

Paul Tuge where he hid after shooting a policeman in 2001, February 18, 2010, from the series Ex-Offenders

DG: Well, I wish I had twenty books still planned. Every now and again I catch myself and say, "Am I really this old?" I don't feel very old. But at the same time, I am aware that my body is changing, and my ability to handle complexities. Age has affected me. I think it would be true to say that when I was younger, the sex drive was a very potent force in what I did. That is less the case now, partly because of physical changes in the body. Do you know the work of Borges, the Argentine writer? He said something marvelous once, and I can never quite remember it, but basically he said that in your youth—this referred to a writer—if the stars are right, and everything is in place, then in his or her maturity, his work might contain a subtle, hidden complexity.

JC: You've always insisted on a strict boundary between your "professional" work done for clients—including the powerful South African mining houses—and what you call your "personal" work. After the 2012 Marikana massacre, when thirty-four striking miners were shot dead by the South African police, did you have occasion to reflect on that dividing line in your work?

DG: Well, I don't think I fully grasped the depth and extent of the exploitation of migrant men working in this country. That became clear to me during this incident at Marikana. It was clear that the migrant workers were in the position of sellers of their labor, in a *very* weak position, whereas the mining houses were immensely powerful, and there's no question that they exploited that difference in power, if you like, over many years. They exploited it. There is currently a class-action suit against the large mining houses for the damage done by silicosis, which is a chronic lung disease caused by the silica dust miners breathe in while working. I photographed some aspects of this. I came along at the end of this long, sorry tale. They had stopped mining asbestos when I came into it. I have to acknowledge that I did things for the mining houses that, in the light of what I now understand better, I should not have done, and should have refused those assignments, those commissions. Or I should have handled them differently.

In my own personal work, in my book *On the Mines*, I have touched on these things in quite brutal photographs. But I didn't sufficiently illustrate that much. And we're not out of that yet. The relationships still stand. Just in the last week or two, there was an announcement of the take-home pay of the executives. It was appalling. Not one of them came up and met the strikers and sat down and talked to them. Not one.

JC: What has age taught you?

DG: I will say that I've learned to be a good craftsman. That goes without saying. I don't think you can seriously engage in photography if you're not a craftsperson. You have to be reasonably competent at handling situations, and the camera obviously. But I have to say that as I've entered my ancient years, my craftsmanship has deteriorated. I forget too much. I take too much for granted. I had a very good friend who was a great architectural photographer, Ezra Stoller, an American man, who was so famous for his architectural photography that great architects would want to "Stollerize" their buildings. And he said to me once—and he was then about the age that I am now—he said that he had lost the ability, the critical faculty to make judgments of prints. Ja, I'm sad to confess that I think this is happening to me. I've been printing now for the last few months, and I've reestablished my connection with my work that I had lost for a time.

JC: I always wanted to be old. Does that sound silly to you?

DG: No, no, not at all. I had a brother, Nick, ten years older than me, and I loved the lines in his face. I had a smooth face. I used to envy him to no end. In many ways, I wish I were younger. But I think, on the whole, I accept growing old. What I am very conscious of is that I probably don't have many years left of active work. I have to be able to climb onto the roof of my camper. I have to be able to drive fourteen hundred kilometers to Cape Town. I must be able to do these things. And my ability to do that is probably limited within the years left. When I was forty, fifty, sixty, and seventy, it seemed like there was an unbroken span in front of me. Now that I am eighty-four, it's a bit unrealistic to hope that it's still an unlimited span. Gerhard Steidl's twenty books in twenty years is somewhat unrealistic maybe.

JC: Did you know that you are very much in fashion right now? If you visit any fashionable person in South Africa they will have a David Goldblatt in their lounge.

DG: I didn't know that. My sales figures don't bear that out.

JC: They even have a particular way they're framed and they'll be hanging next to, like, a Zander Blom or maybe an early William Kentridge print. How do you feel if I tell you that you are at the height of fashion right now?

DG: I feel very vulnerable, because that's bound to change. Fashion is essentially a passing phenomenon, and ja, I am absolutely not at peace with it.

JC: I want to talk about the South African veld. I was driving across the country the last two days and was struck by how exquisite, how devastating it is in some ways. J.M. Coetzee wrote in *White Writing* that whites lacked a vocabulary for the light and the color of the place. I think some people would say—you said it yourself, I think, once—that there was a time when you stopped running away from the light of this place, and tried to find, or did find, a language for that here.

DG: I think that's true. Just now, in the Karoo, where I went after photographing the student dethroning [of Cecil John Rhodes's statue at the University of Cape Town], I went up to an area near Langford that I've often looked at with the idea of photographing it. I once went there about four years ago, five years maybe, and got permission from the farmer to go over his land. I was in my camper, and I drove in there, and I did a photograph that I've never really liked. But I knew that there was something there that I wanted to explore. Just a few weeks ago, I went back there, and for two days, when I had a weekend, I went back to that farm and walked over it, found a koppie [a small hill], drove along the Cape Town–Johannesburg railway and did some photographs, which I think are the beginning perhaps of something. For me there is no question that the land itself, that "land"

as opposed to "the landscape," is something that I would like to explore. I don't quite know how. But when we speak of "the landscape," that already is a value judgment. It considers that you have looked at the land, and formed a picture around it that makes it into a scape.

JC: Making a photo of the land without making a landscape.

DG: A photographer who I really admire, Guy Tillim, has done that in São Paulo, in Tahiti, and he has done it in Johannesburg. The photographs that he did in Johannesburg are amazing. They appear to be fuck all. I think they are great. It's something that, ja, I've been conscious of for a long time.

How do you resist this need to find order? And yet, how do you do that so the photographs are not just chaotic?

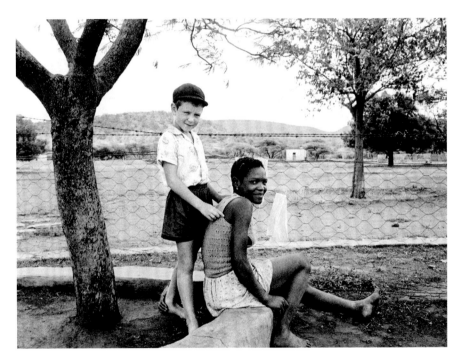

A farmer's son with his nursemaid, Heimweeberg, Nietverdiend, Western Transvaal, 1964, from the series Some Afrikaners Photographed

Jonathan Cane is a writer and researcher who lives between São Paulo and Cape Town. He is researching the politics of South African gardening for his PhD.

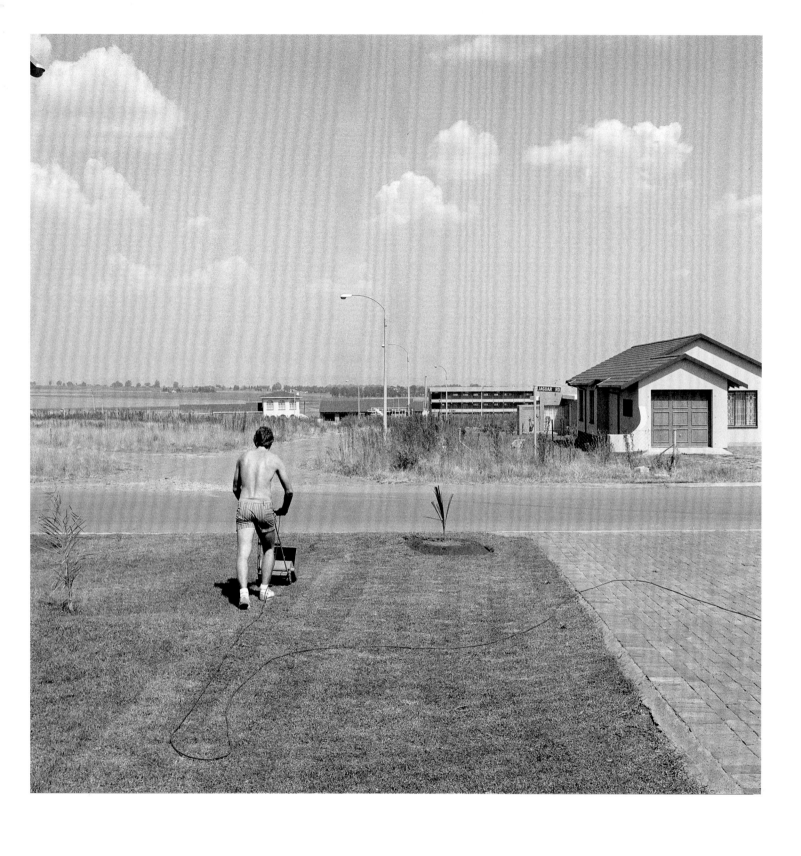

*Saturday afternoon
in Sunward Park*, 1979,
from the series *In Boksburg*

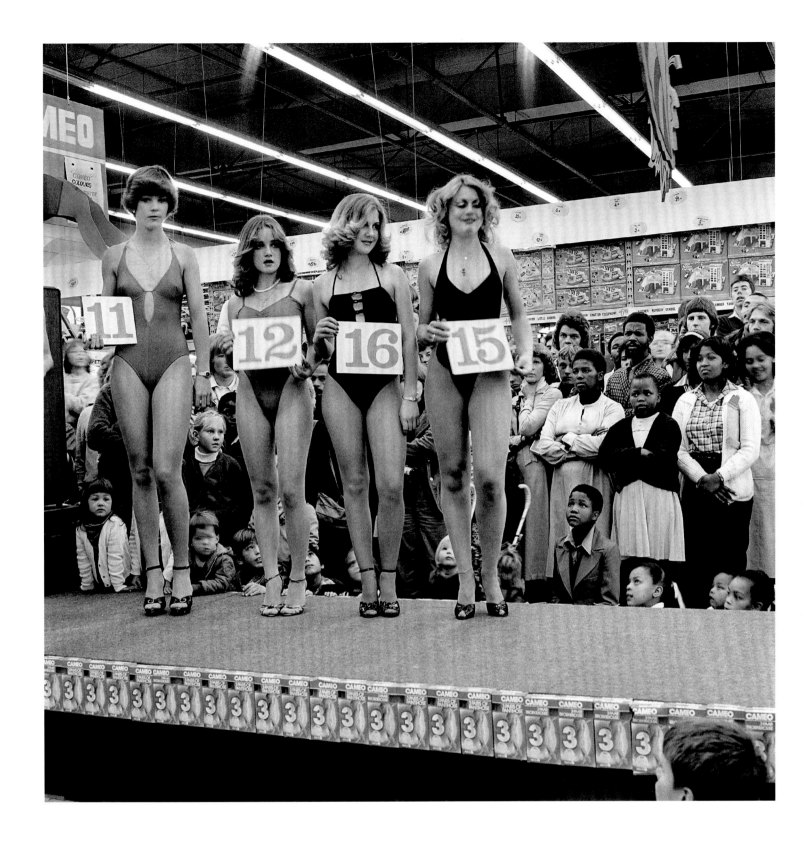

*Saturday morning at the
Hypermarket: Semi-final of the
Miss Lovely Legs Competition,
June 28, 1980, from the series
In Boksburg*

*Team leader and mine captain
on a pedal car, Rustenburg
Platinum Mine, Rustenburg, 1971,
from the series On the Mines*

Drum majorette, Cup final,
Orlando Stadium, Soweto, 1972,
from the series Soweto

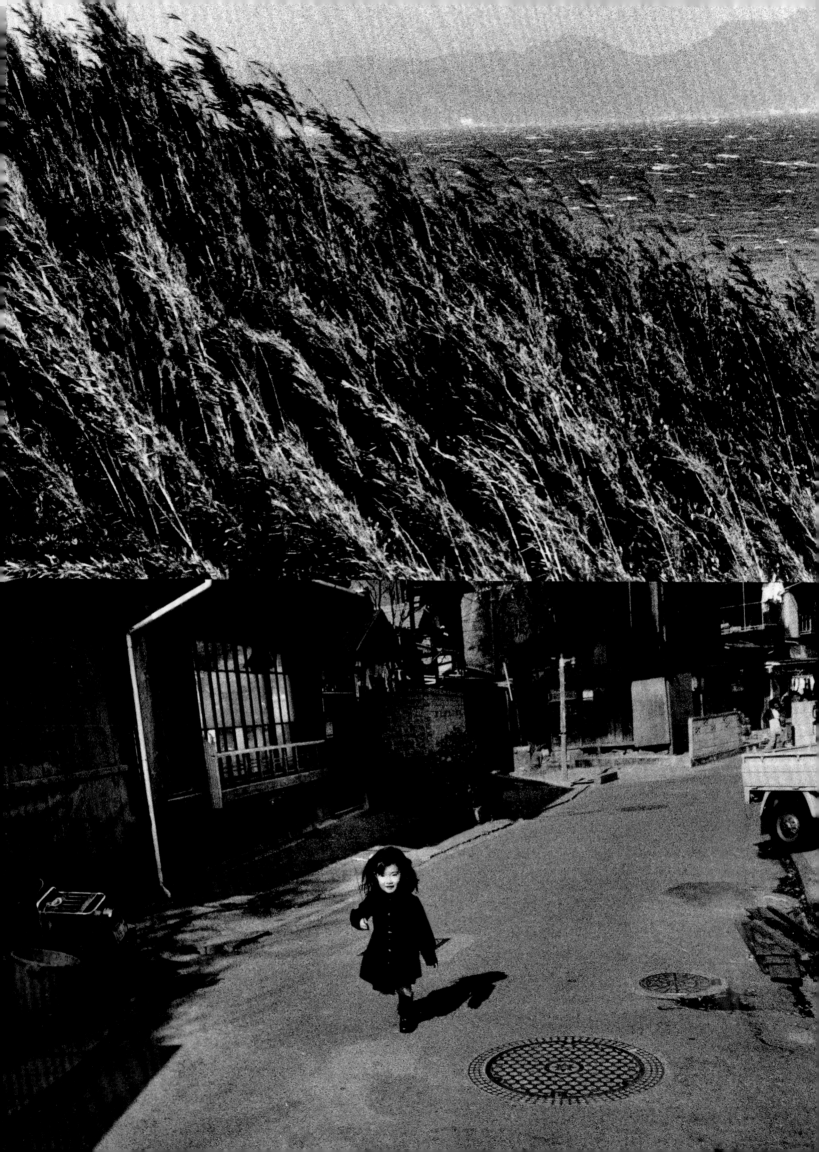

Opposite, top:
Yokosuka Story #5,
1976-77

Opposite, bottom:
Yokosuka Story #98,
1976-77

Ishiuchi Miyako

Interview by Yuri Mitsuda

Through her images of subjects ranging from the American Occupation of Japan and the bombing of Hiroshima, to women's scarred bodies and her mother's and Frida Kahlo's personal effects, Ishiuchi Miyako, born in 1947, has explored the passage of time and history. Like Shomei Tomatsu and Daido Moriyama, renowned Japanese photographers who emerged in the 1950s and '60s, Ishiuchi's early work was shaped by the residual presence of World War II. Her first series, *Yokosuka Story* (1976–77), focused on her coastal hometown, the site of a U.S. naval base that was permeated by American culture. Projects that closely followed—*Apartment* (1977–78), which explored the interiors of Tokyo's postwar housing, and *Endless Night* (1978–80), for which she photographed brothels—honed Ishiuchi's vision as well as her process; for her, the image is a physical object made by hand in the darkroom.

For more recent work such as *Mother's* (2000–2005), featured at the 2005 Venice Biennale; ひろしま / *Hiroshima* (2007); and *Frida* (2013), Ishiuchi turned to color, taking a forensic approach to examine clothing and objects laden with complex histories, underscoring the idea that the traces of time's passage are her true subjects. Last year, Ishiuchi won the prestigious Hasselblad Award, and this fall, a major exhibition of her work will open at the J. Paul Getty Museum in Los Angeles. Here, Yuri Mitsuda, curator at the Kawamura Memorial DIC Museum of Art, speaks with Ishiuchi about the evolution of her explorations of time, her ambivalence about photography, and how she has negotiated a field dominated by men.

Yuri Mitsuda: Let's begin with *Yokosuka Story*. Was this your first show?

Ishiuchi Miyako: When I started out, I was exhibited as part of a group show with *Shashin Koka* (Photography effect), a short-lived experimental photography group that included Hiroshi Yamazaki and Tunehisa Kimura, among others. [Nobuyoshi] Araki came, and Moriyama—well, maybe Moriyama didn't make it, now that I think about it. But anyway, Tomatsu, [Masahisa] Fukase, all those guys came and saw it. Araki said, "If you want to show at Nikon Salon, bring some photos over." It wasn't really clear to whom he was talking. But when I heard that, I spoke up and said, "Sure, I'll do it, though only once."

YM: Why only once?

IM: I didn't want to be a photographer then, but Nikon Salon was the biggest, most famous, most frequented exhibition space. And here was Araki saying, "If you want to show at Nikon Salon, bring some photos over." I had just taken my first pictures in Yokosuka. I was absorbed in the darkroom, where I struggled with the photographic materials as objects. They were not only images to me, but *materials*, and somehow they stood between Yokosuka and myself. But I wanted to show them, and so I thought, Sure.

The title we'd come up with was *Yokosuka Elegy*. But when we showed it to [Jun] Miki [then the director of Nikon Salon], he said, "No, no, that won't do. Much too dark." So he renamed it *Yokosuka Story*. That was right when Momoe Yamaguchi had that popular song, also called "Yokosuka Story."

There's always something about [my photographs] that's cold. Maybe because I never really wanted to become a photographer.

YM: What did you bring to Araki's place to show him?

IM: 12-by-10-inch prints. About a hundred of them.

YM: When I've asked you before how you started taking photos, you've told me, "I haven't always wanted to be a photographer—it's more that, from time to time, that's the equipment I end up using." It might have been by chance that you ended up taking photos, but nonetheless— at that point you had at least a hundred!

IM: That happened once I made the decision to shoot in Yokosuka. Up until then, I had no idea what I wanted to shoot. I went up to Miyako, in the Tohoku region, and I ended up in the station, unable to take a picture of anything. I didn't know what I should shoot. I just knew people brought their cameras to different places and took pictures.

That was the first time I took a camera on the road. I ended up in the waiting area, sitting there wondering why I'd come so far, why I wanted to take pictures here in this faraway place. Then it came to me— what place was I the furthest from really knowing? Yokosuka! Where I'd come from! (I moved from Gumma Prefecture to Yokosuka at the age of six.) So I packed up and went straight back.

YM: From the very beginning you treated your photographs as objects that one could craft.

IM: I threw my whole body into the printing process; to treat a print as something throwaway would be impossible for me. That's why it doesn't feel like I'm developing photos. It's more like I'm *making* something.

I didn't learn photography from anyone. I received a pamphlet for a workshop once. It was Tomatsu's school. I went back and forth about going, but then I saw how expensive it was—200,000 yen for half a year! I decided to do things myself instead. I might try and fail, and I failed a lot. Failing is so important. It's been such a plus for me, never having been taught photography. Though I've been told I hold the camera strangely.

YM: What is the allure of the darkroom for you?

IM: It's the dyeing process. Dyeing white paper, bit by bit. Each tiny chemical grain, one by one, transforming the paper. I did roll printing, after all, when I was starting out. From the *Yokosuka* series on, I would start by buying a roll of photographic paper and then cut it as I went. But it always struck me as crazy that the size of the paper and the size of the film didn't match. My film was 35mm, and the paper was 4 by 5 or so. When you developed a 35mm image on it, there was so much white. So much white! It was really shocking to me. I developed in two steps. I had to add the black border myself. White seemed like simple excess, and it always stood out, and it really affected the sense of spatial composition to me.

YM: You considered the paper rather than the image, how the paper had to be incorporated into the finished work.

IM: I'd decided my project was not going to be documentary. When you think of Yokosuka, the first thing you think of is documentary. Tomatsu shot it, and so did Moriyama. They all ended up shooting Dobuita Street [the street notoriously frequented by sailors from the Yokosuka U.S. naval base]. That street was America, not Yokosuka. I saw everyone shooting Dobuita and calling it Yokosuka, and I thought, Something's not right about this.

YM: It all seems connected, how you were working then: you wanted to shoot Yokosuka, not Dobuita Street; you wanted to avoid the documentary approach and shoot "your" Yokosuka; you wanted to avoid white borders and use black ones instead.

IM: I didn't want to make my photographs "photo-like." I wanted to emphasize the presence of the photographic paper itself. I thought it was really something, the sheer physicality of it. To be Tomatsu-like, for example—that meant being documentary. I represented the furthest departure from that kind of thing. What did that really mean? For me, I wanted to present the images right on the walls. I stuck them on with double-sided tape, but they started to fall down, so I bought tacks, enough for 150 photographs.

YM: Putting all the images into matted frames and lining them up along the wall wouldn't do.

IM: You don't really look at them that way. You end up moving on to the next image right away. I want to make the viewer stop and really look at each photograph. That's why I tend to show as few pieces as possible. Like with *Silken Dreams* (2011). That was an experiment to see how far I could go, if I could display just one image per wall. When I had a show at the [Tokyo Metropolitan] Museum of Photography, people said, "There aren't enough pieces!" It might have seemed quite paltry to visitors who came just to see images. But I wanted people to look at the pieces more than once— ideally, to look at them again and again.

YM: Looking at your work again, I'm struck by the themes of the body, of flesh, of flesh and photograph relating to each other. Capturing precisely the way the sensory aspect of a photo-graph, a photograph's surface, relates to the flesh, to the skin. **They have a bodily quality, these prints, even something like the building in** *Apartment*, **the feel of the tile, the feel of the dirt, it comes across so vividly. In** *Apartment*, **and in** *Endless Night* **too, the tile makes an impression. You can think of it as the building's flesh, perhaps.**

IM: I considered becoming a tile layer at one point. It was what I would do if I ever quit photography. I've always loved tile. It excites me, looking at a black-and-white checkerboard pattern, for example. When I shot *Apartment*, I did think of it as shooting the body of the building. I felt tender toward it, a certain pity. A building can't move. It has to stay where it is forever. That's so sad, I thought. A building has no choice but to sit there and accept everything that happens to it.

YM: Perhaps your pictures feel visceral because of your darkroom process?

IM: I don't know about that, but I have always thought that the darkroom is such a sexual place. Its smell is so strong. And if you do it with bare hands, it's like you're having sex. Photography has that quality; it engages the five senses. It possesses something like sexuality.

YM: So the darkroom had a sexual quality. You can see it in the prints you made, their analog quality. And you also felt the building was a type of body.

IM: Yes. I thought of people as being part of the walls. I shot plenty of humans in *Apartment*,

Yokosuka Story #58, 1976–77

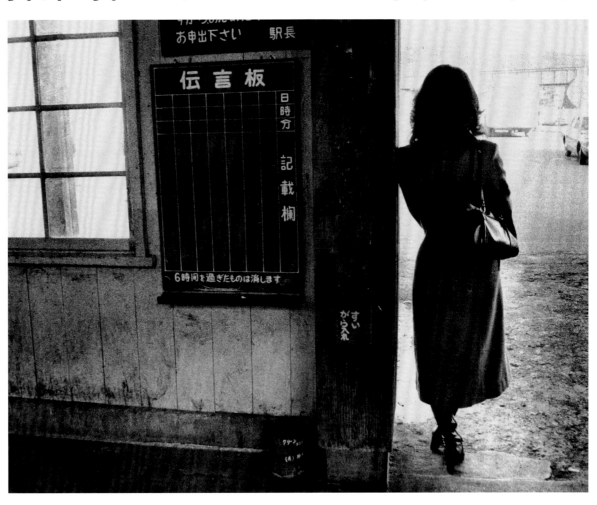

but as if they were part of the walls. Like patterns on the walls. People move away; they disappear. Two years pass and it's all different. So as the humans pass through, leaving their scents, their body odors, their forgotten possessions, the building remains, silent witness to it all. A wall is a skin, you see. That sense was particularly strong in *Endless Night*. Those were brothels.

YM: **The *Scar* (2006) work focuses on actual wounded bodies. It strikes me that the building photos resemble these. You said, "Space is formed from the accumulation of detail," but you might also say that a body, too, is formed from details fitting together.**

IM: You can say I'm shooting scars, but that's not really what I was doing.

YM: **Really?**

IM: Just like in *Endless Night*, I wasn't shooting tile. I was shooting time. The traces of time's accumulation. Like I did in *1・9・4・7* (1990). I was trying to shoot the traces of forty years' passage.

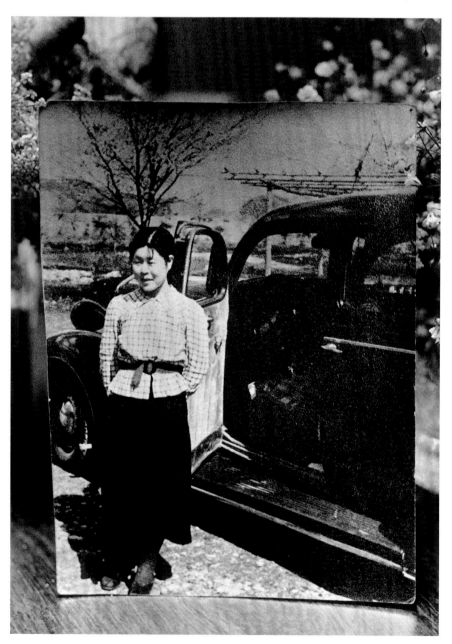

When I think of where in the body time builds up the most, it's the hands and feet. Shooting photographs, you end up shooting surfaces, but I wasn't shooting hands and feet; I wasn't shooting scars. I was shooting something invisible to the eye, something on the far side of the images themselves.

YM: **You're using the word "time," but, for example, with *Yokosuka Story*, you have the prewar, the war, the American incursion, and then you were born and eventually picked up a camera—your photography suggests layers of time. It feels less like a span of years and more like history itself. Through *Mother's*, all your work strikes me as being personal. After that, there's ひろしま/*Hiroshima* and *Frida*.**

IM: Hiroshima was an enormous tragedy, socially and historically. I had people who could bring me into that, if you will—I had those girls who'd worn those clothes and left them behind for me. With *Frida*, too. They invited me, so I went. I didn't have all that much interest in her because of my limited knowledge.

YM: **That's a fascinating aspect of your work. You never really had that much interest in Hiroshima. You also say that you never really even had that much interest in photography.**

IM: I'm a cold fish that way. There's always a distance from photography, since the beginning.

YM: **But your photos are so intense, so hot.**

IM: No, not at all. There's always something about them that's cold. Maybe because I never really wanted to become a photographer, never really loved photography itself. With ひろしま/*Hiroshima* it was a question of what made me able to shoot it. If I hadn't shot Yokosuka, I wouldn't have been able to shoot Hiroshima. They're connected at a fundamental level.

YM: **Looking over ひろしま/*Hiroshima*, it seems that the images you chose have a certain transparency to them.**

IM: Well, I shot for luminescence. All of them were shot in natural light. It's almost seventy years after the war and yet there are still new things, preserved from that time, coming to light—isn't that amazing? I go to visit and end up getting told, "We have some new pieces." It's shocking.

YM: **They're still alive. These personal effects.**

IM: Exactly. People can't bear having them any longer. They can't bear them alone. So they bring them to the museum, make it so we all can bear them together. This kind of history is lost, usually.

YM: **Your project is so different, though, from something like what [documentary photographer] Ken Domon did, or Shomei Tomatsu. It's similar**

in that it's a way to demonstrate that people's lives became defined by this event, but it's such a different approach, taking pictures of people's clothing but not people.

IM: When they were displayed at the Hiroshima City Museum of Contemporary Art, people said, "Oh, they look like high fashion!" Because the images were so pretty, you see.

YM: **How do you respond to that? That doesn't sound like praise.**

IM: Oh, I disagree. I took it as a compliment. I mean, what's wrong with that? I shot them to be beautiful. The response was interesting when they came out as a book—people in the fashion industry, who work with clothing, were so enthusiastic. Rather unexpected. Fashion models buying my photos!

It's because I didn't shoot the clothes worn by the victims as artifacts. These fashionable young women lived, and while they're no longer with us, they left these things behind. These clothes are really nice, I thought. So that's how I shot them. To do them that service. If you look, you can find bloodstains. You can see how they're torn. They went through the bombing, after all. I read later about Comme des Garçons, about Rei Kawakubo and what they called the "postnuclear look." I was so surprised. I wasn't so far off after all, I thought. I've learned so many things shooting ひろしま/ *Hiroshima*. Thinking back over it now, it's striking me anew. It's quite an ordeal, this project.

YM: **You mean, an ordeal to keep shooting it?**

IM: I had no interest in Hiroshima, as you know, to the extent that I didn't think I even needed to visit it. Now I have this bond with the place, even think of it as a second home. Yet I'm still an outsider. Though it's because I'm an outsider that I can shoot what I shoot.

YM: **That's important, isn't it?**

IM: It was the same with Yokosuka—I could shoot it because I was an outsider. I'd moved there, after all. I wasn't born there. And with Hiroshima, I was a complete outsider, so that sense of distance remains. One must be a bit cold to be the one taking photos. Up until recently, I'd never known anyone who'd been directly affected by the bombings. I was able to admit: I don't know. It is impossible to completely understand [the event]. And in doing that, I was able to take on the burden of responsibility for Hiroshima. I've only come to this way of thinking recently. I was being interviewed at a museum, and the woman I was being interviewed with put it that way, that the unimaginable was the unknowable. If you can't even imagine it, then you know nothing about it.

YM: **It's like what Wittgenstein said: "The limits of my language are the limits of my world."**

Endless Night #71,
1978-80

IM: Yes, that's it. The unimaginable signifies that which you can't conceive.

YM: **It's like Fukushima.**

IM: That too. Everything to do with the earthquake in Tohoku.

YM: **I had the thought, looking at *Frida*, that the distance between you and Frida Kahlo isn't so great.**

IM: I'd never had much interest in her, but when I went to Mexico City for the shoot, I came to love her work quite a bit, especially her drawings. The drawings have such lightness to them.

Photography has that quality; it engages the five senses. It possesses something like sexuality.

YM: **Looking at the things Frida's absent body once touched, the traces she left behind, her shoes—they're not unlike scars. The distance between you and the subject in *Frida* seems narrower than it is with ひろしま/*Hiroshima*.**

IM: I think so, too. It became about the everyday life of an individual woman, but in a way, also her life as a whole. She's always spoken of as being so intense, so willful and passionate. But that's just one side of her. No one knew Frida as she was in her daily life. Looking at these things, it really struck me. "Ahh, that's how she was."

YM: **In *Endless Night* and other works like that, you were shooting buildings as bodies, shooting the time those bodies held within them. Were you shooting time as it existed within the spaces of the present?**

IM: Time itself is accumulation. I'm about to turn seventy. It's pretty shocking. How can one conceive

of seventy years' passage? There's not much future left. Maybe twenty more years. I know I'm about to disappear. So it becomes even more imperative for me to treat time with importance. To shoot a photograph is to fix time in place. To fix time like that—I'm only interested in fixing time in its accumulation.

YM: **For *1906: To the Skin* (1991–93), you shot Kazuo Ohno. He's a famous dancer who'd danced with the likes of Tatsumi Hijikata [a founder of butoh dance]. You took nude photos of him, using your signature approach—focusing on different parts, on the surface of the skin. His body in particular seemed to show the passage of time very vividly. Normally, you think of dancers as young, vigorously moving across the stage and displaying amazing technique and then retiring before time really registers on their bodies. But he continued to dance until he died, dancing even in a wheelchair. And it was so lovely, a kind of dance only he could do.**

IM: How can I put it? He was like an angel, and so androgynous. As if male and female didn't matter. There was something very masculine about his flesh, though, his hands and feet. Yet they were smaller than mine!

He was quite willful. It was a difficult shoot. I had thought I was going to photograph his feet and hands, but then I started to have other ideas as I prepared to go. I wanted to take photos of the scars of men. "If you have no scars, then you will pose nude." That's what I told him. He was rather obstinate. I asked, "Ohno-san, do you have any scars?" and he said, "No! I have no scars." So I said, "Could you disrobe for me then?" and all his clothes came off, just like that! I was a little surprised. He put on some music, and then started to dance. It was overwhelming for me. Though also a pleasure, of course. It felt like rising up to heaven. Just us, no one else around.

Apartment #14,
1977–78

YM: **You put out *Main*, an independent magazine, from 1996 to 2000, with photographer Asako Narahashi. Did you want it to be like *Provoke*? There couldn't have been very many people trying to do what you were doing—starting something run only by women, publishing photography not done on commission, but pieces you made because you wanted to make them.**

IM: We were tired of the old-fashioned stuff. All that stuff the men were busy making, we wanted to get away from that. We don't need men, I thought. They're such a bother to deal with, let's just do it ourselves. We wanted a venue for the things we were doing right then.

I didn't have much connection to the photography world. I didn't really get on with anyone, so I don't know what they said about us. I was so impudent. I acted from the start like we were equals. And that was so much more interesting. Of course, I can't say there was absolutely no influence from the *Provoke*-inspired style, it seeps in, but I can say the influence wasn't direct.

YM: **Were you ever excluded because you were a woman?**

IM: Not at all. I mean, Tomatsu loved women. Moriyama too. So there were always women around. I had no interest in them that way, though, as men. There wasn't one guy who was my type among all those photography guys. Thank goodness. But it can be an ordeal, being a woman. People constantly accosting you. I watched it happen all around me. There were a lot of women who wanted to do something in photography, and one after another I saw their efforts come to nothing.

YM: **Why do you think that was?**

IM: They underestimated how hard it would be. In my case, I thought I would do *Yokosuka Story* and then quit. Like I was getting back at an enemy. Yokosuka was a difficult place for a woman because of the sexual violence that occurred there. Rape was a part of daily life, but nobody saw it as a crime. I did not experience rape myself, but it scarred me. I'm gonna kill you once and for all; that was the feeling. That city, Yokosuka, it had inflicted so much on me, so much trauma, so many scars. If I don't kill you I can't move on—that was the feeling I had.

You had to have that kind of intense feeling. I thought I'd do it once and be done, but of course, I ended up continuing. I looked around and thought, Well, now I'll do *Hyakka Ryoran* (A hundred flowers bloom, 1976).

YM: ***Hyakka Ryoran* was an all-woman show you planned for Shimizu Gallery, wasn't it? So you had the sense that you needed to do things as just women, as women photographers.**

IM: Of course I did. We wanted to do something just for women, but separate from the women's lib movement. The mainstream world of Japanese

photography was absolutely a boys' club. People outside Japan noticed it too, and they were right. I had no interest in them, at all. The workshop group was a boys' club, too, of course, but the form it took was different. They were interesting, at least, Tomatsu and all those guys. They were fun to hang around with. We went out drinking every week on the Shinjuku Golden Street. We had fun drinking together. I got my share of sexual harassment, of course. They were old-school guys, after all. It sounds idiotic saying it like that now, but that's how it was.

YM: **The excess energy produced by artists, by people engaged in making things—it doesn't always lead to the most moral conduct.**

IM: And there were plenty of people who left themselves vulnerable. But never me. I got a reputation as pigheaded, a dragon lady. But I stuck to my guns.

YM: **If you didn't, it would come to nothing.**

IM: They'll undermine you, drag you down.

YM: **Do you mean how *Hyakka Ryoran* was thought of as unsuccessful?**

IM: No, it was just completely ignored. There's hardly any record that it happened at all. The only attention it got was in [the tabloid] *Heibon Punch*. They wrote about women taking pictures of men, of women making men strip naked. So that got picked up on television, as a kind of scandal.

YM: **At the time, Diane Arbus was getting a lot of attention as a female photographer.**

IM: But I didn't have a lot of interest in her. She was a special case, though. Arbus wasn't popular as a woman; she was popular as an American.

YM: **These past ten years you've exhibited more and more outside Japan. Do you think that's expanded your view on things? Were there things you encountered that surprised you?**

IM: I was surprised by the Hasselblad Award. I was even more surprised to learn that they knew everything about me—they had all the data, right at their fingertips!

These days, I have many more opportunities to show outside, rather than in Japan. And I find that the respect people have for photography [in the West] is different. Photographers are artists. In Japan, a photographer is just a photographer. No one thinks of photographers as artists in Japan.

YM: **There's a history of Japanese photographers saying things like, "I'm no artist; I'm just a photographer." Especially photographers who specialize in street shots, in Ihei Kimura–style documentary photography. There's a tendency to want to minimize the role of art, to rebel against the legacy of fine-art photography.**

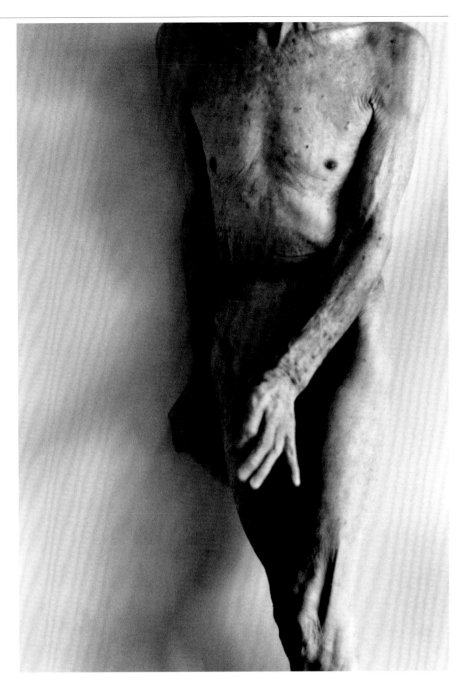

1906: To the skin #60, 1991–93

That was the basis, or history, on which much of Japanese photography was formed.

IM: Of course. And I don't care about definitions of art, about what art is or isn't. All I'm doing is what I feel I must do, regardless of any label.

YM: **All the shows you're putting on, all the books you're writing: your sixties have been kind of a turning point, haven't they? How do you feel now, looking back over them?**

IM: I've had free time up until now. Everyone else has been so busy, but I've had the freedom to do things. So I pushed myself past my limits, to do more than I really am able to. Or rather, to do *everything* I am able to. I know what I can't do, so I only do what I know I can. I've started to think lately that perhaps I really am suited to photography. That's the potential of photography, to be freer and freer, to do things with ever more freedom.

Translated from the Japanese by Brian Bergstrom.

Yuri Mitsuda's many publications include *Words and Things: Jiro Takamatsu and Japanese Art, 1961–72* (2012); *Shashin, "geijutsu" to no kaimen ni: shashinshi 1910-nendai-70-nendai* (At the interface of photography and art: a history of photography from the 1910s to the 1970s, 2006); and *Nojima Yasuzo Shashinshu* (Yasuzo Nojima: photographs, 2009).

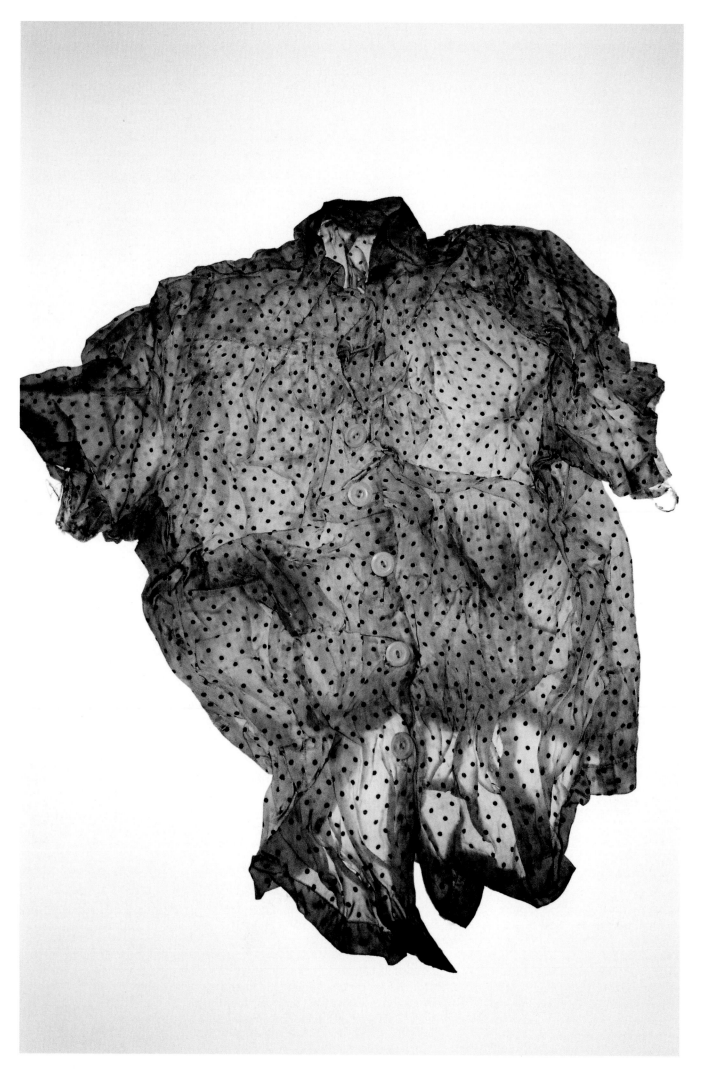

Page 130:
ひろしま/*Hiroshima #69*
(Donor: Abe, H.), 2007

Page 131:
Mother's #39, 2002

This page:
Frida by Ishiuchi #50, 2012

Paolo Gasparini

Interview by Sagrario Berti

Although Paolo Gasparini was born in Italy, Venezuela is his adopted home. He has spent his life documenting the cities and people of Latin America, south of "the northern imperialist," as he refers to the United States in the following interview. Born in 1934 in Gorizia, in Northeast Italy, he emigrated to Caracas in 1954 to join his mother and older brother. This was a time of oil-fueled growth, prosperity, and urban expansion as well as inequality, poverty, and cramped living conditions in new housing complexes. Working alongside his architect brother Graziano, Gasparini sought to document both the transformation of the built environment and the city's inhabitants.

In 1961, impassioned by the Cuban Revolution, Gasparini traveled there and stayed for four years. Later, in the 1970s, he was commissioned by UNESCO to photograph urban centers from Mexico to Argentina, focusing on both architecture and the stark social inequality he witnessed. The project resulted in the photobook *Para verte mejor, América Latina* (The better to see you, Latin America, 1972), now considered a classic.

Gasparini has continued to make work, often reinterpreting his still photographs through the use of sound and elements of performance. In 1995, he represented Venezuela at the 46th Venice Biennale. For this interview, Sagrario Berti, a Venezuelan photography curator, researcher, and longtime friend, met with Gasparini at his home and studio in the Bello Monte neighborhood in Caracas. They spoke about his recent book *Karakarakas*, which features six decades' worth of Caracas work; what it means to identify as a Latin American photographer; and why, for Gasparini, photographs should still be seen as a product of ideology.

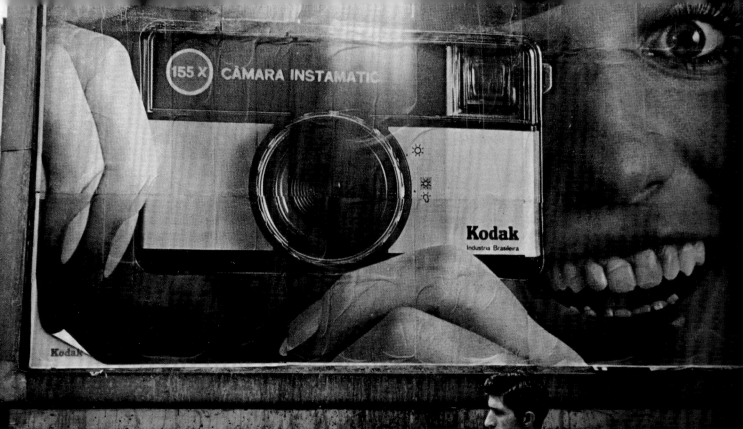

Sagrario Berti: **What led you to immigrate to Latin America and settle in Venezuela?**

Paolo Gasparini: In order to avoid enlisting in the army, before turning twenty-one I moved to Caracas. My father and two brothers were already living there. My mother traveled constantly to Venezuela where Graziano, one of my brothers, was working as an architect and photographer. He was conducting research on popular, indigenous, and colonial architecture of Latin America.

SB: **Were you already taking photographs?**

PG: Yes. After one of my mother's trips to Caracas, she came home with a Leica camera for me as a gift from Graziano, and at seventeen I began photographing. In Gorizia, Italy, my girlfriend Franca Donda and I frequented a photography studio. That's where we learned developing and copying techniques. I also took part in the exhibitions organized by Gorizia's photo-club, where I showed photographs of fishermen, peasants, and circus workers.

SB: **And in Caracas?**

PG: Having only been in Caracas for eight days, thanks to Graziano's architect friends, I began photographing the buildings of Carlos Raúl Villanueva, Venezuela's great modernist architect: the Central University of Venezuela and the

construction of the 23 de Enero [January 23] public housing blocks. I settled into a rich cultural world full of writers, philosophers, critics, and thinkers from the magazine *Cruz del Sur* (1951–61), a publication run by Violeta and Alfredo Roffé that linked cultural issues with societal problems and served as a focal point for leftist intellectuals who opposed the dictatorship of Marcos Pérez Jiménez (1952–58). I worked for Villanueva and for architects like Pedro Neuberger, Dirk Bornhorst, and Jorge Romero Gutiérrez on El Helicoide, a proposed shopping mall and industrial exposition center in Caracas built on a rock of gigantic proportions that was never finished. Now it's a prison.

SB: **You alternated between being an architectural photographer and documenting various neighborhoods. You also traveled around the interior of the country. Which work from this period do you consider most important?**

PG: My architectural work, without a doubt. Remember, this period marked the beginnings of publicity and advertising in Venezuela. I had offers to work in publicity that were much better paid, but I turned them all down because I was not, and am still not, interested in advertising photography used to sell products. I traveled either by myself or with Graziano. We went all over the Paraguaná Peninsula, an arid territory, between 1954 and 1960. We traveled from Los Castillos on the Orinoco

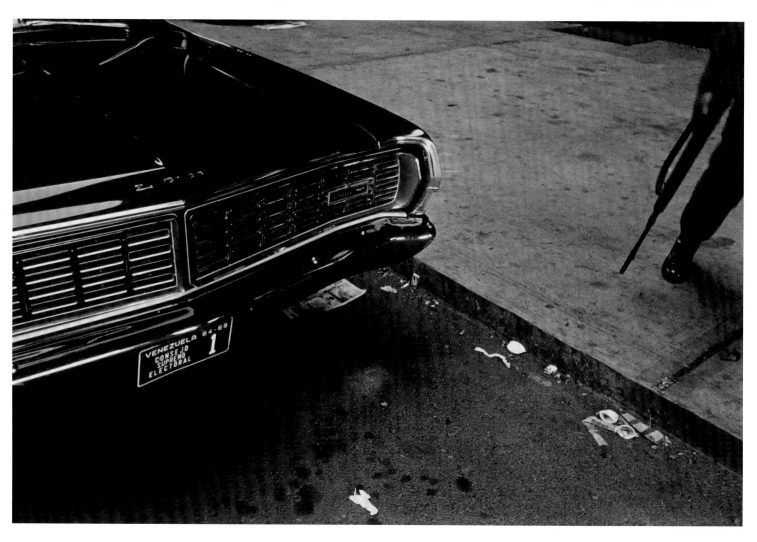

River—in the eastern part of Venezuela—and ended up enjoying ourselves and admiring the white houses of the Falcón State in the west. Then we moved onward to the market of Los Filúos in the Guajira Peninsula, on the border of Colombia, and crossed the Andes. Over the course of these travels I made two photo-essays: *Las Salinas de Margarita* (The salt mines/lakes of Margarita) and *Bobare, el pueblo más miserable del Estado Lara* (Bobare, the most miserable town in the State of Lara). Both were published in *Cruz del Sur*. I photographed Bobare under Paul Strand's documentary influence. Franca, who was living in Paris at the time, contacted Strand—who was self-exiled in Paris, fleeing from McCarthyism in the U.S.—and showed him the work that had been published in the magazine, as well as other photographs that I had taken in Venezuela. Strand brutally criticized *Bobare*. At one point he told me, "I had to look at it under a yellow light in order to soften the unpleasant yellow hue of the print." But he liked the other photographs. [Gasparini and Strand met later, in Orgeval, France, in 1956.]

SB: **Aside from Strand, what were your influences?**

PG: When I was eleven, I saw the horrors of World War II: photographs of bodies that had been mutilated, hung, and shot. The photographs belonged to a Yugoslav partisan and guerrilla fighter. This was my first experience with photography and it caused a deep impression.

My visual imagination was also fed by magazine photography and film. During the postwar period I went to the Venice Film Festival; at the time, in the United States Information Agency offices, the American Army was projecting films in Gorizia and Trieste. In Venice I saw *The Plow That Broke the Plains* (1936); *The River* (1938), which was produced by the Farm Security Administration; [Robert] Flaherty's film *Nanook of the North* (1922); *The Photographer* (1948), a documentary on Edward Weston; and the first images from the concentration camps. I saw films that hadn't been screened in Italy because of the war, *Gone with the Wind* (1939) and *Que Viva Mexico!* (1930), for example, and, of course, the Italian neorealism of [Cesare] Zavattini, [Roberto] Rossellini, and [Vittorio] De Sica.

I became acquainted with the "American way of life" through magazines like *Collier's*, *Life*, and *Picture Post*. I became enraptured by photography in the films of Paul Strand, such as *Redes* (1936), and I was especially drawn to the documentary photography, or rather the "social realism," of his book *La France de Profil* [with Claude Roy, 1952].

So the basis of my imagination was the documentary propaganda disseminated by the United States army. I left Europe for South America with the war photographs that I'd seen, and with my head full of images of America— hence my constant need to represent both worlds in my photographic practice.

SB: **You lived in Cuba between 1961 and 1965, after the revolution. You photographed with Alejo Carpentier, the renowned Cuban writer, and published the book *La ciudad de las columnas* (The city of columns, 1970). What drew you to Cuba?**

PG: On the one hand, there was an interest in modernity, beauty, folklore, and the authenticity of American life—in magical realism. In 1958, on the other hand, the Cuban Revolution had exploded as a response to the deep social problems that existed in Cuba and the rest of Latin America. The Cuban architect Ricardo Porro and Alejo Carpentier—both exiled in Venezuela—invited me to visit Cuba. I went with Franca; we were married by then. We intended to stay six months but the trip was extended to four and a half years. Carpentier wanted to write a book about Havana, an archive of baroque Cuban architecture—that's what became *La ciudad de las columnas*. He liked my "walking" work, he said, because I passed through all of the city streets, registering the stained-glass windows, hallways, and gates. I also befriended many of the fervent supporters of the first revolutionary wave.

SB: **Following the parties celebrating the Cuban Revolution, you shifted the content and style of your photographs, focusing on people living in poverty.**

PG: Yes, the speed of the social and cultural events in Cuba made me change my camera. I switched from medium- and large-format reflex cameras (which I used thanks to Strand) to a versatile 35mm, which obviously changed my way of seeing and capturing reality with tremendous speed. I became part of the artistic and intellectual circles, which included photographers, filmmakers, and architects such as Santiago Álvarez, Alberto Korda, and Iván Espín. In Havana I also met Cartier-Bresson, René Burri, Chris Marker, and Italo Calvino, all formidable intellectuals. This amplified my desire to expand the discourse of the Cuban Revolution throughout all of Latin America.

The basis of my imagination was the documentary propaganda disseminated by the United States army.

SB: **How did your Cuban themes differ from those in your other Latin American work?**

PG: In Cuba I documented the celebration, euphoria, triumph, and hope following the revolution. In the rest of Latin America, I documented social contradictions.

SB: **When did you begin to expand your travel around Latin America?**

PG: In 1970, UNESCO hired me to photograph pre-Columbian, colonial, and contemporary edifices. I focused on the urban building projects being erected from Mexico to the Pampas, from Brasília to Machu Picchu, designed by great modernist architects. I insisted on photographing the lives of marginalized individuals, of those who have nothing, and the huge differences that coexist beside and around these huge building projects.

SB: In addition to the book *Panorama of Latin American Architecture* (1977), you published the book of photographs *Para verte mejor, América Latina*. How did this project materialize and where did the title come from?

PG: It came from an eagerness to document Cuba once again. Edmundo Desnoes wrote the text and Humberto Peña designed the book. The title paraphrases [Charles] Perrault's story "Little Red Riding Hood" (1967).

SB: Tell me about *Retromundo* (Retroworld, 1986), your second book, which was about the representation of two worlds, Europe and Latin America. Here you juxtapose two ways of life: that of the inhabitants of Paris, New York, and Rome, and that of citizens in São Paulo, Mexico City, and Lima.

PG: As I told you earlier, I left Europe with images of America. Later on, I returned to the first world carrying images of the Latin American reality. That's where *Retromundo* came from—a book of photographs that doesn't confront realities but rather tries to serve as evidence for what's occurring on both continents.

SB: And *El suplicante* (The supplicant, 2010)? Where did you get the idea of structuring a book according to your long travels through Mexico?

PG: *El suplicante* was another adventure. I was invited to develop a project based on the urban culture of Mexico City. I took a photographic tour from the border of the northern imperialist to Subcomandante Marcos's land of Chiapas.

SB: And your most recent book, *Karakarakas* [wordplay on *Caracas* that incorporates the "ka" sound from the words *Kodak* and *Kafka*] (2014), takes the form of a political manifesto about the city.

PG: That book brings together photographs taken in Caracas between 1954 and 2014. I put together these photographs with *il senno di poi*, "the wisdom of hindsight." I combined images, connecting them with different themes, places, and dates, in an attempt to organize a new discourse that—by way of architecture and certain aspects of daily urban life—would offer a reinterpretation of Caracas's past and evolution, representing its social, political, and cultural contradictions. As in the previous books, I worked with a great team. The book managed to give significant shape to a politically urgent discourse on the circumstances Venezuela currently endures, from the incongruences of the Bolivarian Revolution to the so-called socialism of the twenty-first century. I also tried to reflect, through architecture, on daily city life in this country that's so wealthy with oil and yet so poor—a failure of modernity—and on the empty commitments of the governments preceding Chávez.

SB: You also include images of the last sixteen years, which comprise the Chávez and post-Chávez years (1999–present). Looking at *Karakarakas*, it seems that the situation has not advanced. We see no changes, and the misery and poverty continue.

PG: Chávez was the product, precisely, of a non-working democracy. He wanted to put an end to the bourgeois government and built a populist state that ended up dividing the people. The result has been the destruction of modern society, economic ruin, and the collapse of basic services: health care, education, work, among others. No one knows—nor can define—the economic, political, and social chaos we're suffering.

SB: In your *Fotomurales* (Photo-murals), which you began in the '90s and are still working on, and in the series *Epifanías* (Epiphanies, 1980s–90s), you use audiovisual narratives. Why use

Untitled, Havana, 1964

an audiovisual component in a photography book project?

PG: This allows me to incorporate spoken or written texts—poetry, music, sound, and imagery. Above all, it allows me to add a temporal shift. For me, audiovisual is the most complex and all-encompassing medium. The form helps deepen what I want to express. There I find what the photograph on its own doesn't provide—with its claim to replace the disorder of the world with the balanced order of the composition.

SB: **Since the 1980s you've been presenting audiovisuals together with slide-show projections, synchronizing three carousels of slides in a cinematic way. You orchestrated the projection in museums as well, as a sort of in situ performance.**

PG: The performance is important because, as the author of the project, I am present. The projection allows me to establish a dialogue with the public. Before projecting the piece, I can insert or extract images and organize a loose discourse, one that's mutable and changeable, different with every projection.

SB: **You have often framed writing in your photographs, be it publicity slogans or graffiti. Do you feel that the image is not significant in and of itself?**

PG: The image on its own nailed to a wall doesn't interest me. My interest has always been to edit images in the same way as words or discourse. From a fleeting image I like to develop visual phrases.

SB: **In the series *Fotomurales*, in some of the audiovisuals (early 2000s), you appropriated the revolutionary iconography of the continent, depicting Che or Tina Modotti; you uplift heroes who were dedicated to the Cuban dictatorship, as in Che's case. Is this a way of remembering or refreshing a political position?**

PG: What you're asking corresponds with a specific moment and context in recent Latin American history. In the '60s and '70s, there wasn't a single place in South America that hadn't been invaded by a political or advertising message, to the point where Coca-Cola and Che both became hypercontaminated icons in Latin America's cultural memory.

SB: **In Modotti's case it seems more like a romantic relationship.**

PG: Tina is special. She was born in Udine, a city close to Gorizia, my native city. When I was very young, Strand spoke to me of her, describing her as a great heroine of the revolution and an extraordinary photographer. In Mexico, I was a friend of [Manuel] Álvarez Bravo's, who studied, worked, and helped Tina with her Mexican ordeal, so full of betrayals. Edward Weston's journals

Electoral campaign,
Caracas, 1968,
from the series *Karakarakas*

speak of Tina, and for years his journals were by my bedside. In addition, Tina was beautiful and her photography was beautiful. Tina is another love in the journey of my life.

SB: **You developed your photography practice in close collaboration with the women you shared your life with.**

PG: I've been lucky. With the women I've loved I've had relationships filled with complicity and mutual interests. They were all intelligent, passionate, curious about photography, and shared my concern for social equality. Franca was a great partner; she helped me with my lab work. Duda Ferrari, an Italian architect, complemented my architecture work and designed several political publications in Caracas in the 1970s. With María Teresa Boulton I began a project of promoting photography as art in Venezuela, through the Fototeca gallery (1977–82), later the Venezuelan Council for Photography. Finally, with Marianela Figarella, an intelligent and passionate researcher, I shared ideas about photography as art and cultural product.

SB: **You still take pictures. Why?**

PG: In the end, after so many journeys, I believe there are some images that "bite," or pierce you, as Barthes notes. I think photographs can help us learn how to look. How to think about and resist this world that's consecrated to the grandiloquence of symbols that propagate lies and that, more and more, reduce and undervalue life.

SB: **How do you view the relationship between politics and photography?**

PG: Whether the formalists and Conceptualists like it or not, the image—the photograph—is a product of ideology. What is captured is in the mind of the person who triggers the shutter. Photography is the result of a thought process; it's a serious subject. It's not a click made with, say, a smartphone for uploading photographs to Instagram or Facebook.

Coca-Cola and Che both became hypercontaminated icons in Latin America's cultural memory.

SB: **Why take a political stance?**

PG: As Georges Didi-Huberman, a popular philosopher among the young Venezuelan Conceptual artists, says, "In order to know, you have to take a position. To take a position is to want, is to demand something, is to situate oneself in the present and aspire to a future."

SB: **What do you think about being considered a Latin American photographer?**

Los Ruices, Caracas,
1967-70

PG: I'm eighty-one years old. I've lived for sixty years in Latin America and twenty in Italy. I've lived between two worlds and I travel frequently. Obviously I consider myself a Latin American photographer in the sense that my work is connected to the social and cultural events of the continent.

SB: Is there such a thing as Latin American photography?

PG: If we locate photographic practice in a given territory, evidently Latin American photography exists, in the same way people speak of North American or Japanese photography. Photography has a history here: The second half of the nineteenth century saw the rise of travel photography and its stubborn depiction of the "other." The first decade of the twentieth century included Agustín Casasola's extensive and unprecedented coverage of the Mexican Revolution. The Cuban Revolution expanded the drive to photograph every corner of Latin America. During the Cold War, the medium was used by those we now call the "Conceptualists of the South" as a tool for dissent against totalitarian regimes, such as Pinochet's in Chile.

Recently, Alexis Fabry curated the exhibition *América Latina: Photographs, 1960–2013* (2013) at the Fondation Cartier in Paris, and also organized *Urbes Mutantes* (Mutated metropolises, 2013–14), in Bogotá and New York; these were extraordinary exhibitions that covered a wide repertoire of photographs made in Latin America. Currently,

many photographers work in the region, documenting diverse local realities, and they generate proposals that are comparable to those of photographers on other continents.

SB: You've spent more than sixty years taking photographs. Do you have an opinion about contemporary photography?

PG: Paul Strand, my teacher and friend, fought all his life for socialist ideals and for photography to be accepted in museums and purchased for its rightful commercial value. Now, in Latin America and in the rest of the world, socialism is dead or confined to museums. Photographs are sold at art fairs, veritable art supermarkets. Strand's photographs sell for thousands at art auctions: they've gone for more than a hundred thousand dollars! It has all come to pass, *cara* Sagrario.

Translated from the Spanish by Elianna Kan and Paula Kupfer.

Sagrario Berti is a Venezuelan art historian and photography researcher. She curated two recent exhibitions of Paolo Gasparini's work in Caracas. Berti also contributed to the catalog of Fondation Cartier's exhibition *América Latina: Photographs, 1960–2013* and was the editorial coordinator on Gasparini's most recent book, *Karakarakas* (2014).

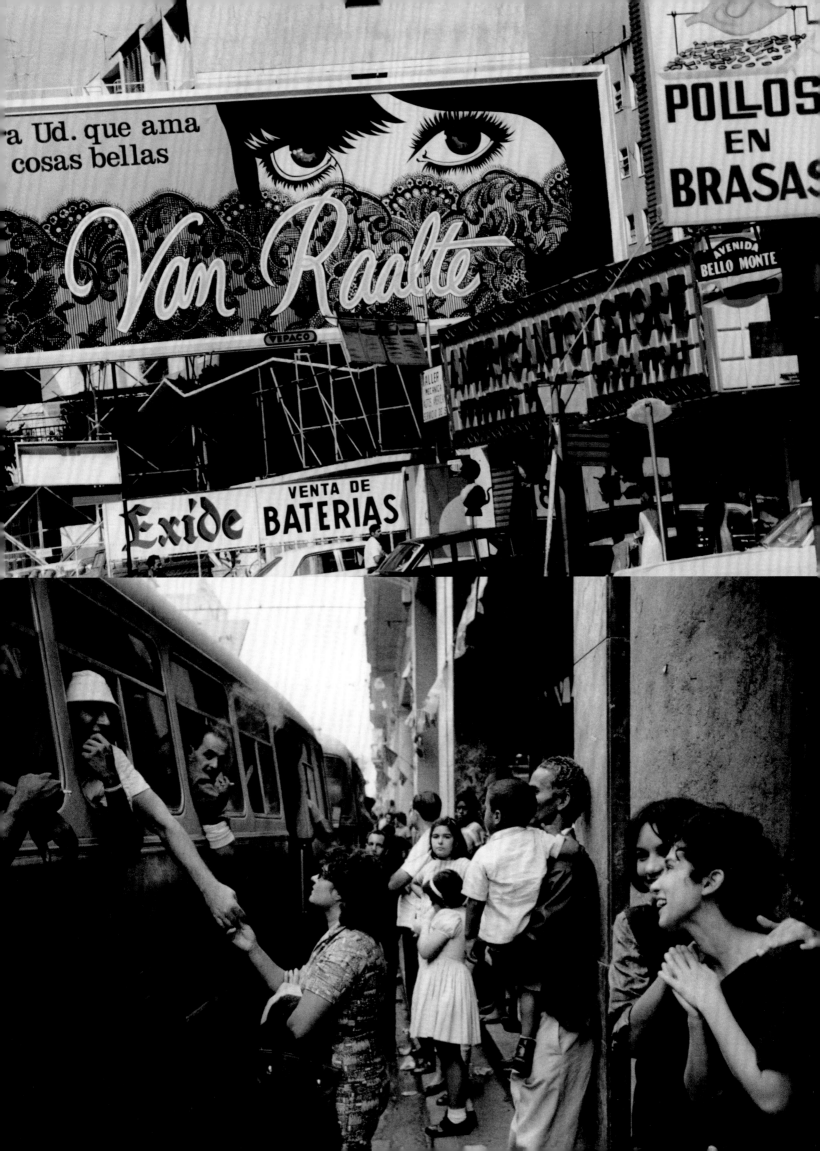

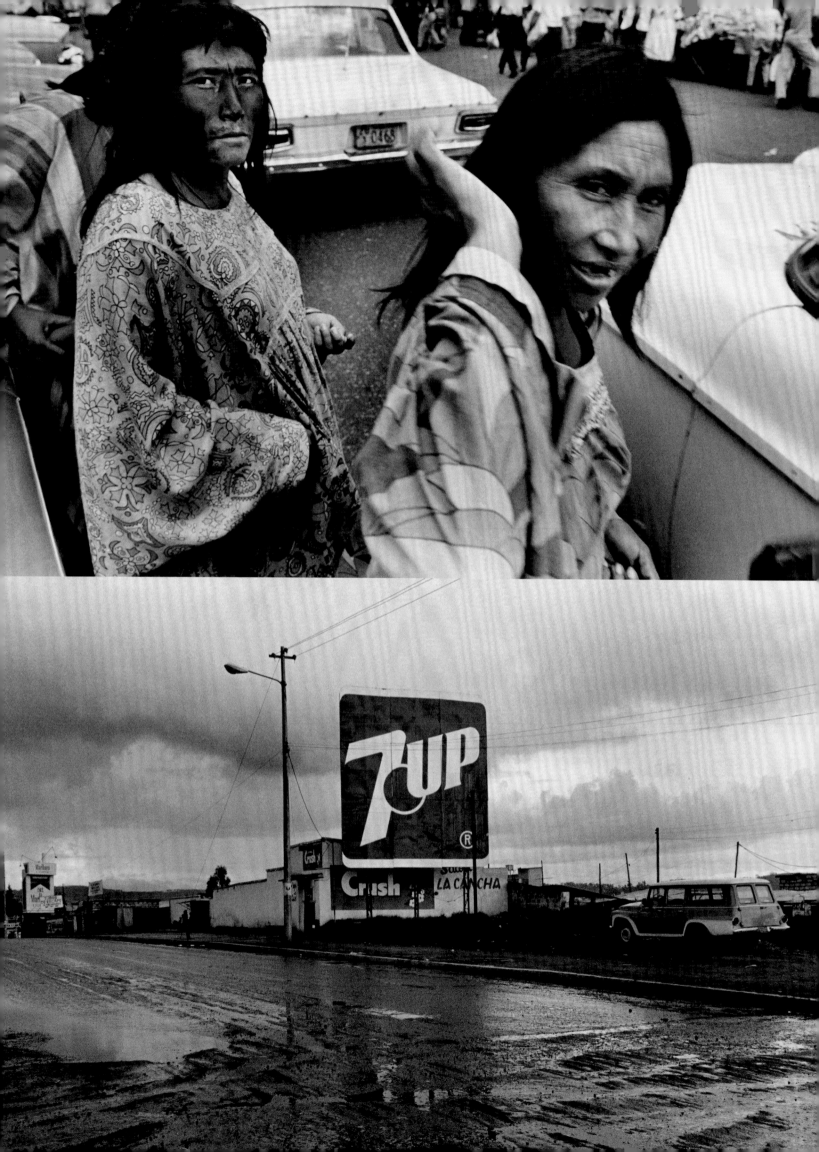

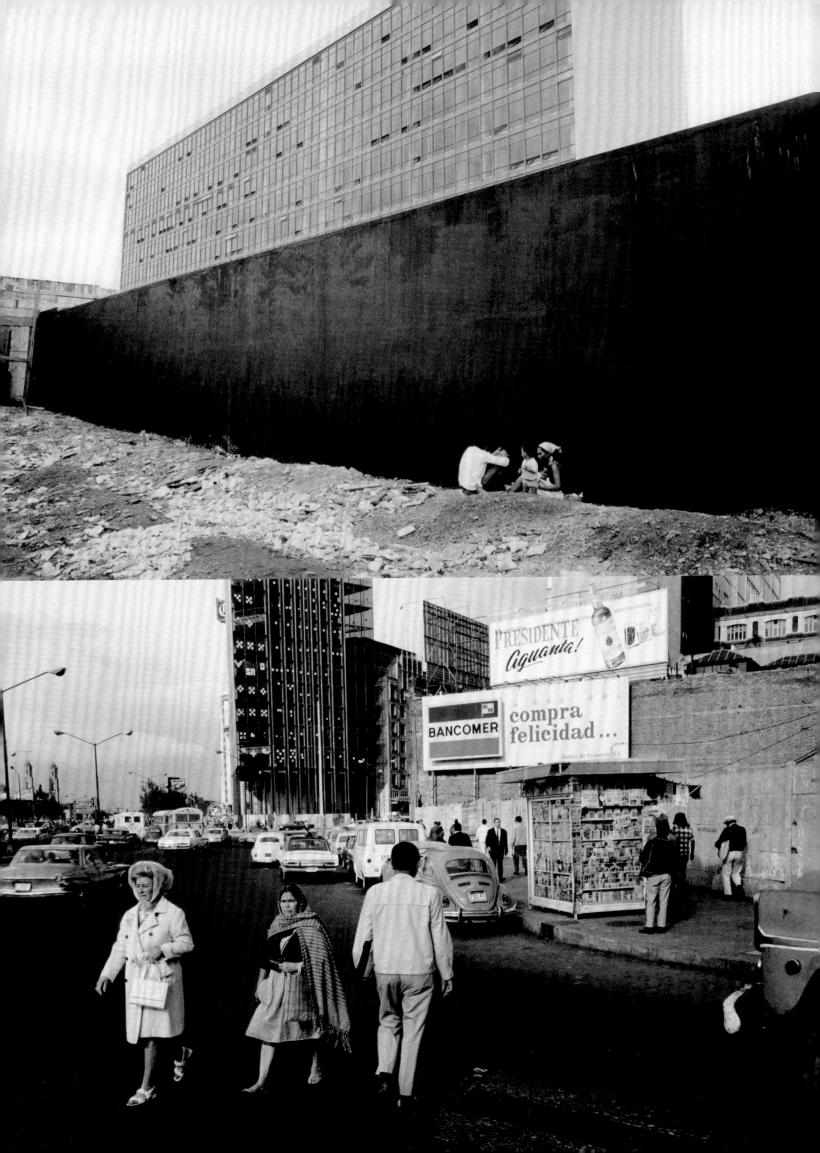

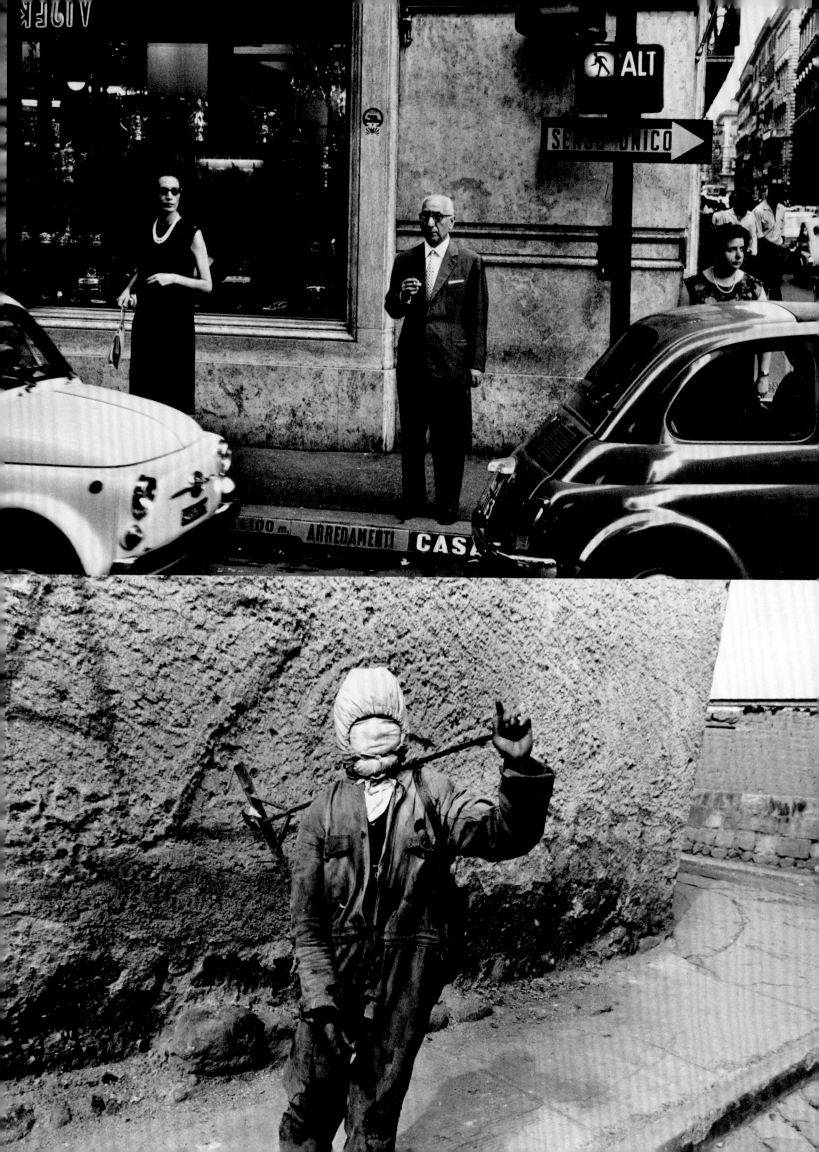

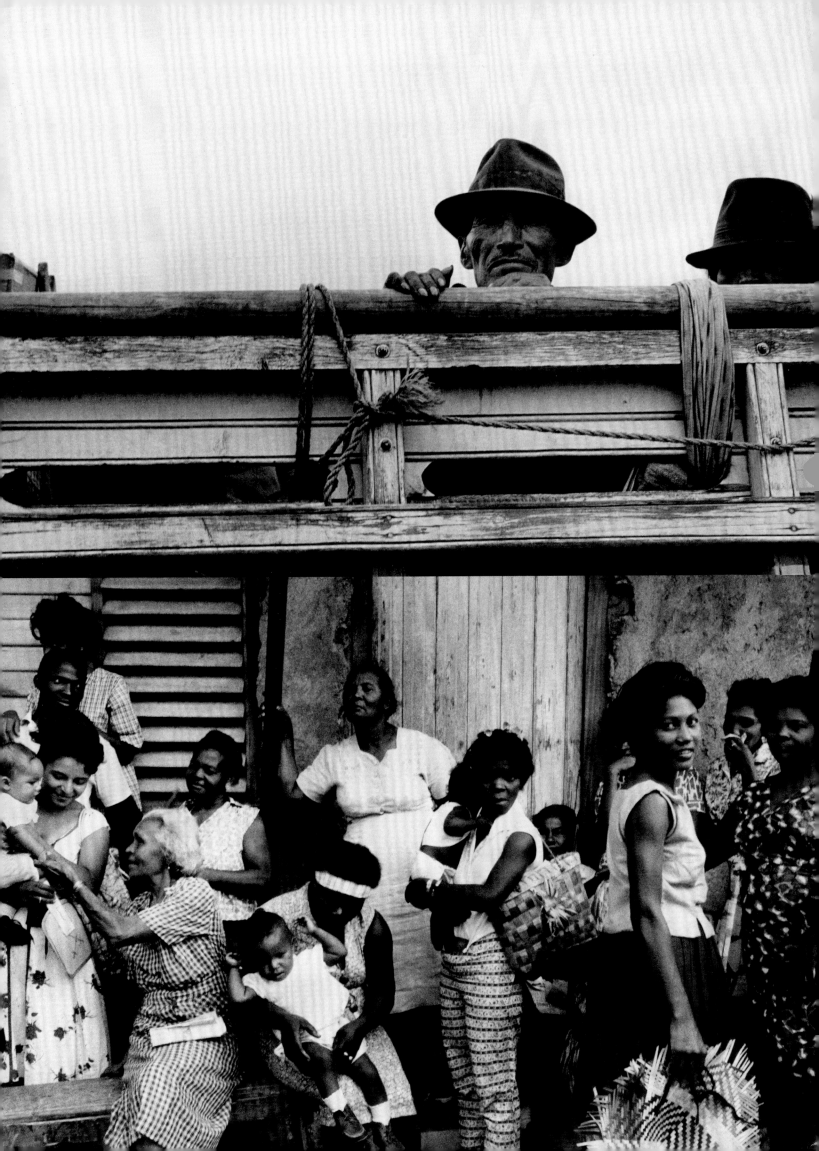

Alumni of MICA's BFA in Photography are leaders in the field, innovating through their practice and shaping the artists of tomorrow.

Graduates of MICA Photo are in the vanguard of contemporary photography. Meet two alumni making a mark on the field through their studio and teaching practice:

Elle Perez
BFA, MICA, 2011
MFA, Yale School of Art, 2015
Theo Westenberger Photography Prize
Featured in FADER, 2015
Artist in Residence, Skowhegan, 2015
Visiting Lecturer, Williams College

Anna Shteynshleyger
BFA, MICA, 1999
MFA, Yale School of Art, 2001
Guggenheim Fellowship, 2009
Solo Exhibition, Renaissance Society, 2010
Louis Comfort Tiffany Award, 2011
Assistant Professor, Pratt Institute

M|I|C/A MARYLAND INSTITUTE COLLEGE OF ART

Left to right: Anna Shteynshleyger, *Covered*;
Elle Perez, *Tennessee*

MICA.edu/bfaphoto

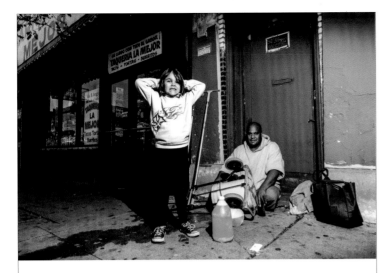

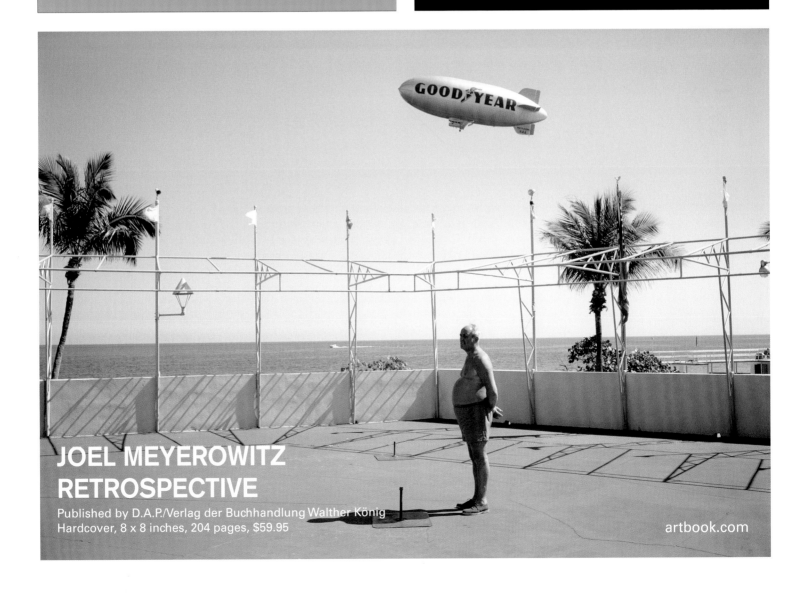

Object Lessons
Manuscripts, 1922

Cover of *Manuscripts* (*MSS*) (December 1922), International Dada Archive, Special Collections, University of Iowa Libraries

"Can a photograph have the significance of art?" This question has vexed the medium since its inception, and in 1922, the experimental arts journal *Manuscripts (MSS)* asked its contributors to offer their thoughts on the matter. They included the painters Charles Demuth and Arthur Dove, Marcel Duchamp, Sherwood Anderson, Georgia O'Keeffe, and Charles Chaplin, among others. *MSS*'s prompt was specific: answers needed to be concise, the maximum word count was six hundred, and all responses would be published unedited. Photographers, however, were not invited to comment.

Edited by journalists Paul Rosenfeld and Herbert J. Seligmann, with the support of Alfred Stieglitz, *MSS* was published in New York from 1922 to 1923, releasing just six issues. By issuing a questionnaire for their fourth issue, *MSS* joined a tradition of publications polling readers to activate aesthetic debates. Art historian Lori Cole has been researching the role of questionnaires in shaping the avant-garde across Europe and the Americas. "Unlike manifestos,"

Cole says, "questionnaires enabled print communities to bring in more voices to discuss a central anxiety or concern, thereby demonstrating its centrality to the magazine's mission." She has traced the genre as far back as the Renaissance, when *paragoni*, "comparisons of the arts," were sent to sculptors like Michelangelo or painters such as Bronzino to defend their respective disciplines.

MSS's 1922 questionnaire revealed that, in regard to photography's status, there was no consensus. Duchamp (identified as "painter," "chess expert," and "French teacher") wrote that he "would like to see [photography] make people despise painting, until something else will make photography unbearable." Writer and artist Joseph Pennell professed that "photography is not an Art—no longer even a science—but the refuge of incapables." But it was the journalist Walter Lippmann who cut things down to size: "It is clear that the men doing it [photography] *feel* its significance, and that is all that is necessary."

—The Editors